VERY HEATH ROBINSON

STORIES OF HIS ABSURDLY INGENIOUS WORLD

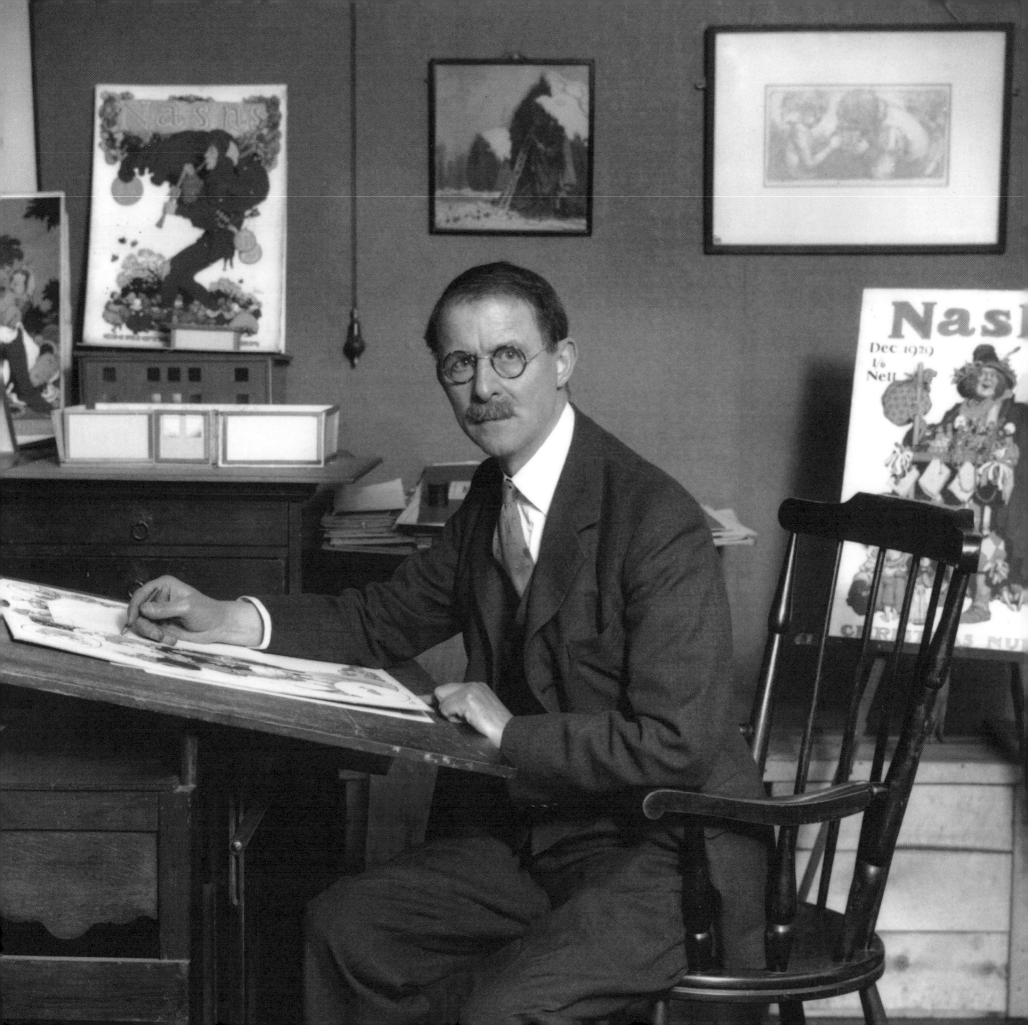

VERY HEATH ROBINSON

STORIES OF HIS ABSURDLY INGENIOUS WORLD

ADAM HART-DAVIS

SHELDRAKE PRESS
LONDON

First published in Great Britain in 2017 by
Sheldrake Press, 188 Cavendish Road,
London, SW12 0DA.
Telephone: +44 (0)20 8675 1767
Fax: +44 (0)20 8675 7736
E-mail: enquiries@sheldrakepress.co.uk
Web-site: www.sheldrakepress.co.uk

ISBN 978 1 873329 48 1

British Library Cataloguing in Publication Data:
A catalogue record for this book is available from the
British Library.

Colour origination by XY Digital Ltd.
Printed in Europe

EDITOR: SIMON RIGGE
Deputy Editor: Chris Schüler
Assistant Editor: Kezia Bayard-White
Editorial Assistants: Kirsty Bradford, Mathilde Charrier,
Daniele Frisson, Peter Jacobs, Harry Lawrence, Isobel Reid,
Giacomo Russo, Zoe Sadler
Design and Art Direction: Richard Ward & Associates
Picture Editor: Karin Robinson
Production Manager: Simonne Waud
Indexer: Geraldine Beare

Author
Adam Hart-Davis is a freelance writer and lecturer.
Trained as a chemist, he spent five years in publishing,
editing science books, and then 30 years in television,
working on such series as *Don't Ask Me* and *Scientific
Eye*, and presenting *Local Heroes, Tomorrow's World,
What the Romans Did for Us, How London was Built* and
many others. He has collected various awards for both
television and radio. He has written more than 30 books,
mainly about science and history, and has been a fan of
Heath Robinson's drawings for 60 years.

Consultant
Jane Humphries is Professor of Economic History at
Oxford University and a Fellow of All Souls College. Her
book *Childhood and Child Labour in the British Industrial
Revolution* was awarded the Gyorgi Ranki Biennial Prize
in 2011. A documentary, *The Children Who Built Victorian
Britain*, which Professor Humphries presented, won the
award for the Best History Program at the International

*Front cover: Among "W. Heath Robinson's Impressions of
Ransomes' Motor Mowers", drawn in about 1920, is this super
deluxe model fitted with a wireless, drinks cabinet, tiffin table
and other refinements for mowing in comfort.*

*Back cover: "The Housewife" motor mower, devised for
Ransomes', is one of the latest types of lawn mower that does
the washing and cools the children as well as cutting the grass.*

*Frontispiece: Never a man to court publicity, Heath Robinson
stares awkwardly at the camera in his studio in Highgate,
28th December 1929. This is where he painted the panels
for the Knickerbocker Bar on the R. M. S. Empress of Britain
and spent the last 15 years of his life. Near the end, he said
to his wife Josephine: "I am afraid I have not left you much,
but perhaps one day, my work may mean something to
somebody."*

*Title: A somersaulting figure in top hat and tails, carrying an
empty purse and an umbrella, represents Heath Robinson's
concept of "My Annual Turnover".*

*Below: Like any self-respecting artist, Heath Robinson
illustrated his correspondence with atmospheric doodles, for
example this self-portrait on what would appear to have
been an off day.*

CONTENTS

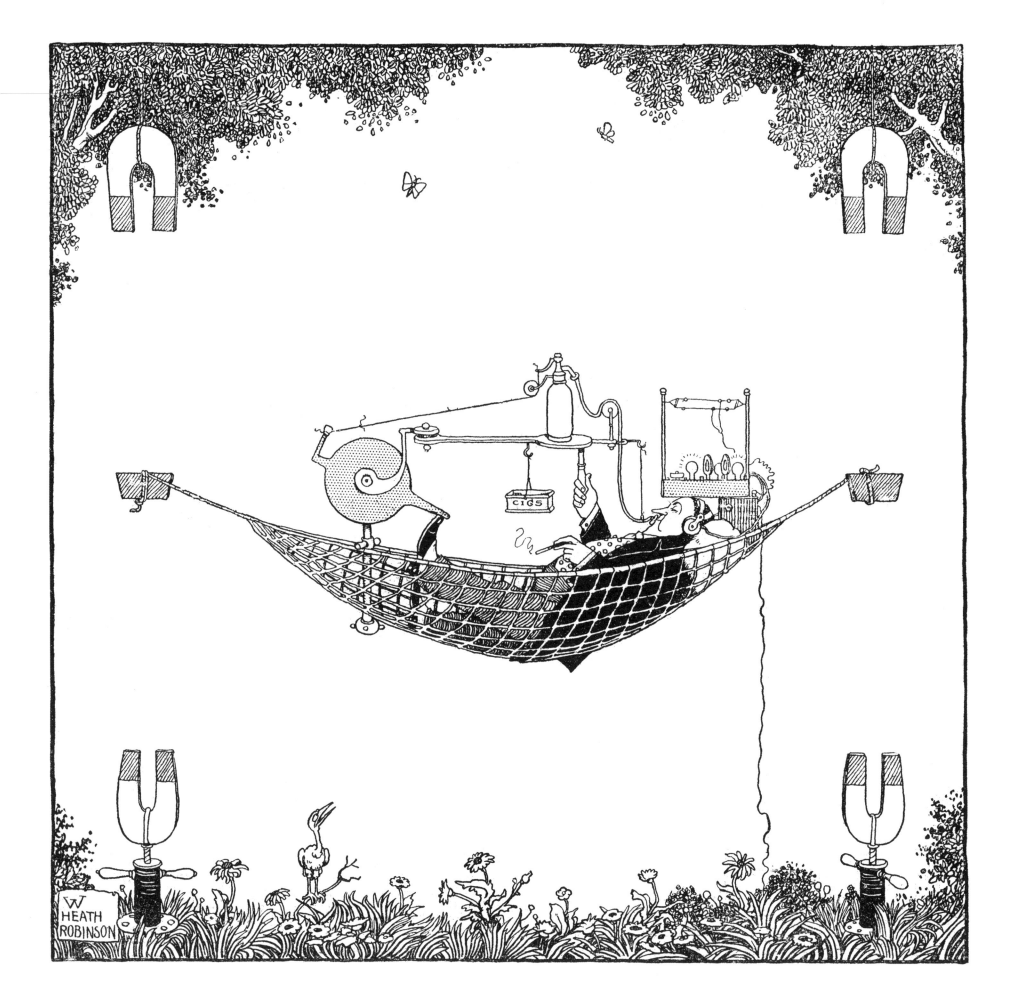

This book is dedicated with respect to all Heath Robinson enthusiasts, would-be enthusiasts and possible future enthusiasts, not to mention all makers of toffee, steam engines and cement, flat-dwellers, spring cleaners in Highgate Woods and the staff and passengers of the Great Western Railway.

With anticipatory delight to those who have not yet set eyes on a Heath Robinson drawing, and are to experience the immense joy of doing so.

Adam Hart-Davis

Heath Robinson's ubiquitous soda siphon, so often delivered on trays by conscientious butlers, here takes pride of place in an automated system of cords and pulleys. A mere touch of the foot delivers a refreshing draught straight to the recumbent figure's mouth. This up-to-the-minute vision of comfort, complete with wireless and headphones, was drawn in 1924 only two years after the B. B. C. commenced broadcasting.

FOREWORD

By Philip Pullman

There are few artists whose name has passed into the language, but there it is in *The Chambers Dictionary*: *Heath-Robinson: adj. used to describe an over ingenious, ridiculously complicated or elaborate mechanical contrivance.*

The delight given by Heath Robinson's absurd contrivances for doing such things as testing mistletoe for its kiss-permitting properties, overcoming the difficulties of conveying green peas to the mouth or trying the nerve of a promising young student at the Royal College of Steeplejacks, has been known and relished by his public for a century now. It isn't just the preposterous complexity, which for all its nonsensical elaboration looks as if it might just work, it's the gorgeous amateurishness of the actual objects themselves: the wheels made of two rough semi-circles of wood nailed together, the drive-belts consisting of several lengths of differently sized string tied with large lumpy knots, the struts formed from several pieces of gnarled and twisty wood laboriously lashed together… It's immediately recognizable, and immensely lovable.

Lovable, because the quality most lasting of all in his work is the charm. These solemn, earnest men with their frock coats and their top hats, and all the other members of the Heath Robinson repertory company, don't know they're being ridiculous. They are convinced that they're being entirely rational and clever and up-to-date. They're silly and harmless and delightful, because they don't realize that they're any of those things.

It's a world that doesn't exist any more, because it's entirely mechanical. You can read how it works by looking at it and tracing this lever and that pulley and this handle and seeing what happens when they move. Our world isn't mechanical any more, and it's lost a lot of charm in the process of becoming digital. Who knows how a mobile 'phone works? You press this button or touch that screen, but what happens inside? No one knows, or no one we know knows. And if it breaks you have to throw it away, because you can't mend it by tying a piece of string around it.

But the world was like Heath Robinson's drawings once. And there's a lot of social observation in them: the very *moderne* dining table and chairs, all made of one length of twisted chromium-covered steel tube; and all the ingenious space-saving devices for people living in small houses or flats, or for preventing their dancing to the broadcast music of the Savoy Orpheans from annoying the people downstairs – this was an inter-war world in which new ways of living were coming about, and were felt to be very up-to-date, but which one had to get accustomed to. But given the mild, earnest, energetic decency of the people, it would all work somehow.

Because there's no wickedness in Heath Robinson's world. There's no evil, no greed, no selfishness. As Evelyn Waugh said of the work of P. G. Wodehouse, it's prelapsarian: there has been no Fall of Man in this universe. These suburban amateur inventors and top-hatted officials may not live in

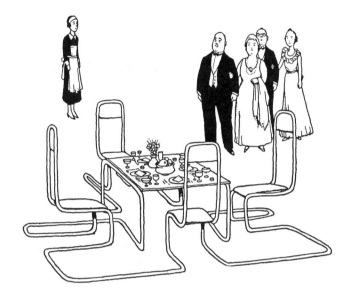

squirt some milk into her bowl. All the work is done by his machinery, which is an indication either that Heath Robinson is more up-to-date than Wodehouse, or (more likely) that the people he depicts are from a different social class, one not quite so much at home with servants, perhaps, or one that found it harder to pay wages than to construct machinery. Certainly these people don't live in Blandings Castle. Their homes are more modest than that – hence all the space-saving devices, the chicken farm suspended over the drawing room, the folding garden on its extendable balcony, the hatchways through which to cook your bacon and eggs without getting out of bed.

Blandings Castle or belong to the Drones Club, but they are as innocent of sin as Bertie Wooster.

Servants, incidentally, are an interesting point of contrast between Wodehouse and Heath Robinson. In Wodehouse all the work is done by servants, and consequently isn't thought about at all. In Heath Robinson, work is thought about a lot. There are a few servants, usually a harassed-looking housemaid pressed into service to hand the plates around during dinner, but more often than not the food, the drink, the soda syphon, the plates (a choice of hot or cold) are delivered by a vast and elaborate system of pulleys, weights and levers, while in the corner the cat sits on top of a bellows, thus providing enough pressure to

Once Heath Robinson had found his particular way of expressing his particular vision, there was no need to do anything else. He could have carried on doing it for ever. But he did have a different side. I have a copy of *Don Quixote* with his illustrations – fantastical, to be sure, as befits the story, but with a delicate fin-de-siècle romanticism. The tales of Hans Christian Andersen, *The Water Babies, The Arabian Nights* – there was a side of his nature that responded to a different sort of fantasy, but the public taste for that didn't last as long as the enthusiasm for his absurd contraptions.

The words "National Treasure" are now applied to any vaguely talented man or woman who reaches pensionable age. We need something better than that to praise Heath Robinson: "Immortal Contraptioneer", or "Mighty Commander of the Preposterous", or "Grand High Celestial Mechanic of Absurdity".

INTRODUCTION

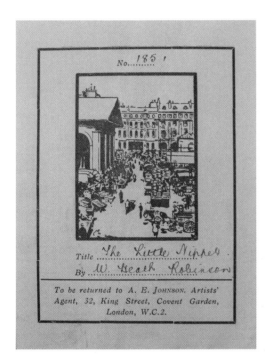

On the back of the Little Nipper artwork, which is still owned by Procter's, is Robinson's agent's ticket.

Left: In 1897, a Leeds inventor called James Henry Atkinson invented a mousetrap and named it "The Little Nipper". He asked the Yorkshire firm of Procter Bros. to manufacture it, and in 1913 the company bought the rights. Heath Robinson produced this humorous advertisement for the firm in 1919.

I first came across the extraordinary creations of the artist and illustrator William Heath Robinson at least 60 years ago. Among the thousands of books in our house were a couple of collections of his humorous drawings, and I loved them, even though I may not have understood every nuance. Seeing them now brings back many happy memories, and I find that when I look once more at old favourites such as the machine for conveying peas to the mouth (page 56) I often spot in the corner some little twist or joke that I had not seen before.

The expression "Heath Robinson" has become part of the English language, and is usually employed to describe a machine that is unnecessarily complex, even though it is designed to do a simple job.

During the Second World War, cryptanalysts at Bletchley Park in Buckinghamshire worked day and night to crack the German codes, in order to read their military signals. One of them, C. E. Wynn-Williams, wanted to break the Lorenz-ciphered teleprinter traffic, and designed a decoding machine so fantastic that it was called Heath Robinson. It was a triumphant success as a prototype for Colossus, the first large-scale electronic computer, and Heath Robinson was actually reconstructed in 2001 by Tony Sale.

On 28th October 2015 Patrick Hosking, writing in The Times of London, likened the British economy to "a gigantic Heath Robinson contraption of interconnected cogs and pipes and pulleys and elastic bands powered by the occasional steaming kettle and stretching as far as the eye can see".

As a cartoonist, Heath Robinson has often been compared to Rube Goldberg (Reuben Garrett Lucius Goldberg), an American contemporary who trained as an engineer but gave up his job in 1905 to become a full-time cartoonist. He soon became famous, like Heath Robinson, for designing immensely complicated machines to perform simple tasks. To this day there are annual Rube Goldberg machine-building competitions. An interesting contrast between their styles is that Rube Goldberg's machine drawings usually have long explanatory captions or speech bubbles, while Heath Robinson's have minimal captions, or none at all.

Early in the First World War Heath Robinson was delighted to receive a fan letter from the famous author of The Time Machine, The War of the Worlds and many other books:

New Year's Eve '14
Dear Sir,
It may amuse you to know that you are adored in this house. I have been ill all this Christmas-time and frightfully bored and the one thing I have wanted is a big album of your absurd beautiful drawings to turn over. Now my wife has just raided the Sketch office for back numbers with you in it and I am running over lots of you. You give me a peculiar pleasure of the mind like nothing else in the world...
I hope you will go on drawing for endless years.
Yours very gratefully,
H. G. Wells

William Heath Robinson was born on 31st May 1872 in Hornsey Rise, north London. He was named after his mother's father, William Heath, who was a pub landlord. He had two older brothers, two younger sisters and a younger brother. His father, Thomas Robinson, earned his living by drawing illustrations for the Penny Illustrated Paper, usually the picture on the front cover and a double-page illustration inside. The P. I. P. was one of the forerunners of today's weekend colour supplements.

Every Saturday afternoon his father would come home with a big woodblock and all his drawing materials, plus either a sketch drawn on the spot by a special correspondent or simply a written description. From these Thomas Robinson would produce his

finished illustration, of an episode from the Zulu wars, the Tay Bridge disaster or a skirmish in Afghanistan. The engraver would come on the Monday morning, take the block away and get the illustration engraved, section by section, ready to print for the Thursday edition.

The children loved watching their father at work, and the boys all wanted to be artists. William claimed that at an early age he "could draw a passable Zulu, with feathered headdress, long oval shield, and assegai". When he was 15, William went to art school in Islington, where he and his fellow students "worked hard intermittently and talked a lot about art". Heath Robinson later acknowledged the influence on his work of many predecessors and contemporaries, including Sir John Gilbert, Aubrey Beardsley, Sidney H. Sime, Walter Crane, Robert Anning Bell, Kate Greenaway and various Japanese artists.

At art school he planned his future: "It was only a matter of choosing whether I should paint frescoes in cathedrals and monasteries, or whether I should wander all over the world painting mountain scenery or old cities, and, on an occasional visit to my own country, the woods and fields of England." He found, sadly, that "It was a little difficult to descend from these ambitious flights to the comparative drudgery of drawing a vase, a cube, and a cone arranged on a board."

On leaving art school, Heath Robinson tried the romantic life of a landscape painter, but things did not work out. Lacking the cash for foreign travel, he chose instead Hampstead Heath, Parliament Hill Fields and Highgate Ponds, which were all within walking distance from home. He spent all summer working there, and then, full of hopes, took his work to a dealer in Balls Pond Road, a pleasant man who greeted him warmly and examined the paintings critically and silently for a long time. Then, having asked whether William would have to depend on his own earnings, the dealer advised him to try another profession.

He did eventually sell one of those paintings, to the mother of a friend, but clearly his landscape painting was not going to earn him a living.

By now his brothers Charles and Tom were selling drawings for reproduction in books and magazines, and

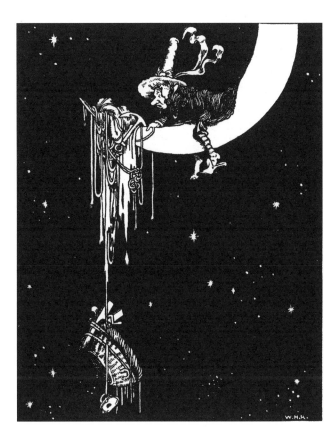

*Above: "She's kind and ever did admire a well-fed monk."
Heath Robinson produced more than 120 of these drawings
for a handsome two-volume edition of Sir Thomas Urquhart's
1653 translation of* The Works of Mr. Francis Rabelais
published by Grant Richards in 1904.

*Above right: Uncle Lubin's attempt at space travel is thwarted
when his hot-air balloon becomes impaled on the point of the
crescent moon.*

*Left: This richly romantic rendering of "The Princess and
the Swineherd" is one of 16 colour plates Robinson
made for Hodder & Stoughton's 1913 edition of* Hans
Andersen's Fairy Tales.

William decided to follow suit. He made a collection of drawings and tramped round all the publishers in central London, eventually succeeding in selling a few, and then getting commissions.

With another artist friend he rented a studio, a small box of a room with a skylight but no windows. Beneath them was a stable; they could hear the horses stamping below. Eventually, driven out by the stench of manure, they found another ramshackle room on the roof of a house in Gower Street, and "open to all the winds. It was good to be up here in a storm. The walls shook and creaked but our trim built craft was taut and seaworthy. At these times, we could picture ourselves blown from our moorings and sailing gaily over London."

By the time he was 24, William was earning a living from his art. He started to sign his works W HEATH ROBINSON, and ever since then he has been known as Heath Robinson. In 1900 he illustrated poems by Edgar Allan Poe, and for the first time there was an element of humour in the brief. Before long Heath Robinson was

doing humorous illustrations for the magazines of the day, notably *Tatler, The Bystander, The Strand Magazine* and especially *The Sketch*. Although I was familiar with his humorous drawings, I did not realize until recently that he also drew immense numbers of serious illustrations for *The Pilgrim's Progress, Don Quixote* and other classics.

In 1914 Heath Robinson joined the London Sketch Club, which included among its members Frank Reynolds, H. M. Bateman, Edmund Dulac and many other distinguished artists. Another contemporary was Arthur Rackham, perhaps most famous for his illustrations for *Alice's Adventures in Wonderland*.

"All truly great thoughts," wrote Nietzsche in *Twilight of the Idols,* "are conceived while walking," and Heath Robinson was an enthusiastic rambler all his life. The Scottish engineer James Watt dreamed up his crucial idea of the separate condenser, which transformed the Industrial Revolution, while walking on Glasgow Green in May 1765. "I had not walked further than the golf-house," he said, "when the whole thing was arranged in my mind."

A similar flash of inspiration – he said it was like the vision that came to Saul on the road to Damascus – came to the teenage teacher George Boole as he walked across Town Fields in Doncaster on a frosty morning in January 1833. That insight led to Boolean algebra, which now forms the basis of the operating system in every computer, tablet, mobile 'phone and washing machine. And a few years later, a stationmaster named Thomas Edmondson was walking near what is now Brampton in Cumbria when he invented the idea of the railway ticket.

Inspiration came to Heath Robinson in the form of an imaginary friend. "At this period," he wrote in his autobiography, "I became conscious that I was being haunted by a strange little genius.... He was sincerity itself and he had the simplicity of a child combined with the wisdom of old father William. No mortal could compare with him for ingenuity and inventiveness. He could do wonderful things with a piece of knotted string. There was one thing he lacked and that was a sense of humour; perhaps this was not a loss as strangely enough it made him all the more humorous..."

The result was *The Adventures of Uncle Lubin,* a children's book which Robinson both wrote and illustrated. This weird and wonderful tale about pursuit of the bagbird by the gentle but serious Lubin, in his striped stockings and floppy hat, was published by Grant Richards in 1902, and is still in print today. Two years later Richards invited Robinson to illustrate the works of Rabelais.

Uncle Lubin was also responsible for a significant – and very different – development in Robinson's career. One Chas. Ed. Potter of Toronto, who had seen *The Adventures of Uncle Lubin,* wrote to the artist to ask him to illustrate some advertisements for the Lamson Paragon Supply Co. Ltd. He suggested they meet at Tranter's Hotel. Suspicious of tricksters from across the Atlantic, Heath Robinson nevertheless went to meet Potter, who "was not at of all the gangster type; on the contrary he was the most amiable little man, who beamed at me in a friendly way through a pair of gold-rimmed glasses." Despite Potter's innocuous

appearance, Robinson cautiously demanded payment on delivery of each drawing, in cash.

"Cash in those days," Robinson recalled, "meant solid gold.... I was soon ashamed of my suspicions and my stipulations lost all meaning. It was, however, so satisfactory to return from my visits with a little pile of gold in my pocket, that I could not remove the conditions I had imposed."

The advertisements for Lamson Paragon marked the beginning of Robinson's advertising work, which enabled him to spread his wings and fill his paintings and drawings with his irrepressible humour. What's more, those pocketfuls of gold provided him with enough capital to marry his fiancée, Josephine Latey, in 1903.

Further important assignments followed, both advertising and for books: illustrating *Hans Andersen's Fairy Tales,* Shakespeare plays and Rudyard Kipling's *A Song of the English.* In 1912 he published another children's book, *Bill the Minder,* which he had also written as well as illustrated.

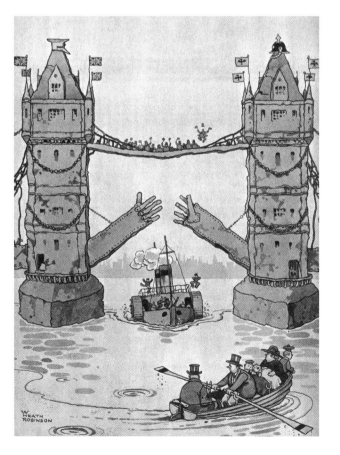

Far left: During the First World War, Robinson gleefully lampooned the German foe in the pages of The Sketch. *Here he delights in an "Unfortunate Mishap to a Zeppelin through a Lack of Proper Caution in Descending".*

Left: When the longed-for peace finally came, Heath Robinson drew a cartoon for The Bystander *showing Tower Bridge festooned with decorations, its bascules converted into clapping hands.*

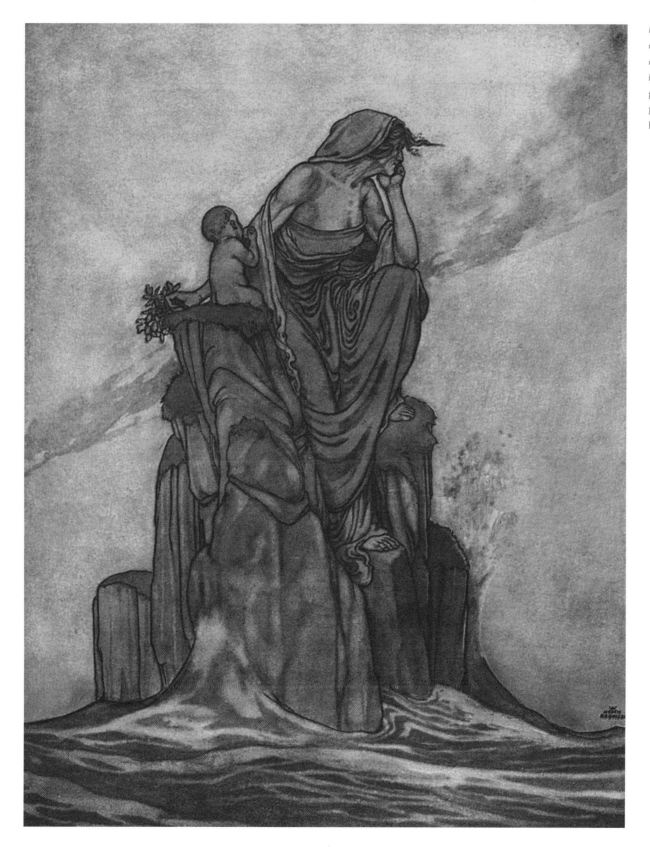

His reputation grew steadily, and when the Great War broke out in 1914 *The Sketch* and *The Bystander* commissioned Heath Robinson to draw a series of pictures of fabulous Allied war engines and propaganda cartoons mocking the ghastly Germans. Many were circulated to the front, and he received various fan letters, including this one, dated 6th November 1916:

Your Some Frightful War Pictures *has just reached our mess within the last few days and you can have no idea how much the illustrations are appreciated out here. All members of this mess have been "At it" since the very beginning and your sketches in the various magazines, &c., have always been a source of great amusement to us.*

After the war was over, Heath Robinson was invited to draw a series of strip cartoons for *The Daily News,* for which he invented a new character, Mr. Spodnoodle, who was really a reincarnation of Uncle Lubin, but particularly clever with machines. These contraptions provoked much interest from a variety of industrial companies, and Heath Robinson was invited to see the real processes of coal mining by Fletcher Burrows and Co. Ltd., of coke and coal-tar production by Newton, Chambers and Co. Ltd., of cement production by G. and T. Earle Ltd., of welding and riveting steel frames by the structural engineers John Booth and Sons and of leather processing by Connolly Bros.

These visits led to still more commissions – for calendars, yearly booklets and yet further invitations, to see the manufacture of Swiss rolls, toffee, paper, marmalade, asbestos cement, beef essence and lager. As Heath Robinson wrote, "The little daemon who haunted me had for some time abandoned the guise of Uncle Lubin.... He was making a heroic attempt to adapt himself to the times. He became in turn an expert in hunting and fishing, in British industries and manufactures, an inventor, a sportsman and an expert in the detection of crime...."

A series of illustrations of "Great British Industries" included such fantastical scenes as "Stiltonizing Cheese in the Stockyards of Cheddar" and "The Pea-splitting Shed of a Soup Factory". One of the most preposterous was an advertisement for Little Nipper mousetraps,

One of Heath Robinson's most prestigious commissions was to decorate the Knickerbocker cocktail bar on the new liner Empress of Britain for the Canadian Pacific Steamship Company in 1930.

with its ludicrous pile of household objects and some 20 fascinated spectators. One detail of Robinson's machines that I love is that almost without exception they include pieces of knotted string.

The peak of Heath Robinson's career came in the 1920s and 1930s when his fame spread to North America, Germany and Holland and he received ever more eye-catching commissions from book and magazine publishers, advertisers and exhibition organizers. Of the books he illustrated, 25 were published in the U. S. A. as well as in the U. K. by the top publishers of the day. Houghton Mifflin Co. commissioned frontispieces to four volumes in a deluxe set of the works of Sir Walter Scott which were not available in the U. K. His drawings appeared regularly in *Life, Sportsman* and *Cosmopolitan* magazines in the 1920s and 1930s. Advertisers followed publishers. In 1927 the forward-thinking men's outfitters Rogers Peet, based in downtown Manhattan, asked Heath Robinson to make six drawings and a cover for a portfolio of loose plates illustrating their dedication to quality, and the City Dairy Company of Toronto

commissioned a cover design for a booklet gloriously embellished with milkmaids and foaming churns. In Germany Heath Robinson produced numerous illustrations for Continental Tyres and for Zerkall Bütten, paper makers in North Rhine-Westphalia.

In 1930, when the Canadian Pacific Steamship Company was building the luxurious new liner R. M. S. *Empress of Britain,* they engaged Heath Robinson to decorate its Knickerbocker Bar and Children's Room. He covered the walls with wonderful cartoons. In 1934 the *Daily Mail* approached him with another giant project, this time to design a "Gadget House" for their Ideal Home exhibition, and a firm was paid to build it to two-thirds scale, like a giant doll's house with the front removed to reveal the inner workings.

When the writer Norman Hunter created his absent-minded and accident-prone inventor Professor Branestawm, it looked like a match made in heaven. The first of this massively popular series, *The Incredible Adventures of Professor Branestawm*, appeared in 1933 with 76 illustrations by Heath Robinson, who received equal billing with the author on the title page. In 1935 he produced a book of *Railway Ribaldry* to mark the centenary of the Great Western Railway, and the following year he began a collaboration with K. R. G. Browne, whose grandfather, Hablot Browne, was better known as "Phiz", the illustrator of many of Dickens' novels. Together they published a series of delightful self-mocking books: *How to Live in a Flat, How to be a Perfect Husband, How to Make a Garden Grow* and *How to be a Motorist.* After Browne died Robinson produced three more books in collaboration with Cecil Hunt. These appeared in the first years of the Second World War, and included light-hearted jibes at war-time austerity and the beginning of the welfare state, as outlined in the Beveridge Report.

As in the previous conflict, Heath Robinson set his sights on the pomposity of the German war machine and devised fanciful ways of repelling an invasion. These drawings, originally published in *The Sketch,* were collected in a book, *Heath Robinson at War,* in 1942.

For this book we have chosen more than 300 of our favourite drawings, many of which have not been published between hard covers before now. As far as possible we have gone back to the originals, and ignored the many later, poor-quality reproductions. For almost all the drawings, Heath Robinson used just pen and ink, often with half-tones, which were sometimes printed in sepia. He also liked to depict parts of a scene or distant figures in solid black silhouette (see pages 40/41 and 95, for example).

When he was commissioned to do pictures in colour he charged extra. He then drew with pen and ink as before, and filled in meticulously with watercolour washes, in most cases just simple solid colour, and no wet-into-wet or other such techniques. Looking at these coloured pictures, you will see that he enjoyed a strong red, and often showed metal as grey, but otherwise was often content with a range of mushroomy browns and yellows.

Robinson said that artists seldom retire, and he maintained a prodigious output until his health began to fail in the summer of 1944. He died of heart failure on 13th September that year.

Many artists of his era are long forgotten, but Heath Robinson's name lives on. He has influenced a wide range of people, from Nick Park, the creator of *Wallace and Gromit* – their house is remarkably similar to the Gadget House – to Michael Rosen and J. K. Rowling, who contemplated devising a Heath Robinson-type machine while dreaming up the Sorting Hat at Hogwarts. A Heath Robinson revival is afoot, with the formation of the William Heath Robinson Trust and the opening of The Heath Robinson Museum. As I write, there is even a Heath Robinson-inspired garden at the Chelsea Flower Show in London.

The secret of his enduring popularity lies in his unique ability to inject humour and humanity into the cold efficiency of the machine age. He let the outlines of his superb draughtsmanship go wonky so that his drawings share the endearingly amateur appearance of the makeshift contraptions they depict. We are invited into a reassuring world of gentle eccentricity, cheerful stoicism, a flair for improvisation and a gleeful debunking of officialdom – and anyone else who takes themselves too seriously.

Between 1936 and 1940, Robinson and his collaborator K. R. G. Browne produced a series of tongue-in-cheek "How To" guides tackling pressing modern concerns from marriage to motorism.

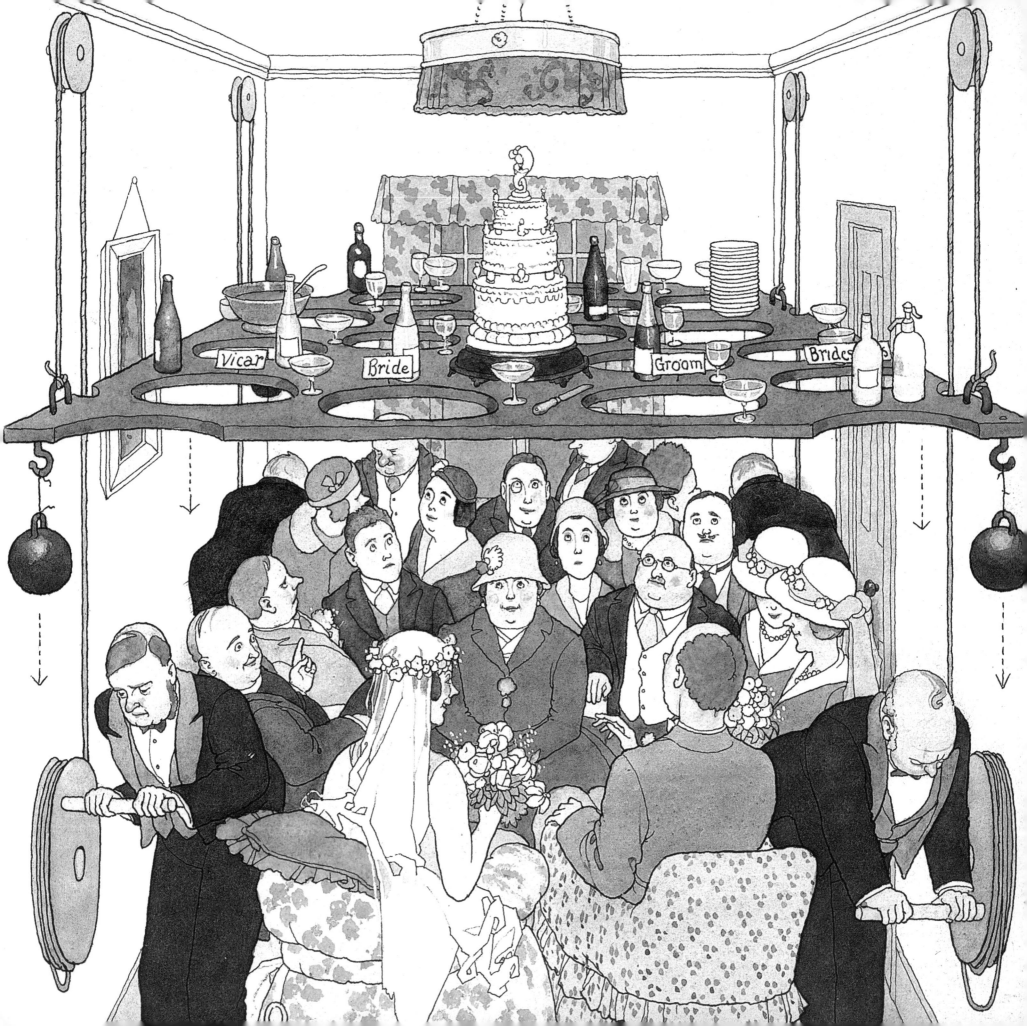

CHAPTER I

IDEAS FOR DOMESTIC BLISS

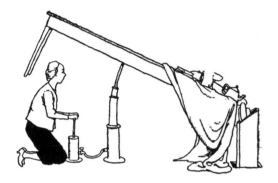

Clearing a table after breakfast can be a time-consuming chore. This apparatus, powered by a simple hydraulic pump, disposes of tablecloth, crockery and cutlery in one swift, satisfying slide.

During the 19th century the Industrial Revolution had brought significant changes to Great Britain. The population increased from eight million in 1800 to 30 million in 1900, and these people had to live somewhere. The rapid development of cotton and other mills attracted workers into the towns and cities, and at the same time the modernization of agriculture meant that many fewer labourers were needed on the farms. Before 1800 most people worked in the fields and lived in the country; after 1900 most people worked in industries and lived nearby.

As people migrated into towns and cities, suburbs developed to cope with the influx. Suburban houses were small, and often divided into maisonettes and flats. During the 19th century most better-off families had two or three servants: perhaps a cook, a parlour maid and a butler. The Robinson household, William claimed, included "a general servant, a kitchen maid, a nurse, a housemaid, and a cook; but as all these retainers were united in one person, our household was not greatly increased thereby".

Aspiring middle-class families did not really have enough money to employ servants, nor space to house them, especially if their new home was less than a complete house. For some, the loss of servants was a dreadful imposition. How could middle-class people be expected to light their own fires, cook their own food and clean their own houses? In addition, how could they possibly live in a small house? Once his imagination got to work, however, Heath Robinson found ingenious solutions to such potential problems. The wedding breakfast scene on the opposite page is a typical example of his answers to the problems caused by lack of space.

Meanwhile, in the real world, the advent of domestic gadgets meant that servants were becoming less necessary. Hubert Cecil Booth's original vacuum cleaner of 1901 was a steam-powered machine the

size of a large cart, and pulled by horses. When you summoned it, the monster was brought to the road outside your house, and pipes led in through several windows to bring the vacuum to your carpets and upholstery. This was an important social event, and ladies would invite their friends to come and take tea and observe the wonderful machine in action.

The wealthy Chicago socialite Josephine Cochrane invented the first effective dishwasher in 1886. She was not the sort of lady who liked getting her hands dirty, and had plenty of servants. She invented the machine not to avoid washing up, but because she was fed up with her servants breaking her expensive china.

In 1908, James Murray Spangler, a 60-year-old asthmatic janitor in Canton, Ohio, put together a carpet sweeper with a fan and a pillowcase on the back to catch the dust. He could take this portable electric machine round the building with him; it kept the dust down, and reduced his asthma attacks. He took out a patent, and set up the Electric Suction Sweeper Company to make his machines.

William H. Hoover, who made leather horse collars and harnesses, was worried about the threat to his business from the advent of the automobile. He saw one of Spangler's machines, was immensely impressed and bought the entire business for $36,000. Offering a week's free home trial, the company was so successful that we still talk about "Hoovering" rather than "Boothing" or "Spanglering", even though Hoover did not invent the vacuum cleaner.

During Victorian times, most middle-class people in England washed themselves when they considered it necessary, which usually meant once a week. Only the wealthiest had piped water and plumbed-in baths. Others used a galvanized iron bath in front of the fire in the sitting room or the kitchen. It was filled with water heated on the fire or the kitchen range, and

Even in the cramped confines of a modern flat, it is possible to entertain a wedding party in style: with Heath Robinson's ingenious mechanical dining table, their place settings will come to them.

then the entire family would bathe in turn, starting with Father, then Mother, then the children in order of descending age. Last of all were the babies. By then the water was so dirty you could easily lose someone in it, hence the saying "Don't throw the baby out with the bath water!"

Alternatively they could go to the public baths that were springing up in most towns. At Cambridge Heath Bridge Baths in London you could have "Baths Hot or Cold with towels and soap for 6d." (2.5p.), while the Paddington Public Baths and Wash Houses offered baths and showers, and "a private laundry, where persons may have the use of tubs, hot and cold water, steam wringers, drying chambers, irons and mangles at a charge of one and a half pennies per hour".

William Heath Robinson took a mischievous delight in these developments. Some of his ideas were technological: he invented a hydraulic table-clearing machine and complex mechanical slimming engines to roll or pummel you into shape. Others were simpler and often more whimsical: servants could be replaced by pieces of string, so that people could bring themselves whatever they wanted without moving from their chairs – the early 20th-century version of remote control. Chickens could be brought into the house to lay fresh eggs for breakfast. You could even get the milkman to start the automated house at dawn by stepping on a loose paving stone by the front door, so that everything from the alarm clock to the kitchen stove sprang into action without anyone lifting a finger.

The rapid expansion of the suburbs left many stranded far from the green expanses their forebears took for granted. For these new urban dwellers, the garden became an oasis of calm, a status symbol and a relaxing hobby. Horticulture, once the preserve of the landed gentry, was now a national pastime. But without the armies of labourers that aristocrats had at their disposal, working- and middle-class gardeners had to rely on a plethora of labour-saving gadgets such as lawn mowers – and the quintessentially Heath Robinson character of much of this equipment gave rise to some of the artist's richest comic inventions.

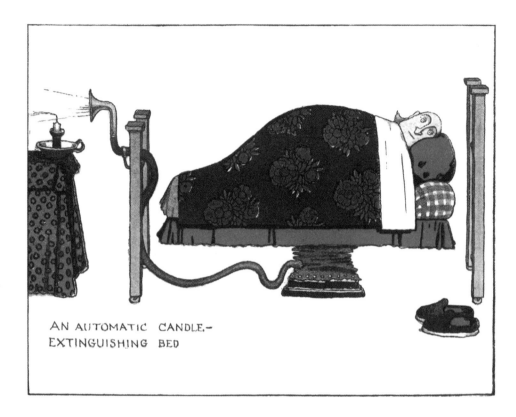

AN AUTOMATIC CANDLE-EXTINGUISHING BED

Well into the 20th century, people still used candles to light their way to bed. But how to extinguish them safely once one was snugly tucked up? As ever, Heath Robinson had the answer.

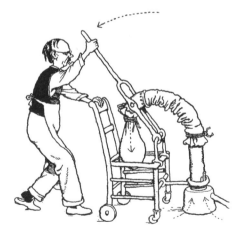

This home-made vacuum cleaner bears more than a passing resemblance to James Murray Spangler's original makeshift invention. As Heath Robinson says, "anyone can make a vacuum cleaner".

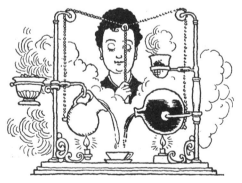

Heath Robinson's "super-de-luxe coffee-maker" makes "a much-appreciated gift" for the busy housewife.

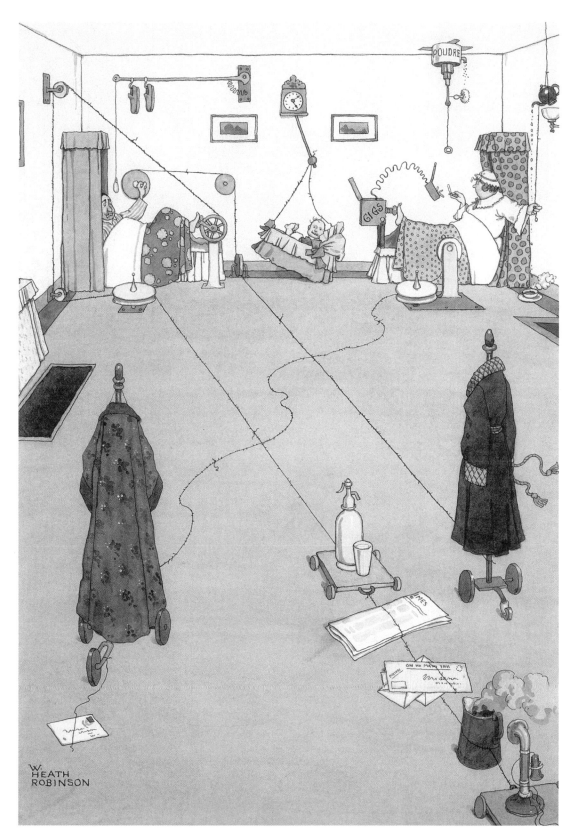

W. Heath Robinson, *My Line of Life*, 1938

" My designs
for machinery were
certainly considered
efficient. **"**

*In the bedroom, a system of levers and pulleys allows Mother
and Father to fetch the morning mail, the newspaper and the
telephone, pour tea, select a dressing gown and slippers, and
even take a cigarette from a spring-loaded box, while
the pendulum clock rocks the baby.*

A Day in the Life of the Gadget House

By the 1930s Heath Robinson had become so well known for his ingenious labour-saving gadgets that he was invited to design an automated house, named The Gadgets, for the Daily Mail Ideal Home Exhibition. This was not to be a drawing but a fully functioning model home, with the front removed to show the activities within. It was inhabited by a family of three-quarter-size dummies called Glowmutton, after Aunt Galladia Glowmutton in Heath Robinson's children's story *Bill the Minder*.

At the start of the day Mr. and Mrs. Glowmutton were woken by an alarm clock, which made them a cup of tea, whereupon a bucket shower released a jet of hot water. The breakfast gong then operated two pulleys, which carried Mr. and Mrs. Glowmutton straight through the bedroom floor and down to their breakfast. When the chairs landed, they turned on the radiogram, squirted milk for the cat and lifted the lids off the breakfast. Meanwhile the cook beat the eggs using bicycle power and a revolving wheel of sponges washed the baby.

All these ideas had been trailed by Heath Robinson over previous years in a series of drawings that celebrated the new inventions then coming on to the market. Perhaps the most blissful for the rising middle class, after centuries when only kings could afford copious hot water, was the instantaneous domestic gas-fired water heater. The first was invented in 1868 in London, England, by a painter called Benjamin Waddy Maughan. He called it a geyser after the gushing hot springs in Iceland. Gas burned at the bottom and heated a web of pipes, through which water flowed down from the top, and into the bath. On chilly mornings, Heath Robinson imagined how delightful it would be to set the bath running using cords and pulleys to turn on the geyser while still tucked up in bed.

Heath Robinson's flat-dwellers can fill the bath, switch on the electric fire, pour the tea and cook breakfast without leaving the comfort of their twin beds. The husband is identifiable by his striped pyjama bottoms, the wife by the frilly cuff of her nightie sleeve.

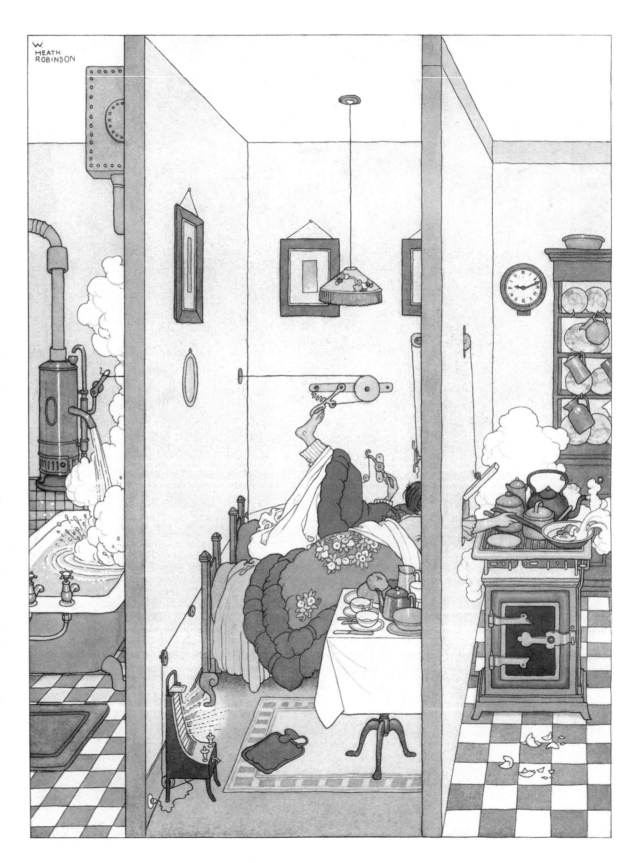

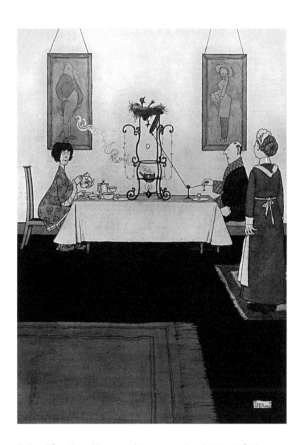

At breakfast, this table-top gadget ensures the ultimate in freshness by delivering the egg directly from the hen to the pan of boiling water.

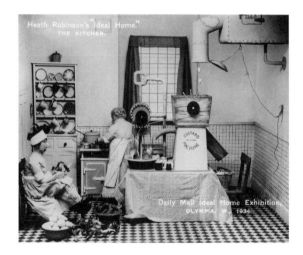

For the Daily Mail Ideal Home Exhibition of 1934, the firm of Venreco built a gadget house to Heath Robinson's specifications. Its residents, the dummy Glowmutton family, were provided with every comfort and convenience in his typically ingenious fashion (above). They drew big audiences (right).

The electric fire in the bedroom was also new technology. First invented in 1912, it did not become popular until the 1950s, probably because it used a great deal of electricity, and many domestic supplies were not powerful enough to run space heating. But in Heath Robinson's mind, it too lent itself to being switched on remotely.

The first kitchen range or stove was invented by an extraordinary man called Benjamin Thompson. Born in 1753 in Woburn, Massachusetts, he was poor and without prospects, but after wooing, winning and wedding the richest woman in the state, he persuaded the powers that be to make him a major in the New Hampshire Militia. During the American Revolution he spied for the British, but was caught out and ran away to England, abandoning his wife and baby daughter.

On the strength of a long and deeply boring scientific paper about gunpowder he was elected to the Royal Society, and then went off to assist the Prince-Elector of Bavaria, where he reorganized the army and invented a new soup, a new coffee

pot and the kitchen range. In 1791 he was made a Count of the Holy Roman Empire in honour of these achievements; he called himself Count Rumford, after the place in America where he had been married.

Leaving a couple of mistresses, he returned to England, was knighted by King George III and founded the Royal Institution in 1799 with Joseph Banks. True to his itinerant instincts, he was soon off again, this time to France to marry the widow of the scientist Antoine Lavoisier, whose head had been chopped off by the revolutionaries. According to legend, Rumford and his new wife lived unhappily ever after.

The cast-iron range shown in Heath Robinson's drawings was typical of those in English and American kitchens in the early 1900s. They were heated either with solid fuel – wood or coal – or by gas. All these things were brought together and displayed in action at the Daily Mail Ideal Home Exhibition of 1934. According to the publicity, "The Gadgets is the joke of the year and the laughter it raises will soon be echoing all over London."

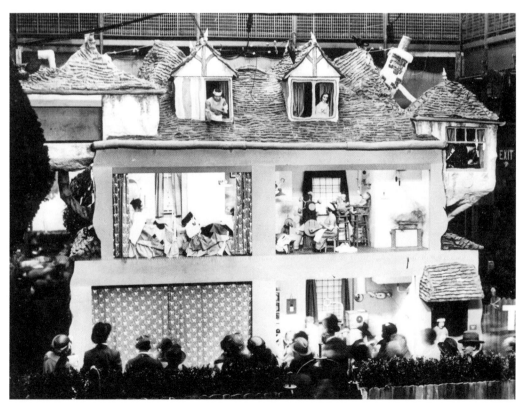

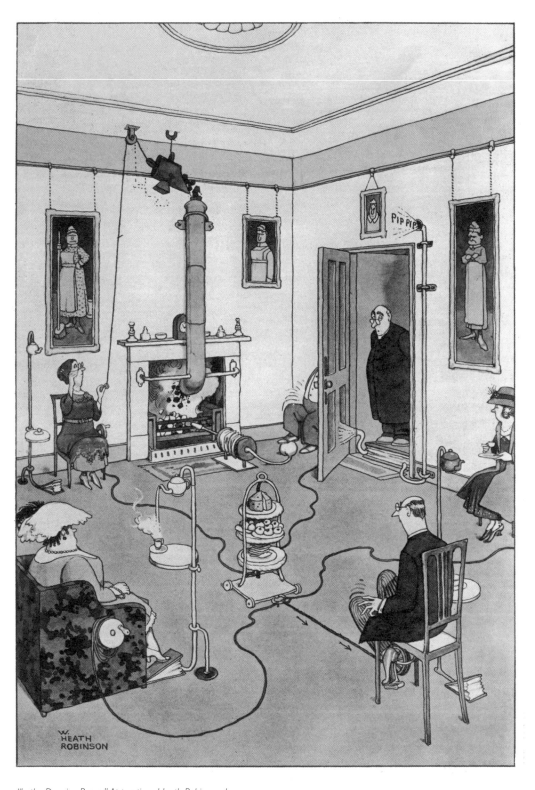

" There are few hours in life more agreeable than the hour dedicated to the ceremony known as afternoon tea. "

Henry James,
The Portrait of a Lady, 1881

"In the Drawing Room." At tea time, Heath Robinson does away
with the need for servants by fulfilling every domestic necessity
at the operation of a foot pedal or a tug at a cord.

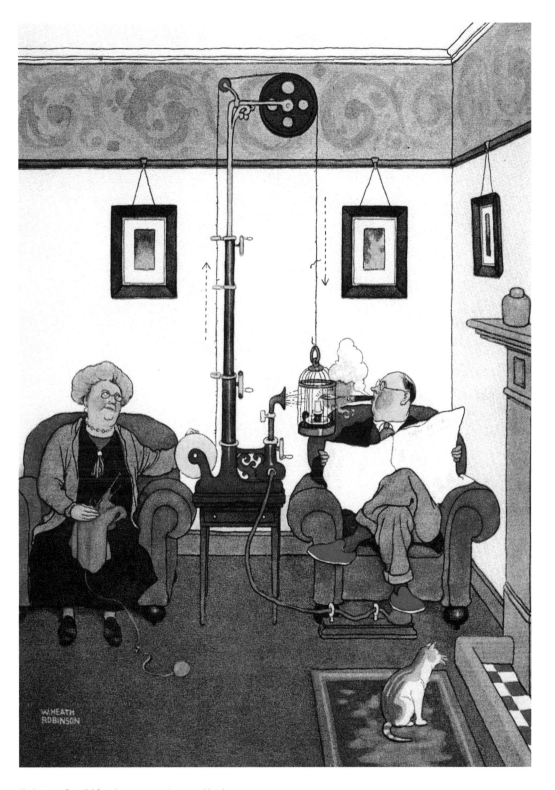

"Lighting a Cigar." After dinner, repose is assured by the
appropriate gadgets. Driven by a foot-pump, this clever apparatus
saves the smoker the inconvenience of laying aside his newspaper
to light a match.

AND SO TO BED

At the close of day, mechanical assistance was on hand to carry the Glowmutton family effortlessly upstairs to the comforts of the bath and bedroom.

Heath Robinson loved baths, and many of his drawings feature bathrooms filled with billowing clouds of steam. Abundant hot water was still a novelty for many people. I remember all too well having to bathe in only three inches of water, because there wasn't enough hot. I had to slop handfuls of water over various bits of my body. Washing my hair meant bending my knees double and lying back so that my head could go flat on the bottom of the bath, sitting up again to apply shampoo, and then lying right down again to rinse it off in the shallow, scummy water. I wish I had been able to use Heath Robinson's inflatable water-deepener.

Many people in the 1930s still resorted to a public bath. Steam baths, Islamic *hammams* and Russian *banyas* immersed the body in steam, while the Victorian Turkish bath used hot dry air. You would start by relaxing in a warm room, move on to a hot room where you would sweat profusely and then wash in cold water. Then came a massage and relaxation in a cool room.

Heath Robinson's home-made Turkish bath is a precarious contraption; the entire family must have spent hours getting the bather into position, where he is not only surrounded by quilts, pillows and blankets, but also provided with a pipe to smoke, a book to read, a gramophone to listen to and a telephone. Meanwhile the bath is heated with a paraffin stove and candles, and four kettles are boiling away, filling the enclosure with steam, rather than the dry air provided by the commercial Turkish baths.

By the time Robinson gets his people to bed they are clearly in need of a good night's sleep. They are usually piled high with blankets and quilts, sometimes in double beds, sometimes in twins, and always sound asleep, even if that requires some elaborate extramural precautions to ensure fresh air and quiet. By morning, they require a trumpet blast to wake them up.

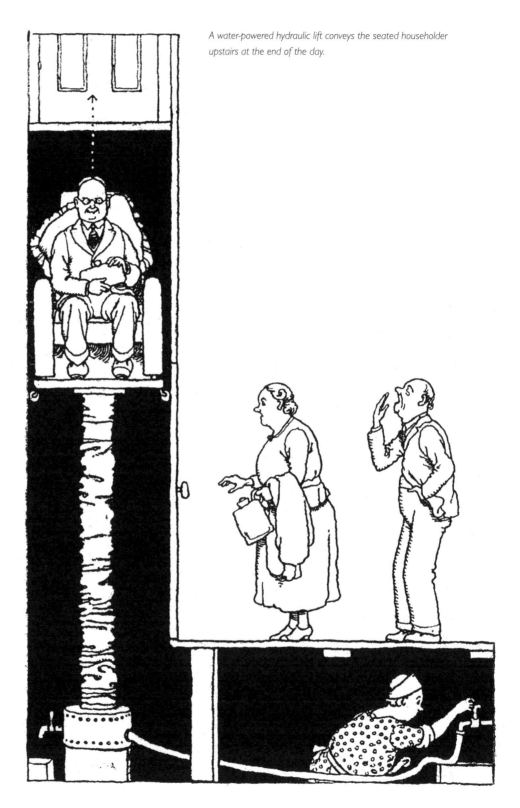

A water-powered hydraulic lift conveys the seated householder upstairs at the end of the day.

❝ Friday night was bath night, and in a tub before the bright kitchen fire we were bathed one by one. **❞**

W. Heath Robinson,
My Line of Life, 1938

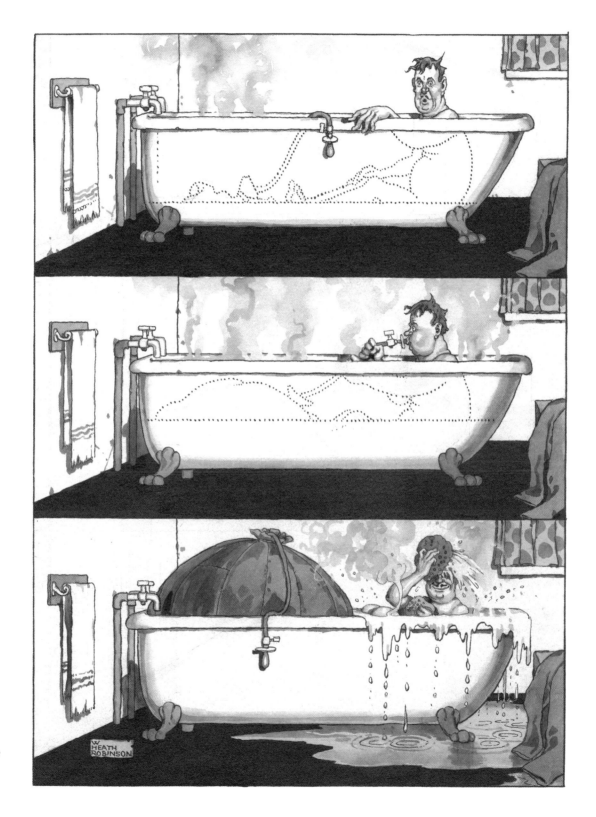

Hot water was in short supply between the wars, and there was seldom enough to fill a bath. Heath Robinson's inflatable water deepener provides the solution to this tedious problem.

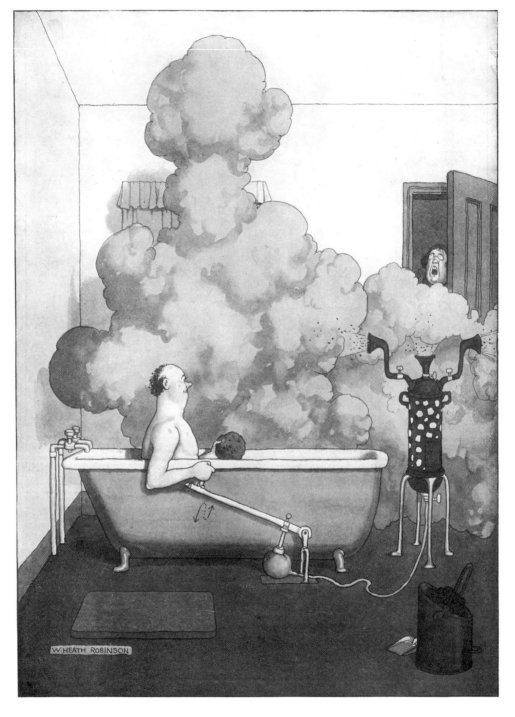

Filling the bathroom with smoke to avoid embarrassment
would be ingenious, but it might perhaps have been easier to
mend the lock on the door.

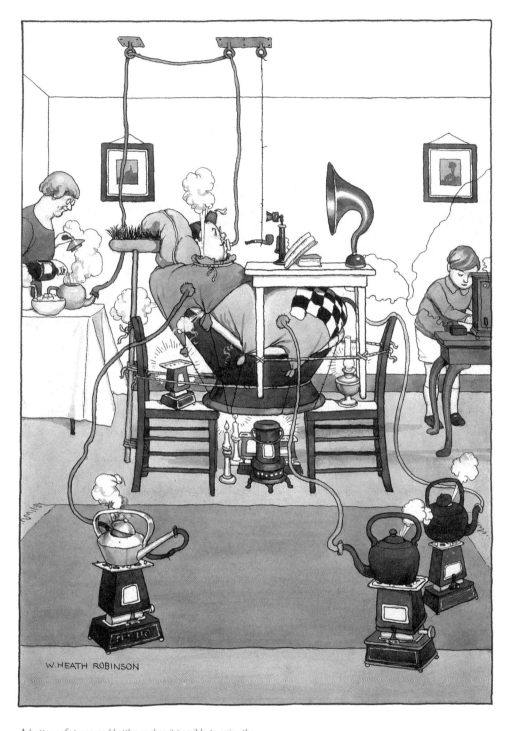

A battery of stoves and kettles makes it possible to enjoy the
invigorating effects of a steam bath at the same time as every
domestic comfort.

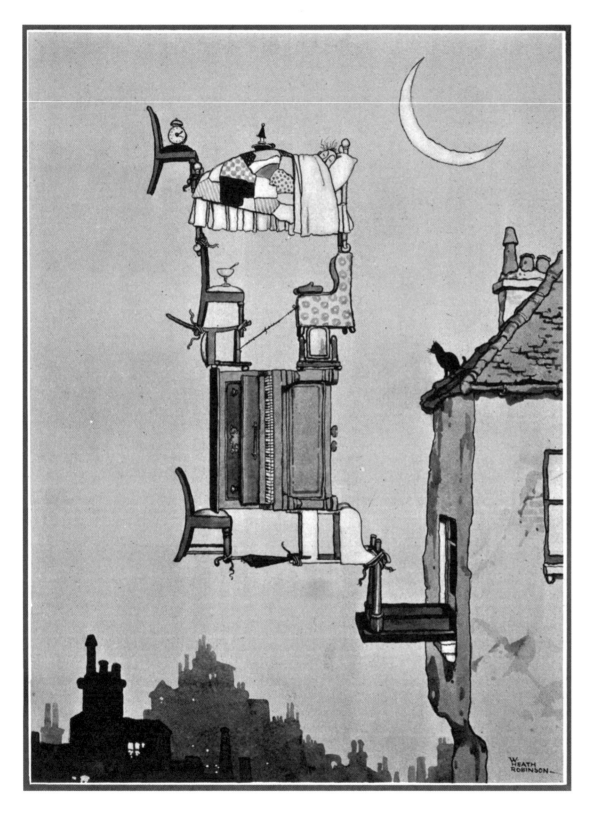

"A good suggestion for stuffy summer nights."
The household furniture finds a new use
elevating the sleeper out of the fuggy interior
into the refreshing nocturnal breeze.

"How to obtain a good night's sleep in spite
of interruptions." The baby, meanwhile, will
benefit from a dose of fresh air.

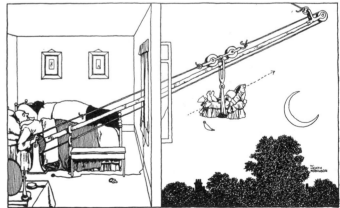

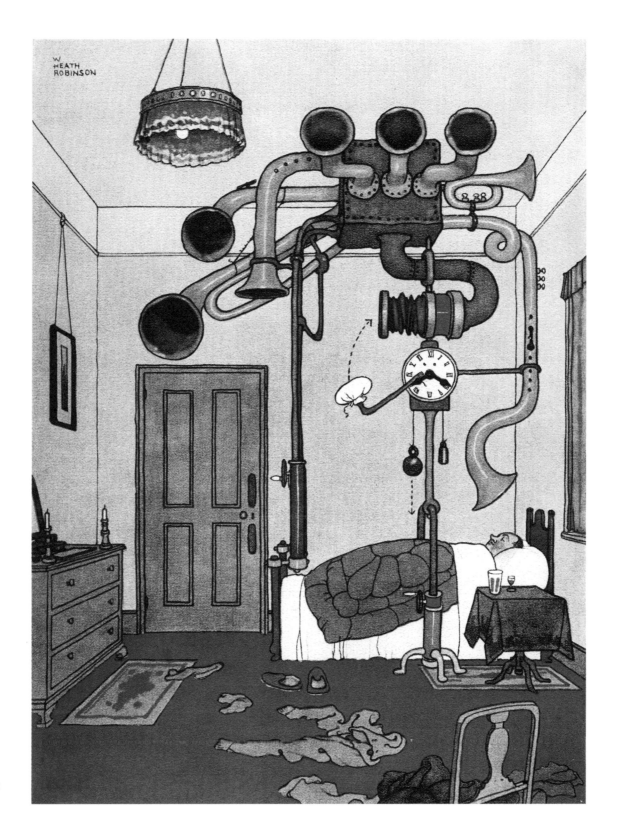

Heath Robinson's musical alarm clock is designed to wake even the heaviest sleeper with a rousing blast from the brass section.

CLOSE QUARTERS

How To Live in a Flat, *Heath Robinson's first book with K. R. G. Browne, appeared in 1936 and offered an array of ingenious solutions to the restrictions imposed by lack of space.*

Population pressure in European cities, coupled with shortage of space, had long been encouraging builders to go upwards, constructing taller and taller buildings, and filling them with flats or apartments. Flats had been around since ancient times – they were well-known in Rome and Old Cairo – but the idea of piling them higher depended not only on improved building techniques but also on the lift, for people do not enjoy climbing many flights of stairs. On the day my sister-in-law and her husband moved into a tower block, there was a power cut, and the removal men had to carry all her furniture up 22 flights of stairs.

In spite of this, four- and five-storey apartment houses were built in Paris in the 18th century, and then in other European cities. Tall blocks of flats known as tenements, up to 15 storeys high and built from the local sandstone, were a feature of Edinburgh from the early 18th century, when 35,000 people crammed into the narrow "wynds" either side of the Royal Mile. The lower floors were occupied by relatively posh people, who therefore had fewer stairs to climb. Similar tenements were built in the Gorbals, the poor quarter of Glasgow, and in New York City's Lower East Side, where the apartments were called "railroad flats" because the poky little rooms were built end to end like boxcars. Many of these flats were poorly equipped, with just a few small rooms, shared bathrooms and kitchens and little privacy.

Builders in England lagged behind. The first "garden flats" in London were built in the 1860s, and imposing blocks of spacious "mansion flats" followed in the 1870s, but the idea was slow to catch on, because most middle-class families wanted their own house with a garden. Some lower-class citizens, however, occupied a flat above a shop – which was precisely where my first child was born in 1967.

The development that made it possible to build ever higher was the widespread adoption of the lift or elevator. Devices for raising and lowering people and goods had existed for thousands of years. My Ancient Greek friend Archimedes is reported to have made his first lift in 236 B. C. In 1823 a pair of architects in London built an "ascending room", from which the paying public could enjoy fine views of the city. The crucial step came in 1862, when Elisha Otis introduced the safety elevator, and demonstrated it in a death-defying stunt at the Crystal Palace. His basic idea was that even if the supporting rope broke, the elevator would not crash to the ground.

After his marriage in 1903, Heath Robinson and his wife moved into a furnished flat. "It was at the top of a tall building at the side of a music hall in the north of London. There were no lifts, and our home could only be reached by climbing long flights of stone steps. Our evenings were enlivened by occasional bursts of applause which we could hear through the wall separating us from the theatre. When we were entertaining and conversing with friends, the applause would sometimes occur at inopportune moments, and make an unexpected commentary on the conversation. It was disconcerting, for instance, when, in the polite pause following a guest's declining a second helping, a burst of clapping intervened."

For most of his earlier life Heath Robinson had lived in houses of a reasonable size, so moving into this flat must have been a bit of a shock. Inside, there was scarcely space to swing a cat, while outside there was no garden, and therefore no space to do anything

Heath Robinson stylishly lampoons the Bauhaus-inspired architecture of firms such as Tecton and Isokon that was springing up in London in the 1930s.

remotely sporty. Well, thought Heath Robinson the dreamer, where there's a will there's a window ledge. Even on the shortest and most lofty perch the golfers could perfect their swings, the cricketers their googlies and off-drives, the angler his patience and the tennis-player her backhand.

He never forgot his experience of flat living, and in 1939 with K. R. G. Browne produced a book called *How To Live in a Flat*, which is still a delightful read today. In the first chapter, entitled The Evolution of the Flat, they say, "Reduced to its lowest terms (which, however, are seldom less than £80 per annum), a flat is simply a portion of a house that has been converted but not entirely convinced. Since the primary purpose of flats is to enable at least five families to live where only one hung out before, thereby quintupling the landlord's income, they are apt to lack that spaciousness which characterizes the Grand Central Terminal, New York. From the keen cat-swinger's point of view this is regrettable."

A serious problem for flat-dwellers is noise. One person playing the drums or listening to pop music at 2 a.m. can ruin life for everyone in the building, and the problem is much worse if the flats are cheaply built and lack proper sound insulation. I once stayed in a cheap hotel in San Giovanni Rotondo in south-eastern Italy. My room was on the ground floor, underneath the main ballroom. That night there was a wedding, and the noise of a thousand stiletto heels stomping the night away on the marble floor immediately above my head will stay with me forever.

Given his first-hand experience of this problem, Heath Robinson came up with all kinds of elaborate solutions involving mattresses, upholstered dadoes and spongy galoshes.

"Sports without broad acres." With open country and leafy villas slipping beyond reach, flat dwellers are forced to find new ways of practising their favourite outdoor pursuits.

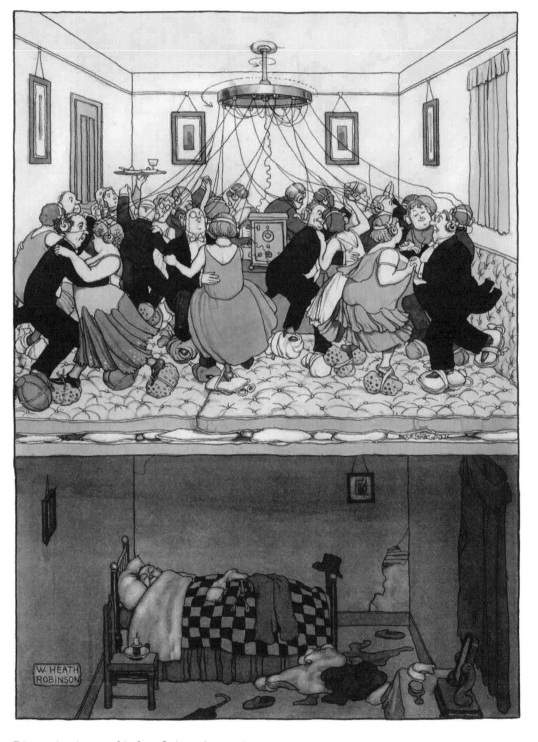

"How to take advantage of the Savoy Orpheans dance music broadcast by the B. B. C. without disturbing the neighbour in the flat below." Heath Robinson inadvertently invents the silent disco, though it is hard to imagine what will happen to the wires trailing from the electrolier as the couples pirouette around the room.

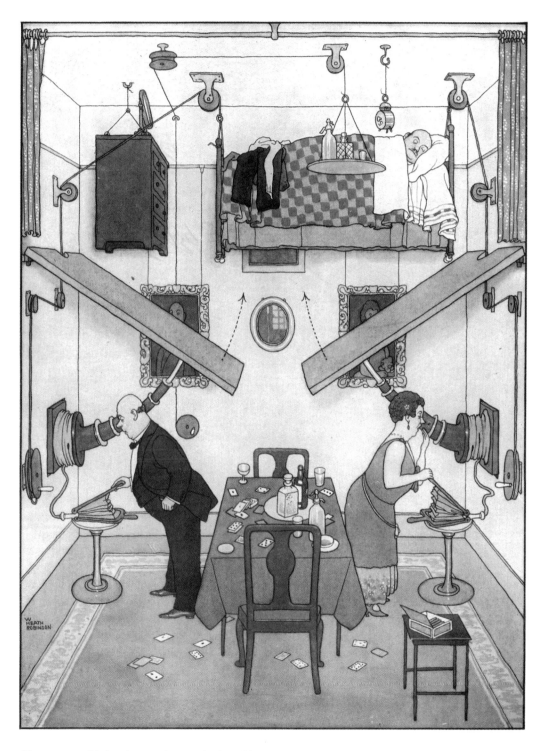

"The spare room." An ingenious contrivance makes it possible
to accommodate a guest in even the smallest flat.

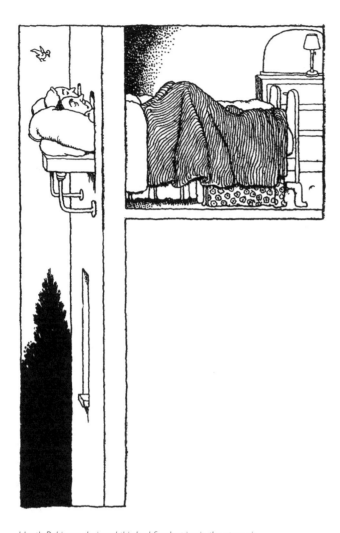

*Heath Robinson designed this bed for sleeping in the open air
in the belief that being awakened by birdsong would release
"new artistic urges in the system which colour the whole day".*

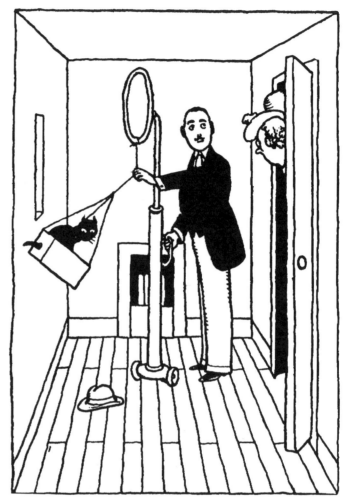

*"Proving that there is room to swing a cat. This gadget
is so designed that the arc of the cat-swing can be regulated
to fit any room... at no risk of dashing the animal's brains
out against the wall."*

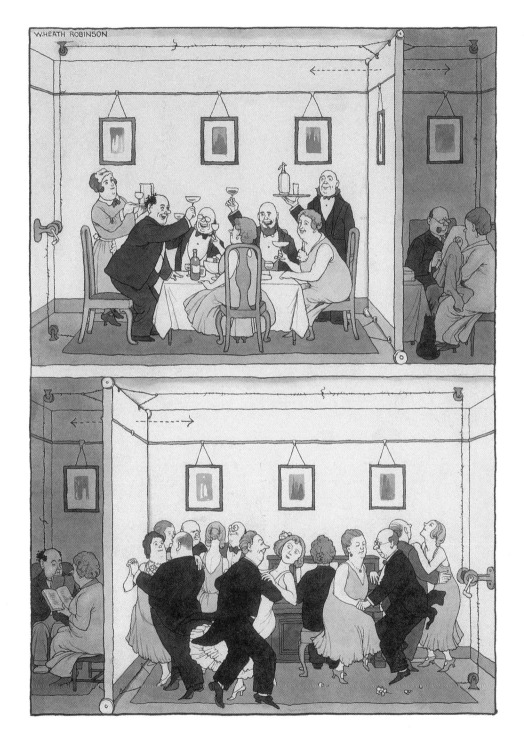

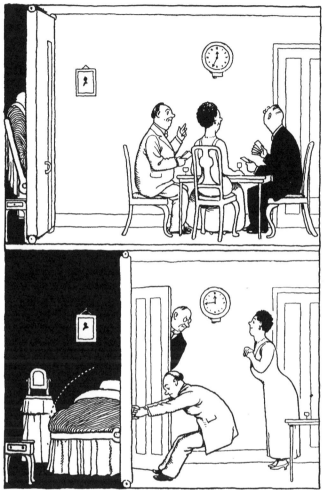

*In the flat of the future, a sliding wall could create a spare
bedroom from part of the dining room (above),
or (left) turn a snug into a dance hall.*

SHARING SCARCE FACILITIES

Heath Robinson was forever looking for ways to maximize the limited space available to flat dwellers. One possibility was to share facilities. A normal house might well have a stove or fireplace in every room, which meant much carrying of coal and a good deal of clearing out the ashes, not to mention dirt and dust everywhere. Perhaps an entire flat could be warmed by a single stove, shared between all the rooms – the ultimate form of central heating.

The bathroom was another place where space was wasted. The room had to be large enough to accommodate the tub, but even if all the family had a bath every day, it would be unused for much of the time. How about a communal bath, then, shared between four flats? There could be a daily timetable that allowed perhaps half an hour for each flat before the bath moved on.

This arrangement would call for clever plumbing and water heating. There would also be some difficulty maintaining propriety, since clearly no one would want the neighbours to see them in a state of undress – nor vice versa – but think of the saving of space. Everyone would gain. Another possibility, rather simpler from the technical point of view, would be to have a bath big enough to accommodate three people at a time. Then all the men in the communal property could bathe together, and all the women later. Both space and water would be saved.

One feature familiar to all those who have bought a house, or even contemplated doing so, is the dodgy jargon of all estate agents. "Ripe for modernization" means that the property is falling down and probably has neither plumbing nor electricity. "Peaceful location" means more than ten yards from a major road junction or building site. "Rustic simplicity" means an outdoor toilet. "Sea view" means from the roof, using a telescope. Heath Robinson shows us a superb example of what a modern estate agent might call a "spacious family home" and he calls "Heath Robinson Mansions W. – TO LET: Attractive flat containing: — Music-Bath-Room, H. & C., Bedroom, Billiard Room, Dining Room, Kitchen, Scullery, Offices."

"Sectional view explaining the use of the communal bath." The revolving bath is a scaled-down version of the Victorian public baths, serving four flats instead of a whole neighbourhood.

Sensitive souls whose inhibitions cause them to recoil from the lack of privacy in the communal home can take comfort from these "modesty toilet boxes" in the shared dressing room.

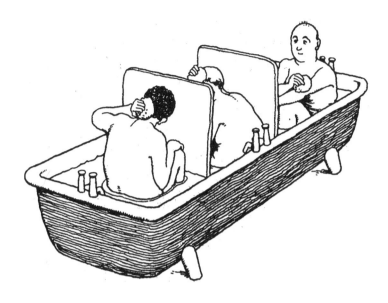

"The threesome or communal bath" enables bathers
to preserve their modesty while sharing scarce hot water.

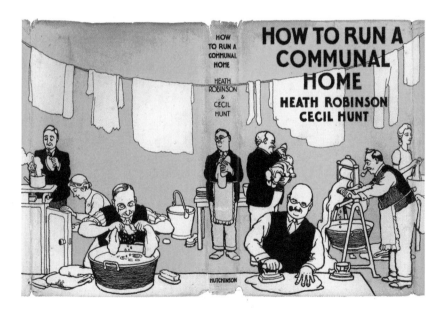

In How to Run a Communal Home, which appeared in 1943,
the year after the Beveridge Report laid the foundations of the
Welfare State, Heath Robinson and a new collaborator, Cecil
Hunt, gently satirize communitarian ideals.

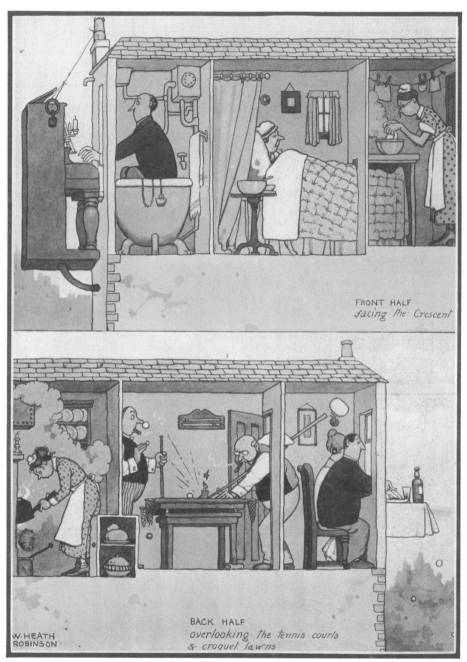

The Heath Robinson Mansions contain compact apartments
with every space-saving expedient, including a piano off the
bathroom and a dining room with open-air eating.

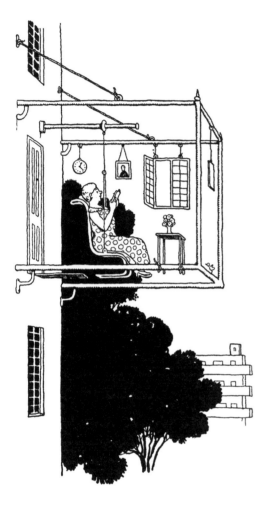

With space at a premium, it is only common sense to make use of the aerial void beyond your walls. This "fresh air parlour" not only extends the flat outwards but also affords the user the invigorating effects of oxygen and sunlight.

EXTENDING OUT

Another solution to the lack of space in many flats was the balcony or, in the absence of a real balcony, a virtual one. All you needed, according to Heath Robinson, was a few cantilevers and some pieces of rope, and you could enjoy the great outdoors as well as in the grounds of a stately home. If you were lucky enough to have a real balcony you could treat it as an extension of the house, and arrange all sorts of activities in the open air. Children could roll their hoops, sail their yachts, fly their kites, play tennis and enjoy the swing, while housewives, having finished mowing the lawn, could take the baby out in a pram.

Lacking a dining room, how could you arrange a jolly dinner party; indeed how could you meet the neighbours if they were always behind closed doors? The simple solution was the community supper party, which could no doubt be arranged for every Saturday evening. All would be convivial and friendly, wine would pass from window to window, and witty conversation would flow backwards and forwards. Perhaps one couple would volunteer to cook the roast for all, while someone else made canapés and a third organized dessert.

Difficulties might arise if it was raining, if one of the men insisted on repeating not-very-funny jokes or if you fell out with the couple next door, but compromises could probably be found. There would be all sorts of compensating advantages. Everyone would do their own washing up, so no one couple would be left with a sea of crockery after a large party. Those on the ends of the row could depart early without disturbing the others, and any crumbs could be left for the birds to clear up.

But why stop there? Stretching the ingenuity and the cantilevers a little further, Heath Robinson imagined landscaping, greenhouses, birdcages and safe playgrounds for pets – indeed entire gardens perched in the sky. In these proposals the long arm of Health and Safety does not seem to have impeded him in any way.

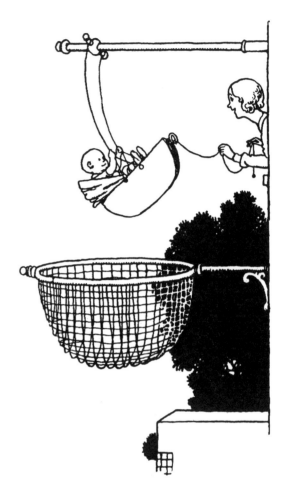

Heath Robinson's "new safety swing, for flats without nurseries" was not actually so far-fetched; a wire "baby cage" was patented in the U.S.A. in 1922, allowing infants to frolic in the fresh air outside an apartment window.

*The principle of aerial extension can also be employed
to overcome the lack of a garden, as in this "artistic way
of hiding an unsightly view".*

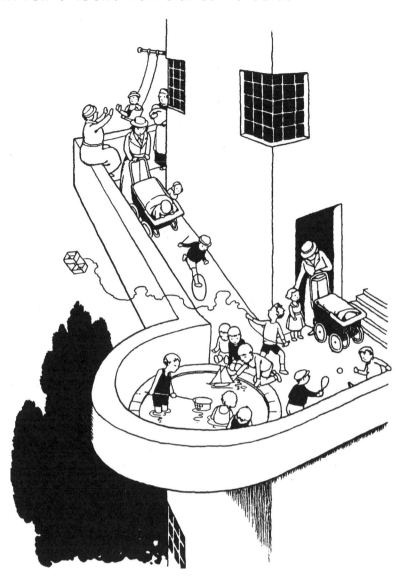

Pets' playground: "I include babies in this category," notes
Browne, "because they are – very properly – treated as pets
in the majority of households."

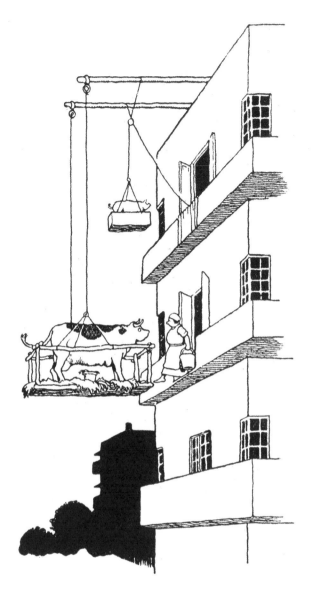

"Some flat dwellers manage to keep a cow."

"A community supper party." If you have no garden or fence
over which to chat, you can still meet the neighbours. Just
slide up the bottom sash, lay the window sill, fill one another's
glasses and you're away.

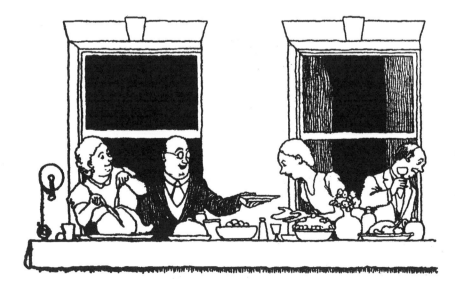

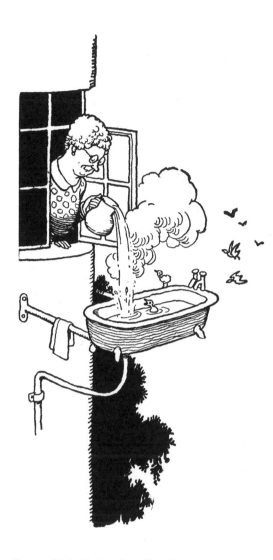

"A pretty little bird bath at Linnet Court."

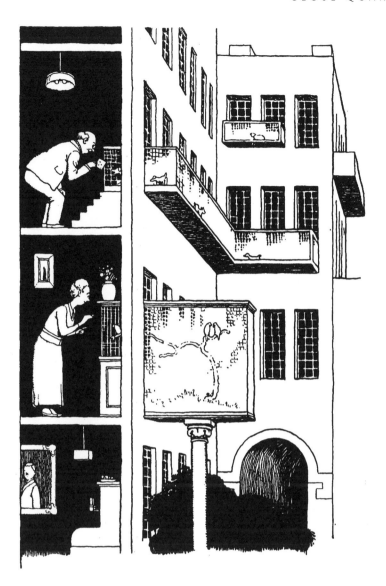

"Pets' corners: pets and babies can be suspended in cages
(en plein air, *as the French say) from stanchions attached
to the exterior wall of the building.*"

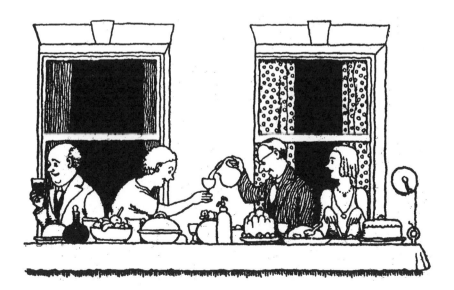

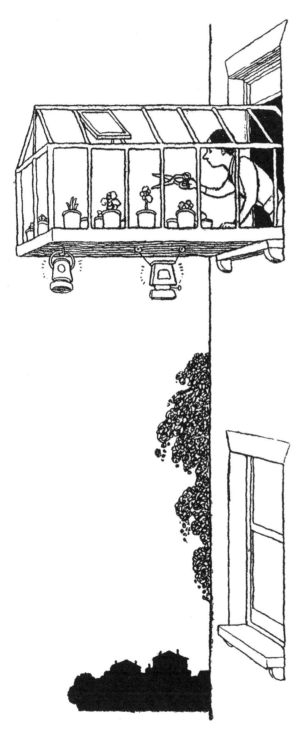

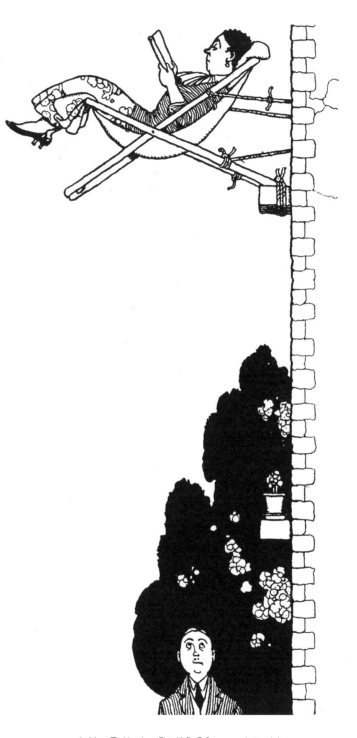

Green-fingered flat-dwellers can avail themselves of this "window-box greenhouse for those without a garden" to provide fruit and vegetables throughout the winter months.

In How To Live in a Flat, K. R. G. Browne admitted that neither he nor Robinson had personally tested this deckchair for unbalconied flats because "we both weigh a good deal".

> **"** The Deckcheyrie
> For Unbalconied Flats...
> will be found
> to work perfectly,
> we shouldn't wonder.
> If not we're sorry. **"**

W. Heath Robinson and K. R. G. Browne,
How to Live in a Flat, 1936

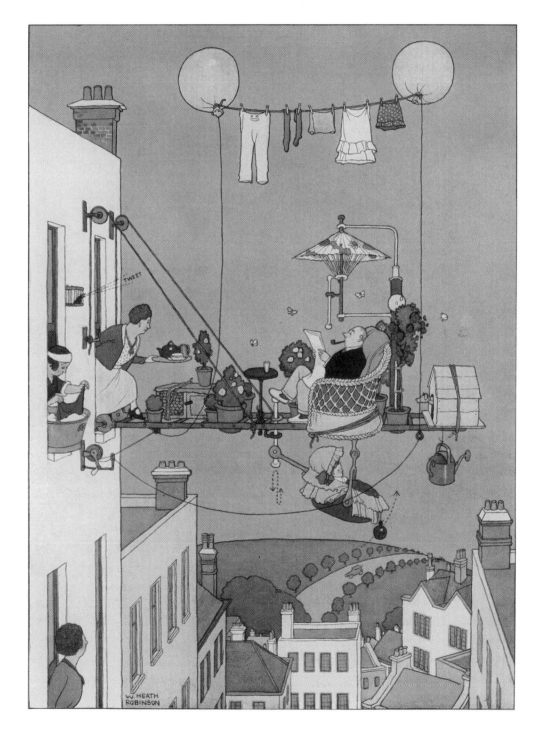

*"The folding garden for flat-dwellers with a love of open-air
life will appeal to all householders who like to enjoy rustic
amenities in an urban setting."*

MAKING THE MOST OF THE GARDEN

One of the joys of moving into the suburbs was that you might acquire a small garden, and many home owners wanted to make the most of their patch. But Father was generally out at work, and Mother had the housework and children to cope with, so some mechanical assistance was clearly necessary – and who better to provide it than Heath Robinson? With its sheds, greenhouses, tools and contraptions, gardening was also rich in comic potential, which Robinson cultivated in a series of drawings that accompanied K. R. G. Browne's article A Highly Complicated Science in *The Strand Magazine* in 1938. This blossomed into another fruitful book-length collaboration, *How To Make a Garden Grow.*

For practical reasons, most gardens had to be equipped with a clothes line, so that the family washing could dry in the sun and wind. Then there had to be a space for children to play, which generally meant a lawn. After that came the question of design. Did you want to make it look as though Capability Brown had come to suburbia, and build terraces, hills and vistas? Not easy in a confined space.

Some people planted flowers or shrubs. Others tried valiantly to grow their own vegetables. There is no doubt that eating your home-grown produce is immensely satisfying, but it often needs prodigious labour, especially if the builders have left the "garden", as Browne put it, just an "untilled patch of virgin soil, rich in sardine tins and old boots".

Even those who did manage to grow useful quantities of vegetables or fruit discovered that they were continually plagued by bad weather, birds, insects and slugs, and had to undertake the chores of weeding, watering, fertilizing and pruning. Heath Robinson had a number of ingenious solutions to these problems, such as asphyxiating wireworms with pipe smoke

and using a trained tortoise to hunt snails in the dead of night. Some householders saw their gardens simply as a leisure area, and went to some lengths to turn the space into a tennis court, croquet lawn or cricket pitch. Robinson took matters a stage further, suggesting that they create a "waterway" for punting.

Lawns presented their own set of challenges. Grass will grow naturally, even on thin topsoil over builders' rubble, and if it is continually cut short it becomes a lawn, but it does need constant attention. Before 1830 the best way to cut grass was with a scythe; rich landowners would employ a dozen men to cut their lawns, which was best done early in the morning with the dew still on the grass.

In 1830 came a revelation and a revolution. Edwin Beard Budding was an engineer working at the Brimscombe Mill in Thrupp, near Stroud, Gloucestershire. His job was to make, maintain and repair machines for trimming the nap off cloth such as carpets, rugs, corduroy and velvet. Budding had the bright idea that if you could make a machine to trim the nap off cloth, you could also design one to trim grass. In 1830 he patented "a new combination and application of machinery for the purpose of cropping or shearing the vegetable surface of lawns". The main roller at the back provided drive through gears to the cutting cylinder in front, a roller in the middle could be adjusted to raise or lower the height of the blades, and the grass cuttings were thrown forward into a tray. The patent says that "country gentlemen may find in using my machine themselves an amusing, useful and healthy exercise".

More than a thousand machines were sold in the 1830s, enabling the creation of not only suburban lawns but also cricket and football pitches, golfing greens and lawn tennis courts, none of which were really possible without the mowing machine. Budding

Following the success of How to Live in a Flat, *Robinson and Browne's* How To Make a Garden Grow *contained a cornucopia of advice for those who preferred to live in houses, "each with its allotted ration of this blessed plot, this earth, this realm, this England".*

Opposite: Robinson's advertisement for Ransomes, Sims & Jefferies' petrol-driven lawn mowers suggests a range of accessories that would allow the users to mow in comfort, or complete a range of other tasks – from keeping the children amused to perfecting their dance steps – without neglecting the lawn.

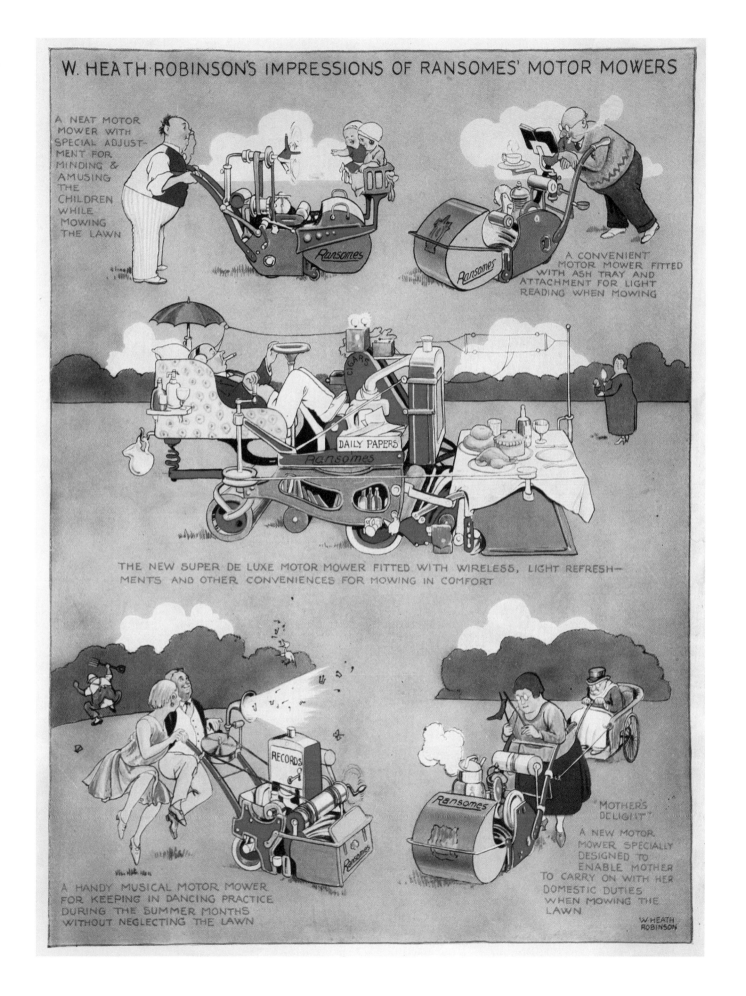

W. HEATH·ROBINSON'S IMPRESSIONS OF RANSOMES' MOTOR MOWERS

died in 1846 when he was only 50 years old, but he would by then have seen how successful his invention had become.

In 1928, Ransomes, Sims & Jefferies of Ipswich commissioned Heath Robinson to draw possible machines for the future. The result was a host of adaptations to suit every type of user. Unfortunately, although today we have ride-on mowers, robot mowers and huge machines for sports grounds, and Ransomes still make a variety of mowers, we don't seem to have any with Robinson's ingenious accessories.

Just occasionally he launches a Swiss Army knife of a machine, including a mowing machine for the housewife, which also pulls the pram, fans the toddlers, makes hot water for washing the clothes, drives the mangle to squeeze them dry, holds up the washing line and makes the tea. What is slightly shocking is that the gentleman may be able to mow his lawn while reclining in luxury; in contrast the housewife not only has to push her machine, but is also expected to carry on with her household chores while doing so.

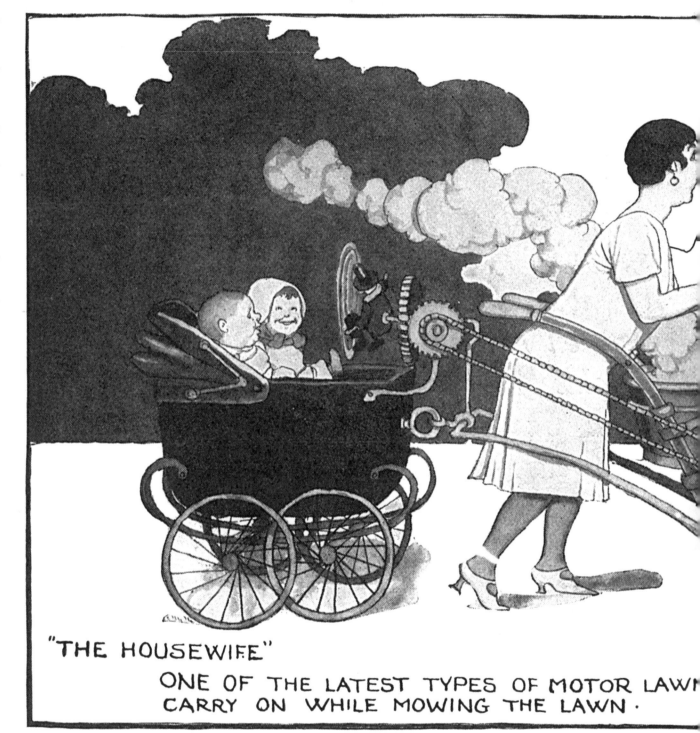

"THE HOUSEWIFE"
ONE OF THE LATEST TYPES OF MOTOR LAWN
CARRY ON WHILE MOWING THE LAWN.

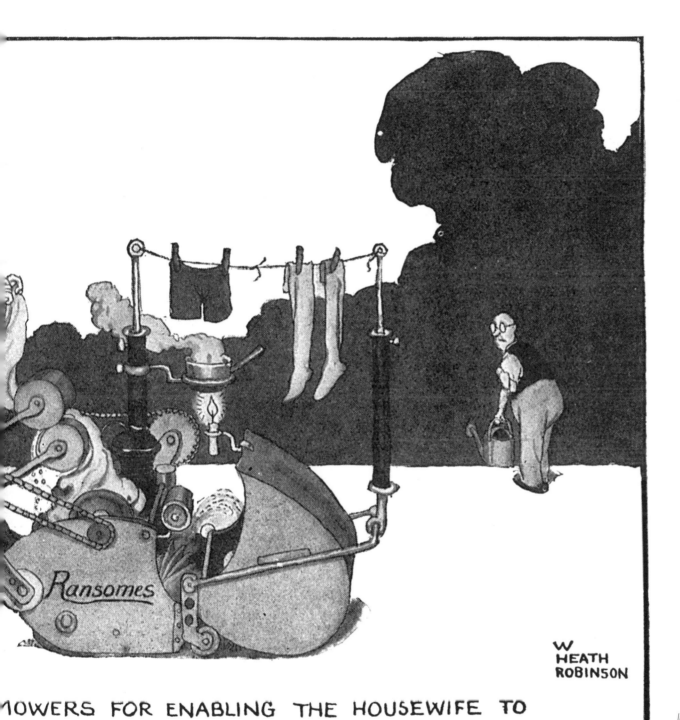

MOWERS FOR ENABLING THE HOUSEWIFE TO 5755

W HEATH ROBINSON

"There was not much time to spare for children on washing day. We were always in the way, and the back garden was unplayable because of the clothes props and the wind-blown sheets and undergarments."

W. Heath Robinson, *My Line of Life*, 1938

In another advertisement for Ransomes, Robinson shows the housewife mowing the lawn while also fulfilling the roles of nanny and maid, to the alarm of the potentially redundant gardener.

Gardeners who cannot afford a full-size greenhouse may wish to avail themselves of this pocket model, which will accommodate one adult and two tomatoes.

"The earwig trap: lured to the trap by a trail of caviar or some similar delicacy, the little creatures can easily be stunned with a mallet."

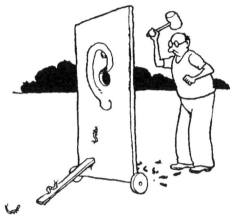

When pruning a tree, a little foresight will enable the gardener to anticipate the future utility of a well-trained specimen.

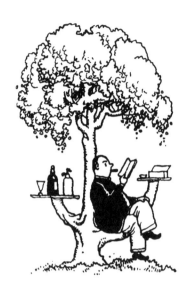

When preparing a lawn, "ex-cats and salmon-tins can be thrown over the fence under the cover of darkness; the Roman pottery will be welcomed by any local museum; and stones can be removed with the help of an agile assistant".

This convenient apparatus enables the gardener to weed his beds without trampling tender seedlings, compacting the soil or even getting his boots muddy.

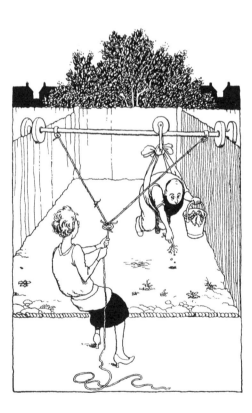

"Carrying pollen from one plant to another by means of a trained butterfly."

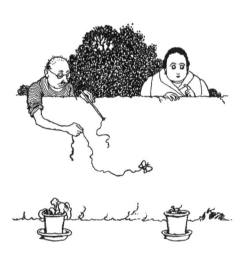

Wireworms are dastardly destroyers of the roots of delicate plants, but they may be asphyxiated using "the subterranean gas-attack method devised by Mr. Heath Robinson and depicted here".

Paths are an essential component of any garden, but they must be well drained to avoid puddles forming. This simple test will measure the speed at which rainwater runs into the subsoil.

It is sometimes desirable to restrict the growth of a plant by root pruning. This ingenious method avoids the need to unearth the specimen, and the risks attendant on such a procedure.

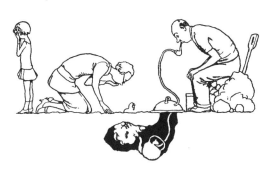

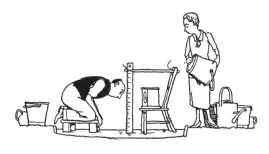

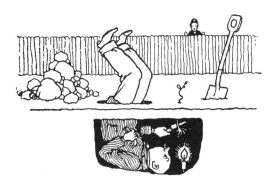

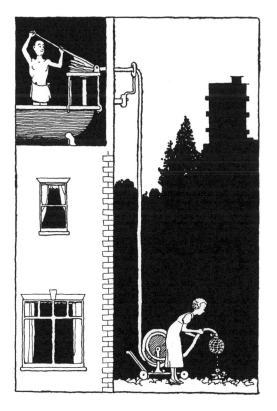

Snails are notoriously destructive pests that can wreak havoc in the lettuce bed, but help is at hand: a specially trained tortoise, unleashed at midnight, will make short work of them.

"As bath-water that has been carried about by hand in saucepans and fire-buckets lacks the energizing qualities of that which is pumped direct from bath to consumer," wrote K. R. G. Browne, "Mr. Heath Robinson has designed an apparatus (see diagram) whereby the healing fluid… can be transferred directly to the garden."

Inexperienced punters may find themselves stranded atop a quivering pole as their vessel drifts downstream, but there is no risk of a ducking in the security of your own back garden.

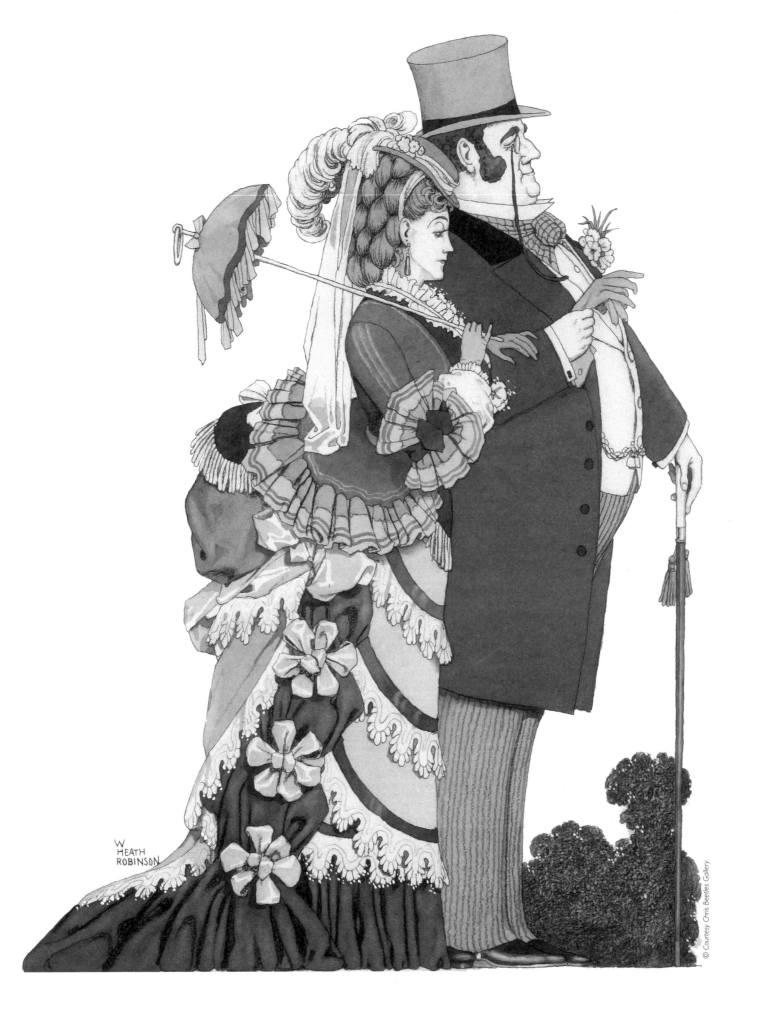

CHAPTER 2

KEEPING UP APPEARANCES

Soup is a perennial problem for the etiquette-conscious diner, but spills can be avoided with this napkin-tie.

Left: Looking back from a more informal age, Heath Robinson pokes affectionate fun at "Our Grandfathers and Their Respectable Fiancées".

For the aspiring middle classes in the early 20th century, nothing was more important than maintaining and improving their status in society; not merely keeping up with the Joneses but aiming to be slightly better. This meant polishing every nuance of behaviour not only in public but also in private. Dress and deportment had to be perfect; table manners exquisite; courtship genteel and gracious.

Heath Robinson was brought up according to the rules of the day, always respectfully observed in the public rooms of the house, the drawing room and the dining room. "For my mother, her duties as a hostess were a matter of conscience," he recalled. "The Sunday mid-day dinner was still my mother's grand achievement of the week. It was a work of art, a symphony in roast beef, baked potatoes and pudding."

Compared with many families, the Robinsons moved in a Bohemian world. William's father's work as an illustrator brought them into constant contact with journalists and writers, and they drew their friends from many walks of life. The daily routine of an art student was naturally a trifle raffish, and even after the arrival of children and family responsibilities, Heath Robinson kept alive a light-hearted view of the formal world in which he had been brought up.

The accoutrements and proprieties of the middle-class dining room provided him with a rich vein of satirical subjects, which he mined with enthusiasm. The use of cutlery was a finely tuned social accomplishment, and a pitfall for the unwary. In the distant past, rich people had spoons of metal or ivory, while the poor used spoons carved from wood. In the 11th century an Italian monk and cardinal, St. Peter Damian, wrote 67 treatises, not to mention letters, sermons, prayers and hymns, but spent his spare time carving wooden spoons. He gave four reasons for this: wooden spoons are humble; they are useful; they can be made with only

a few tools; and spoon-making is a revelatory craft. This last point became clearer to me when I started making spoons three or four years ago. The spoon is already there in the log, and merely has to be released.

The Greek god Poseidon brandished a multi-pronged spear called a trident for catching fish, but the table fork came later. Rich Greeks and Romans had forks, but their use seems to have died out. In 1075, three years after St. Damian the spoon-carver died, Princess Theodora Anna Doukaina was married in Constantinople to Doge Domenico Selvo, and subsequently arrived in Venice with not only a large Greek retinue but also finger bowls, napkins and forks. Her haughty and fastidious ways soon made her highly unpopular. It was reported that "she did not touch the food with her hands, but had each dish cut into tiny pieces by her eunuchs, which she then advanced to her mouth using a sort of miniature golden spear with two prongs".

Thus the fork was new to Italy in 1075; it was introduced to France in 1533 by Catherine de Medici and did not reach England until 1608, when one was brought back from Venice by Thomas Coryat, sometimes known as Furcifer (Latin for fork-carrier). Coryat lived in Somerset, and was a courtier to Prince Henry from 1603 until 1607, along with Ben Jonson, John Donne and Inigo Jones, all of whom seem to have regarded him as something of a buffoon. Then in 1608, perhaps to escape from the court, he walked to Venice, returning via Switzerland, Germany and the Netherlands.

He wrote about his travels in *Coryat's Crudities*, published in 1611. This provides a lively picture of contemporary life in Europe, and helped to introduce the idea of the Grand Tour, which became popular later in the century.

According to the arbiter of society etiquette *Debrett's*, established in 1769, "a knife should be held firmly in your right hand, with the handle tucked into

your palm, your thumb down one side of the handle and your index finger along the top (but never touching the top of the blade). It should never be eaten off or held like a pencil.

"When used with a knife or spoon, the fork should be held in the left hand, in much the same way as the knife, with the prongs facing downwards."

A Victorian cookery book of 1890 advised, "don't use your knife to carry food to your mouth", which was not welcome to Ogden Nash, who wrote this poem, recited on the radio on 2nd February 1944:

> I eat my peas with honey;
> I've done it all my life.
> It makes the peas taste funny,
> But it keeps them on the knife.

When Heath Robinson was growing up, children were taught to use a fork with the prongs pointing downwards in the correct manner. Eating peas in this way is difficult; perhaps that is why he invented a magnificent machine for conveying peas to the mouth – although since the final stage involves a spoon, his machine might not have found favour with his parents. Blowing on hot food to cool it down was also discouraged, so he invented a simple device to do the job for him.

Naturally every couple would like to hold large dinner parties in their spacious and elegant dining room. Victorian manners stipulated that the dinner table and the dining room should be seen at their best. The room should be immaculately clean, and delicately furnished, with a view to convenience and comfort, but with no ostentatious display of wealth. The walls should be dark, perhaps maroon or bronze. Wooden furniture – sideboard and buffet – should be of dark wood, and there might be a cage of stuffed birds, or some tropical plants in large pots.

Meanwhile the table should be beautifully and artistically laid, ideally with a centrepiece of a low dish of

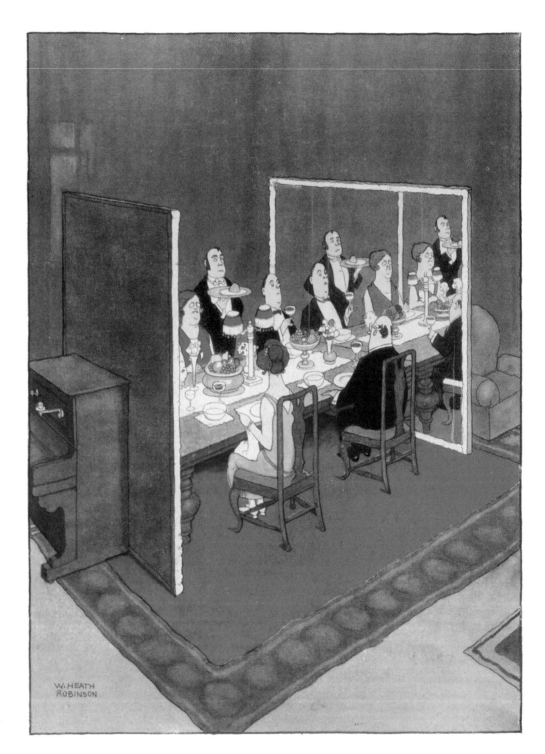

"The glass of fashion: a pleasant little fiction practised in upper circles when only a few of the invited guests turn up for dinner."

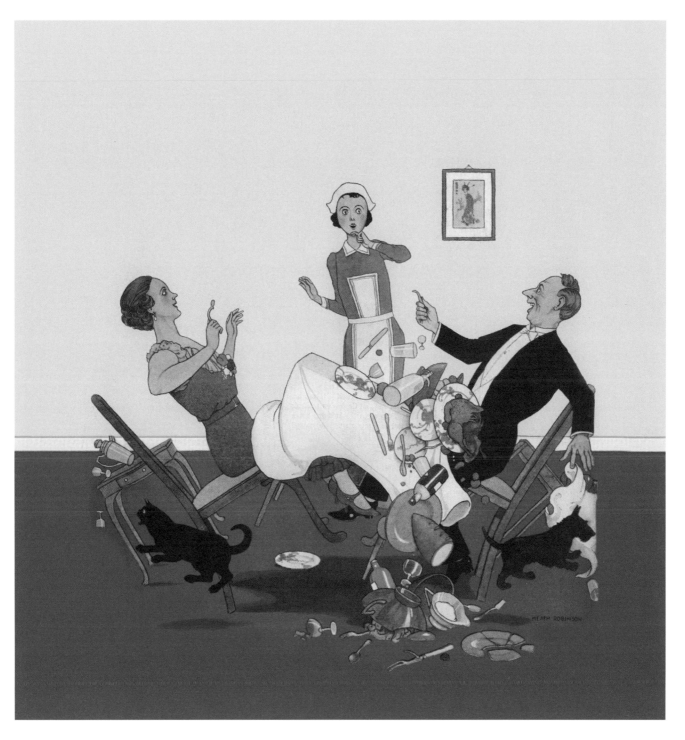

Pulling the wishbone is a charming custom, but can cause havoc at the dinner table.

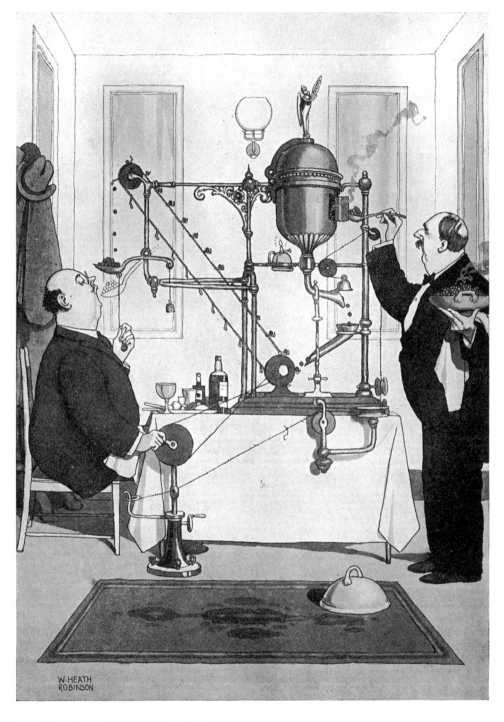

"An interesting and elegant apparatus designed to overcome once and for all the difficulties of conveying green peas to the mouth."

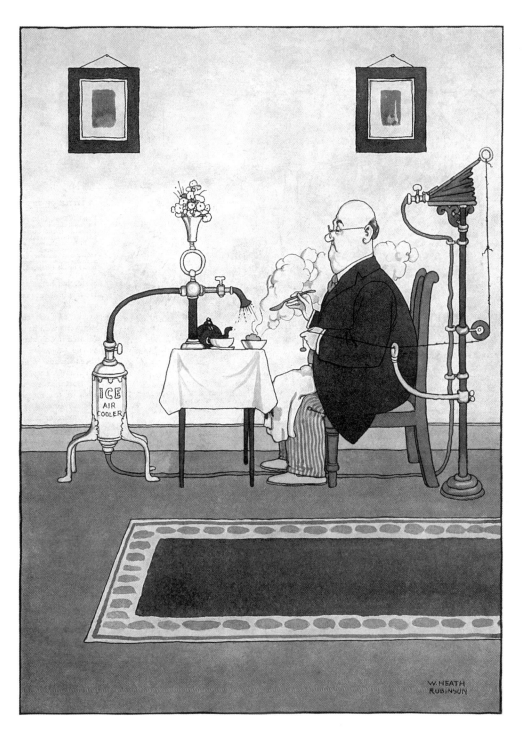

"An elegant device now in use at many seaside boarding houses to obviate the rather indelicate act of blowing on one's food to cool it." Discretion is all and a small vase of flowers incorporated in the machine helps lift the tone.

flowers, with light fragrance, and not so high as to impede the guests' view of one another. Beside this should be a pair of stands filled with fresh fruits, and small dishes of celery, olives or radishes.

Each place setting should include a plate with a minimum of two large knives and a fish knife on the right, as well as a tablespoon for soup, and an oyster fork, if oysters were to be served; on the left three large forks, and a small fork for fish. Each knife should have its own knife rest. There should also be a glass or goblet of water on the right, accompanied by up to six stemmed glasses for the various wines that might be served. On or beside each plate should be a napkin and a thin slice of bread. At the conclusion of a course, the knife and fork should be laid side by side across the middle of the plate – never crossed – with handles to the right.

Suppose, however, that half the guests failed to turn up; Heath Robinson suggested that a pair of wall mirrors carefully positioned at either end of the table would deceive the eye and improve the ambience. The same trick might be useful for upwardly mobile hosts with only a small dining room, or with few friends. The elegant house would be filled with "antique" furniture, but then, as now, there were always unscrupulous dealers ready to pull the wool over the eyes of unwary householders by giving a mundane stick of furniture a bogus appearance of age, a trade which Heath Robinson was quick to lampoon.

His humour turned on taking things to the extreme, the *reductio ad absurdum*. In his mind the prevailing desire for elegance and tidiness could not be confined to the dining room or even the house. He saw it spilling out everywhere, like white-painted stones and mown verges marking the approach to a country villa. In Highgate Woods (where he liked to go walking), he fondly imagined a small army of civil servants, or perhaps volunteers, polishing not only the eggs and the birds' nests, but even the ducks and fish in the ponds.

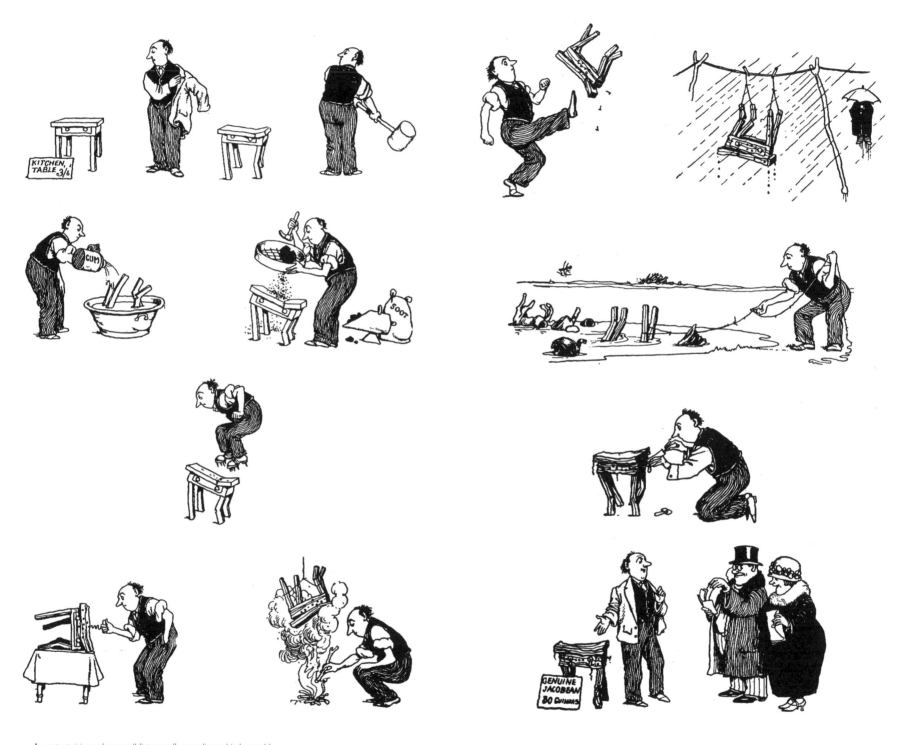

An enterprising salesman "distresses" an ordinary kitchen table
to give it the rich, historic patina of a rare and valuable antique.

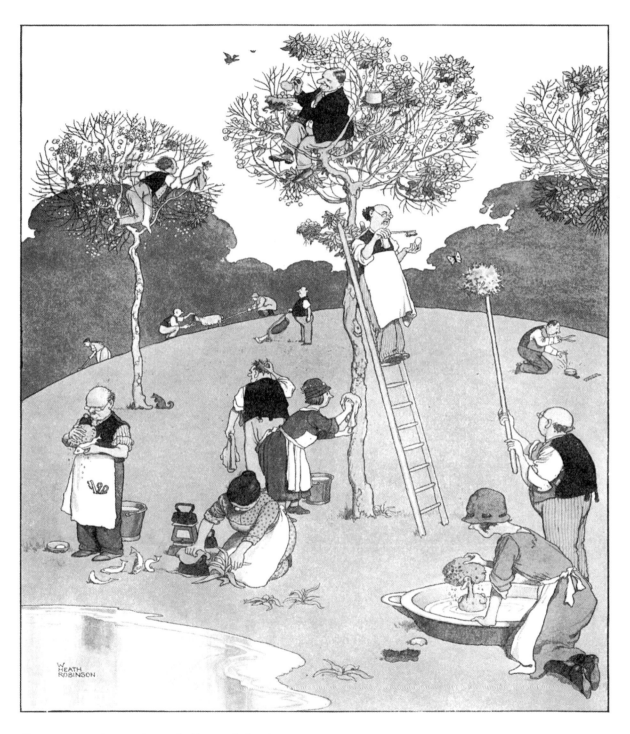

There is no reason why spring cleaning should stop at the front door;
these industrious spirits are determined to keep Highgate Woods as
spick and span as a well-maintained drawing room.

MANNERS
MAKETH MAN

Even when he is not positively looking for a mate, a gentleman should always strive to be well mannered. The assertion "Manners maketh man" appeared first in William Horman's *Vulgaria*, a Latin grammar published in 1519, and became the motto of Winchester College where Horman was headmaster, and of New College, Oxford, where he was a fellow.

According to Dickens's Mr. Micawber, "It is by politeness, etiquette and charity that society is saved from falling into a heap of savagery".

When sitting in a crowded train or bus a gentleman should invariably offer to give up his seat for a lady who is standing. Indeed wherever he finds himself settled he should offer to give up his seat – except, Heath Robinson postulates, under truly exceptional circumstances.

Should he meet a lady in the street, a gentleman will naturally raise his hat in a polite greeting. On the rare occasions when he is not wearing a hat, then perhaps a little nod may suffice – the slightest inclination of the head to acknowledge her presence.

During the course of their professional lives, most gentlemen will find themselves having to address an audience. The first time can be terrifying – that sea of expectant faces, the dry mouth, the blank memory, the lost notes.... All gentlemen will benefit from a short course in public speaking, and given the benefit of wifely tuition, many will go on to become great orators and lecturers.

❝ Life is short, but there is always time enough for courtesy. **❞**

Ralph Waldo Emerson

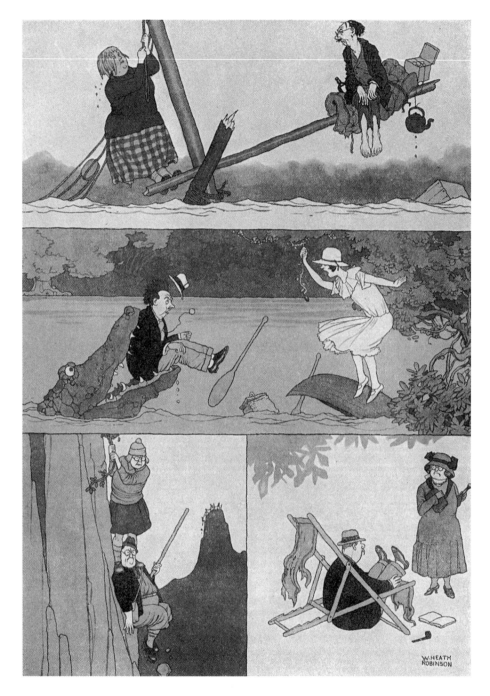

"Some occasions when a gentleman is not expected to give up his seat to a lady."

Speaking in public can be intimidating, but this simple expedient will accustom the novice to the presence of an audience.

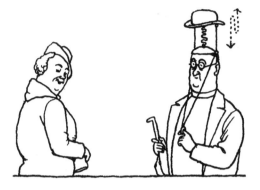

"The automatic hat-raiser for popular people."

"How to go to bed without disturbing the household after a late night."

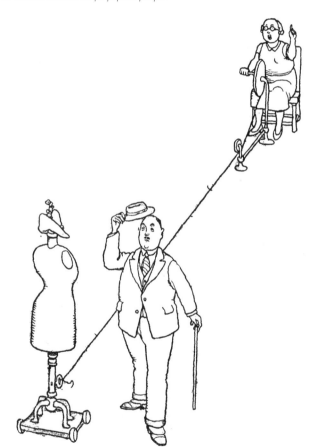

"Training a husband in an act of common courtesy."
A wife employs a mobile mannequin to teach good manners.
They do say practice makes perfect.

FINER POINTS
OF COURTSHIP
AND ROMANCE

The late-Victorian era was noted for its suppression of sexuality. Women wore dresses down to the ground lest the mere glimpse of an ankle might inflame a man's lust. In the Edwardian age that followed during the early 1900s, the rules loosened a little, but they were still strict. There were no wine bars or clubs like today's. Women rarely went out alone in the evening, and never into public houses. As a result, looking for a girlfriend was difficult to say the least.

Heath Robinson had a simple idea, the dating machine, which unfortunately was beyond the bounds of acceptability, and had to remain a figment of his imagination.

In the absence of obvious gathering places, men and women hoped to meet that special someone at a genteel public occasion. At tennis tournaments and concerts where they were singing or piano playing, they could show off their prowess and converse. There were occasional opportunities to dance, and the gentleman who could lead his partner skilfully around the floor had a decided advantage.

When a man did manage to come across an attractive woman, there was an uphill path to follow. In order to court a lady he would knock on her family's front door and present his calling card. If he was in luck she might agree to see him, but she would not go out. Rather he would go into the parlour, and sit there with her mother and all the family, making polite conversation. He was allowed to bring her flowers or chocolates. He could also, if the mood took him, proclaim his love by sending her romantic letters, stories and poems.

In his autobiography Heath Robinson describes how his brothers courted their ladies around the turn of the century: "After dinner, those who were engaged to be married departed in silk hats and

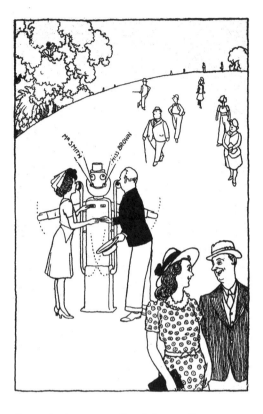

The social embarrassment of introducing oneself to a stranger can be surmounted with the aid of this penny-in-the-slot machine, which appears to be facilitating many a romance.

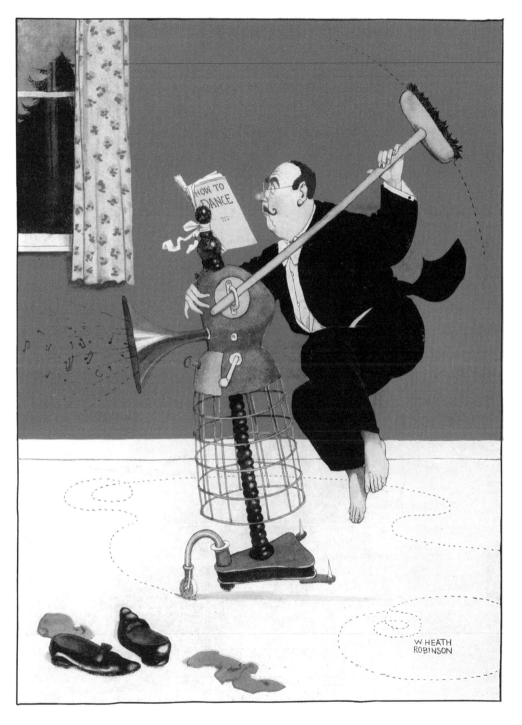

frock coats to meet their fiancées, and to bring them home, where we gathered again for tea.… The young men who were engaged to be married were resplendent with luxurious growth of hair and heavy but well-trimmed moustaches. They were rather uncomfortable in their high stiff collars and clothes that must not be creased. The girls were charming in high coiffures, blouses with wide leg-of-mutton sleeves, and flounced skirts that rustled on the ground as they walked. After a little polite persuasion, a young lady, with becoming reluctance, would oblige by playing on the piano."

Sadly, Heath Robinson avoids all description of his own courting. He seems to have been a mild and gentlemanly sort, and gives no hint of the angst and unrequited longing experienced by most teenagers and twenty-somethings. He simply states "Our wedding took place in the year 1903, after a long engagement". He was 31 years old.

When a young unmarried woman went out on any social occasion, especially when men might be involved, she would have to be accompanied by a chaperone, usually an elderly married woman or widow, perhaps an aunt or great aunt. The chaperone's duty was to guarantee the young woman's virtue. So when a couple started "going out" together, they would normally be minded by a chaperone, whose task it was to keep them in order.

Today chaperones are legally required to look after children who are performing in films or on television, in much the same way as teachers and parents supervise children on school trips, and try to prevent indulgence in drink and drugs. The word may have come from *chaperon*; in the sport of falconry a *chaperon* is a hood which is put over the head of a falcon to prevent it from wanting to fly.

Under the stern gaze of the chaperone, the young

"An ingenious device which enables the student to learn dancing in his own home, and particularly to avoid treading on the toes of his partner."

couple might be allowed to hold hands or gaze into each other's eyes, but they could never kiss; that would be gross impropriety. Heath Robinson even imagined that impetuous young men and women needed supervised lessons in self-control, standing close to one another and resisting the temptation to press their lips together.

Courting for young couples around 1900 was even more difficult than it is today, in view of their almost total ignorance about sex, and their desperate fear of the possibility of premature pregnancy. Some young men – and indeed some not-so-young men – found ingenious and romantic ways to proclaim their passion, posing as statues of Cupid or writing love letters in the sky, at least according to Heath Robinson. If ever they found themselves alone, and there was a danger that the temptation might grow too strong to resist, they would have to take precautions against being discovered, for terrible wrath would come from both sets of parents if they heard that their children had taken liberties with each other.

Valentine's Day, 14th February, is named after one of several Valentines who became Christian martyrs, but most probably Valentine of Rome, who was clubbed to death in 269, or Valentine, Bishop

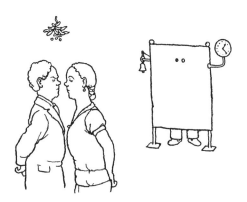

"An exercise in self control." How long will this couple hold out before they give in to gross impropriety? As Heath Robinson remarks, this machine "gives such exercise to the abominable muscles that appetite is immediate and imperative".

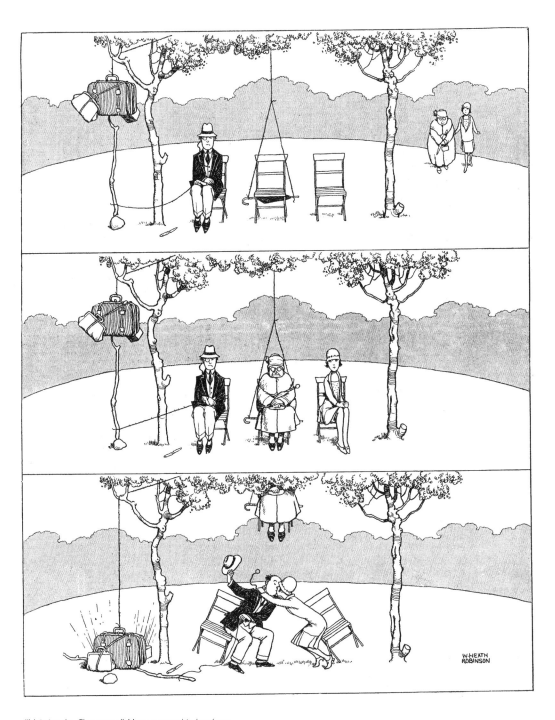

"Hoisting the Chaperone." Many a courtship has been thwarted by the presence of a chaperone, but for the modern suitor who "cannot absent himself from his office long" there is an effective solution.

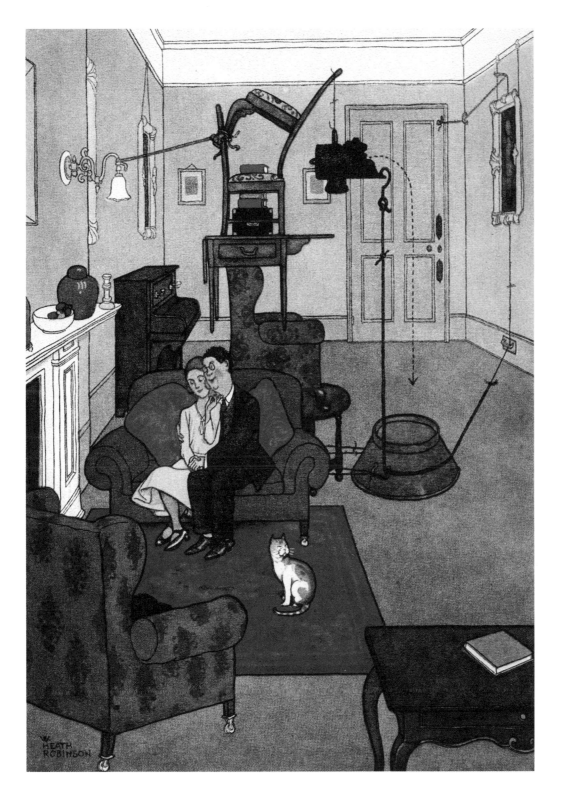

of Terni, who was martyred a few years later. There was no connection with love and romance for more than a thousand years, until Geoffrey Chaucer wrote, "For this was on St. Valentine's Day, When every bird comes to choose his mate". Shakespeare chimed in, with "Saint Valentine is past; Begin these wood-birds but to couple now?" in *A Midsummer Night's Dream*, and "And I a maid at your window, To be your Valentine" in *Hamlet*.

The process of choosing Valentines is really a relic of the ancient Roman fertility feast of Lupercalia, which was held from the 13th to the 15th of February, until it was abolished in the late 5th century. So the Roman ideas rose again, in spite of the Christianization of the festival. Home-made Valentine cards were sent in the 17th century; by the 19th they had largely given way to mass-produced cards; now around a billion cards are sent every year, and Valentine's Day, despite its questionable roots, is celebrated all over the world.

Cards are the primary presents, but many lovelorn swains give chocolates and flowers, and some also serenade their inamoratas. Supposing everything goes according to plan, and both seem certain they have found a perfect partner, the suitor will go down on one knee and ask for his lady's hand in marriage. Provided her parents agree and he has enough money to support her, the couple can hope for a celebratory wedding and a blissful honeymoon.

> **❝** The only way to
> get rid of temptation
> is to yield to it. **❞**
>
> Oscar Wilde,
> *The Picture of Dorian Gray*, 1890

Some courting couples will go to great lengths to avoid being discovered in inappropriate proximity.

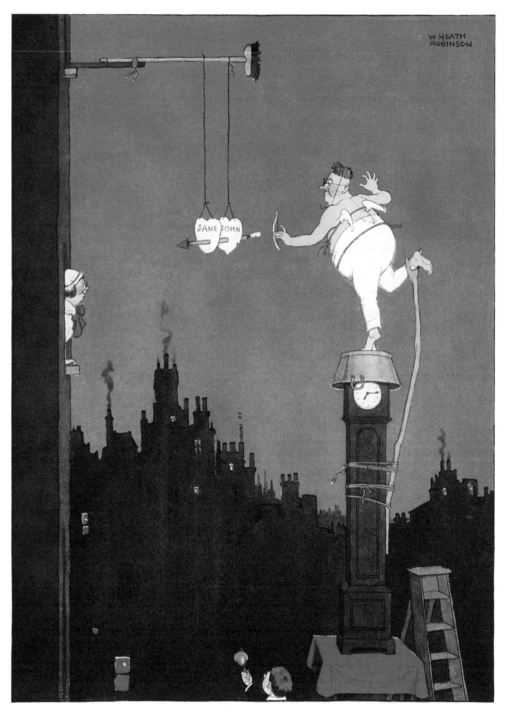

"A graceful tableau staged by a well-known member of the
Stock Exchange as a pleasant surprise for the wife of his
bosom on St. Valentine's morn." At the sound of a bell, John can
reaffirm his love for Jane and cry once more, "Oh, will thou be
my Valentine?"

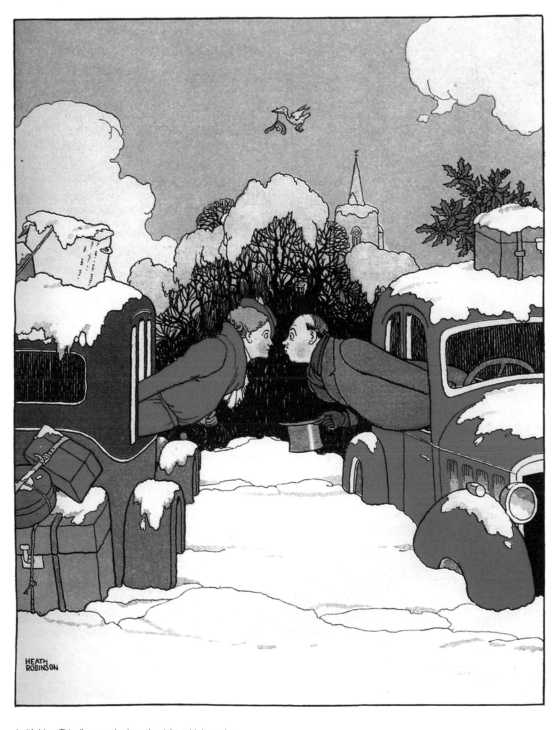

In "A Near Thing", a couple show the right spirit in coping
with meteorological adversity, making the most of their chances
under the mistletoe. The motor car gave lovers a freedom
unavailable to their Victorian forebears.

An amorous sailor is despondent when a mermaid spurns
his gift of a spring onion, but when spring is sprung this
"idyll of the sea" has a happy ending.

*Hoping to lure a mermaid from her native element, this
romantic gentleman has disguised himself as one of her kind.*

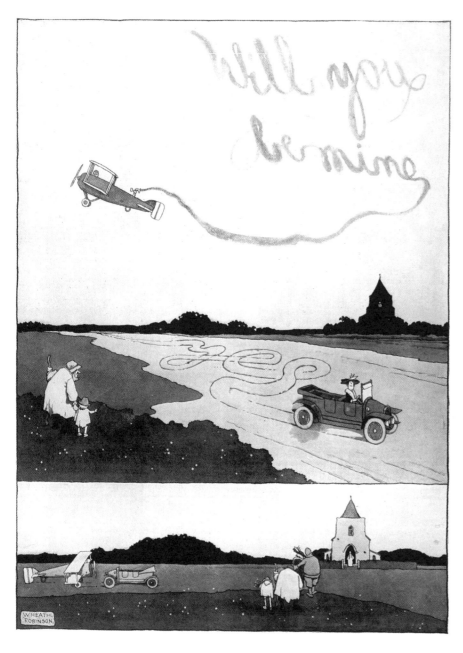

In matters of the heart, the sky's the limit.

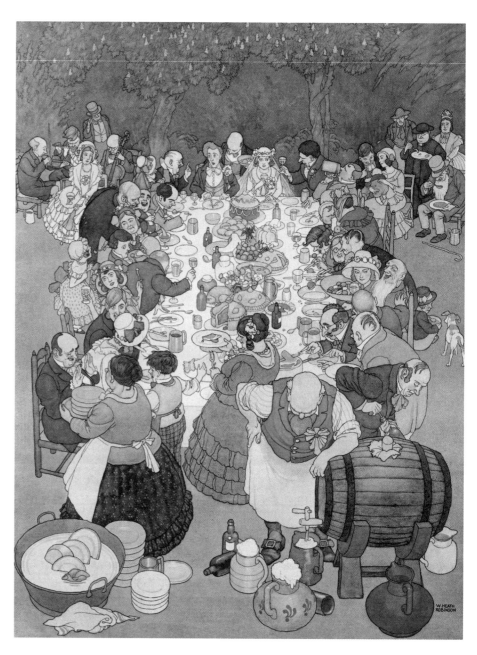

Heath Robinson rolls out the barrel for a wedding feast of almost mediæval splendour.

The family deploy their confetti machine to wave off
"the honeymoon taxi", decked with bouquets, charms and
shoes for every eventuality.

"The air honeymoon."

" Love is notoriously blind. "

Heath Robinson and K. R. G. Browne,
How to be a Perfect Husband, 1937

SECRET LIAISONS

If parents disapproved of a match or if, disaster of disasters, a young woman discovered that she was pregnant, the couple might have to escape the watchful eyes of their guardians and steal away to get married in secret.

Gretna Green was the most popular destination for eloping couples because it was the first village in Scotland on the road from London to Edinburgh, and in Scotland it was possible for anyone over the age of 16 to get married without parental consent. The favourite location was the Blacksmith's Shop, and almost anyone could marry you. Gretna Green is still enormously popular as a wedding venue today; more than 5,000 weddings are held there every year.

The course of true love does not always run smoothly, and sometimes an elopement must be carefully contrived.

*Determined lovers will find a way to thwart
the vigilance of an unsuspecting spouse and
steal an illicit kiss or two.*

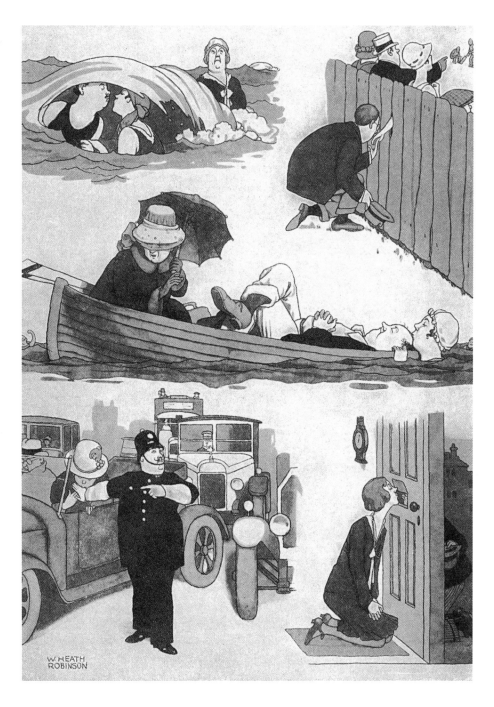

DRESSED TO IMPRESS

Finding the right clothes and being smart has always been difficult for some people. There are gentlemen who seem always to be immaculate, but most of us struggle to maintain a respectable appearance.

Braces present two problems. First, they are always the wrong length: either too long, allowing the trousers to slump around the hips and the turnups to trail on the ground, or they are too short, causing discomfort in the bottom bracket. Second, they sometimes tend to slip off the shoulders, causing a sinking feeling both above and below. Heath Robinson's solution was a pair of super-high-tech braces with an electrical control panel to adjust the apparatus automatically in several directions, maintaining perfection at all times. Wearing this superb equipment, the gentleman could be sure that no slippage of any kind could possibly occur.

Every time he rises in the morning, a gentleman must face a series of complex decisions about what to wear. Will he be attending the office, appearing in court or merely going to the allotment to dig in manure? What is the weather, and how will it vary during the course of the day? Should he take the precaution of donning woollen underwear, even if the sun might emerge later on?

Some people rely on the weather forecast broadcast on radio and television, but that is notoriously unreliable in my part of the world, where the sun can be shining in the next village while rain is bucketing down on me. Indeed Robert Fitzroy, who invented the weather forecast in 1861, received such fierce criticism when he got it wrong that he lost all confidence and eventually took his own life.

Heath Robinson's solution to this problem drew on personal observation and deduction, with a dash of appropriate technology. Only by using the most advanced and sophisticated meteorological

"The new electric braces for those men who haven't the time to fiddle about with the ordinary kind in the morning."

*"What shall I put on?" Deciding what to wear can
be perplexing when the weather is changeable, but this
convenient bedside apparatus will make the decision for you.*

apparatus could a chap be sure of choosing the right clothes for the day.

No gentleman could feel amazing without wearing a silk top hat, invented in the late 18th century; the first man to wear one in England was called John Hetherington. In January 1797 he caused such a stir walking down the Strand in a topper that he was arrested and charged with disturbing public order. The policeman claimed that he "had such a tall and shiny construction on his head that it must have terrified nervous people… women fainted, children began to cry and dogs started to bark".

The Times newspaper, however, retorted the following day, "Hetherington's hat points to a significant advance in the transformation of dress. Sooner or later, everyone will accept this headwear". *The Times* was correct: the silk top hat soon became the conventional headgear for gentlemen in Great Britain, Europe and North America.

The bowler hat, on the other hand, was designed specifically to protect the heads of gamekeepers from murderous poachers and low-flying branches on the Holkham Hall Estate in Norfolk, owned by the Earl of Leicester. In 1850 the Earl's younger brother William Coke (pronounced Cook) went with his own design to the family hatters, Lock & Co. in St. James's Street in London. A week later he went back to try on the prototype hat. It fitted snugly, and when he jumped on it the hat did not collapse, so he ordered a dozen.

Lock's did not actually make the hats themselves, but put them out to the brothers William and Thomas Bowler in Southwark. So the hat came to be called a Bowler or Billycock hat (after William Coke); but Locks called it a Coke hat, and still call it a Coke hat, because it was designed and ordered by Mr. Coke.

Once you have bought your clothes from the appropriate outfitters, the question is how to look after them. To assist gentlemen in their quest for sartorial perfection, Heath Robinson tells us how to remove the shine from blue serge trousers – a problem that has always baffled me – and also explains a simple way to stretch and flatten a pair of trousers without having to use an iron.

Neighbours watch over the garden wall as a committed gentleman employs the sandpaper method of removing the shine and restoring the original matt surface to his blue serge trousers.

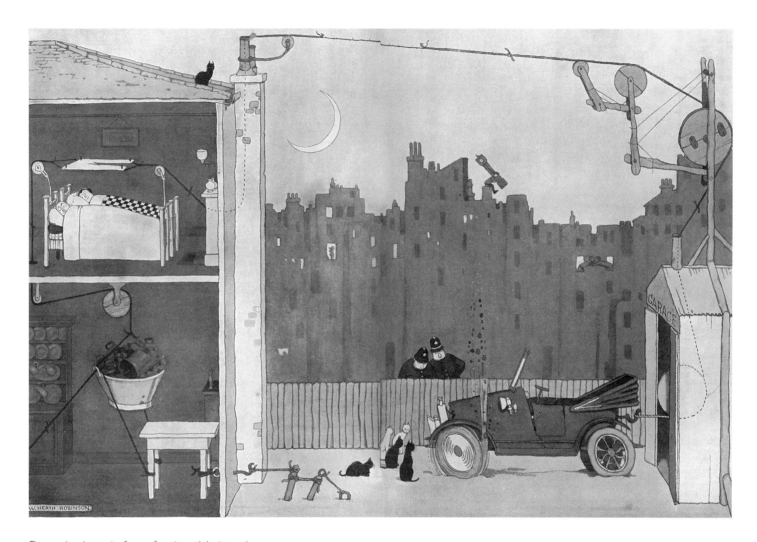

*The equal and opposite forces of gravity and the internal
combustion engine remove the creases from a pair of trousers
while their owner sleeps.*

❝ Many self made men
attribute their success to their lifelong
habit of pressing their trousers. ❞

Heath Robinson and K. R. G. Browne,
How to be a Perfect Husband, 1937

CLOTHES FOR HIRE

During my later teenage years, I was occasionally invited to evening events for which the dress code was dinner jacket and black tie. I did not possess such things, so I went to Moss Bros., who were always ready to hire me not only evening dress, but a wedding outfit, funeral clothes and any other attire I might need for a few hours or a few days.

In 1851 a second-hand clothes dealer called Moses Moss rented a pair of shops in Covent Garden. When he died in 1894, he left the company to his sons Alfred and George, who rebuilt the shop and changed the name to Moss Bros. In 1897 their friend Charles Pond, an actor, had run out of money but needed outfits in which to perform, so they kindly lent him some clothes for a small fee.

Moss Bros. gradually expanded as a supplier of gentlemen's clothes both bespoke and ready-made, as well as for hire. They did well making uniforms for service personnel in both world wars, and during the 1920s they opened a saddlery department to supply riding breeches and other equipment to the equestrian community.

In 1936 Heath Robinson was commissioned to produce a series of drawings to illustrate what went on behind the scenes at Moss Bros., and the results clearly both shocked and delighted the directors.

Today Moss Bros. have clothes for sale and to hire even on cruise ships. In their own words, "Moss Bros. is an editor for men, providing a versatile range of menswear.... As a brand we inspire and guide, helping men feel amazing whatever the occasion."

"Noble effort of a policeman to kill the slowly dying myth about flat feet."

THE SPRING MOULT

In a letter to a Surrey customer, the company director Alfred Moss had this to say about Heath Robinson: "It is amazing," he wrote, tongue firmly in cheek, "how he has contrived to distort the sober efforts of the firm."

In preparation for "the spring moult", the gentleman alighting like a winged cherub at Moss Bros. will find valet service awaits him.

The booklet entitled Behind the Scenes at Moss Bros.
contains 15 half-tone illustrations full of improbably
exaggerated detail, in which Heath Robinson sought to portray
the dress-hire firm as a glorified version of a Savile Row tailor,
with automated fitting machines and flunkeys aplenty.

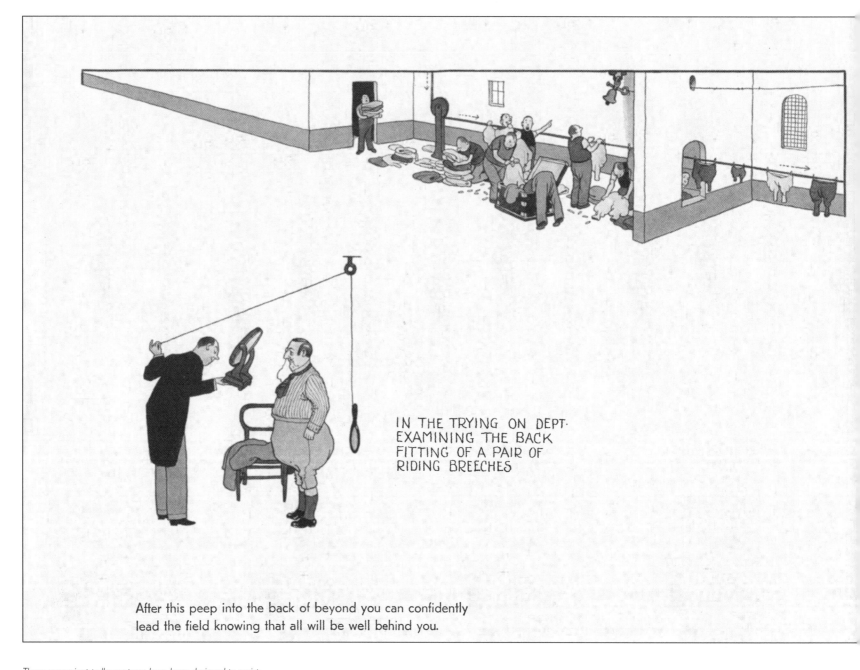

IN THE TRYING ON DEPT·
EXAMINING THE BACK
FITTING OF A PAIR OF
RIDING BREECHES

After this peep into the back of beyond you can confidently
lead the field knowing that all will be well behind you.

*These convenient pulley systems have been designed to assist
the customer in selecting a pair of breeches.*

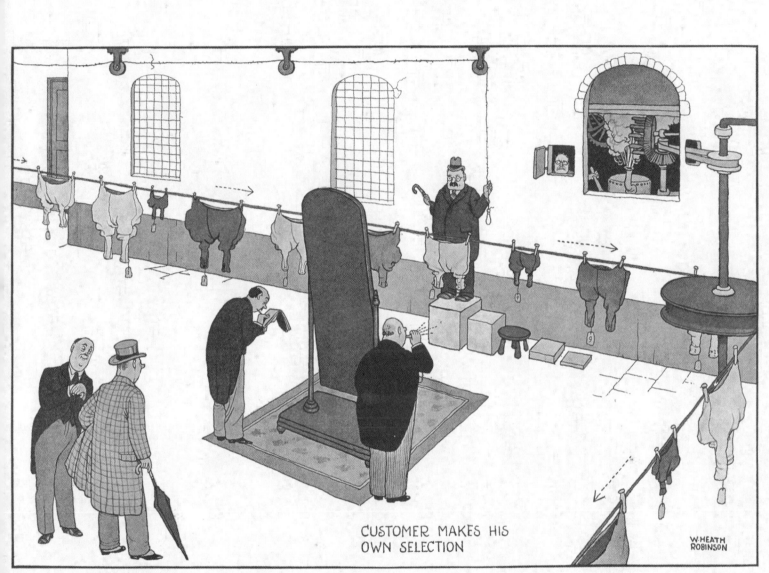

CUSTOMER MAKES HIS
OWN SELECTION

W.HEATH
ROBINSON

You will find it impossible to upset our Breeches Buoys
(bless them!) however much you try it on.

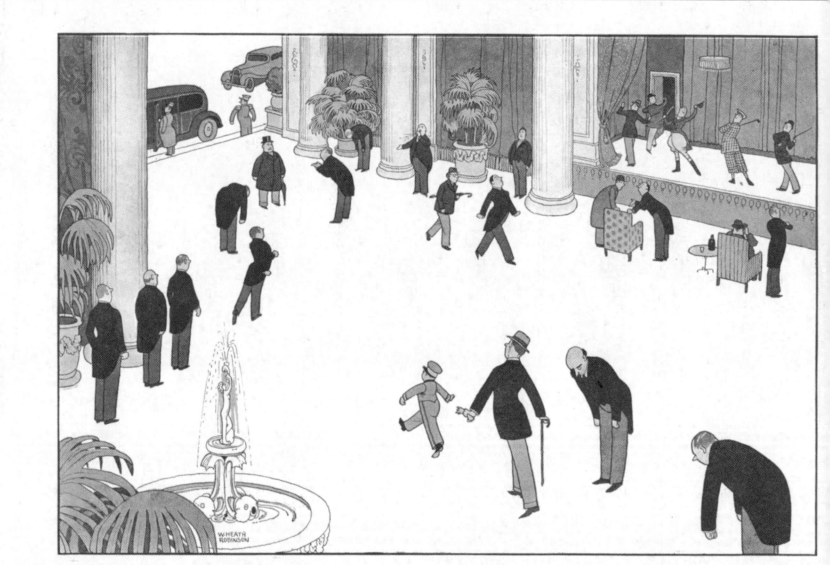

MOSS BROS. de Luxe Our Emporium is exactly like this except for the palms, fountains,

*In the palm-fringed emporium of Moss Bros., customers make their
selection from the garments displayed in a catwalk parade, before
they are measured for a fitting.*

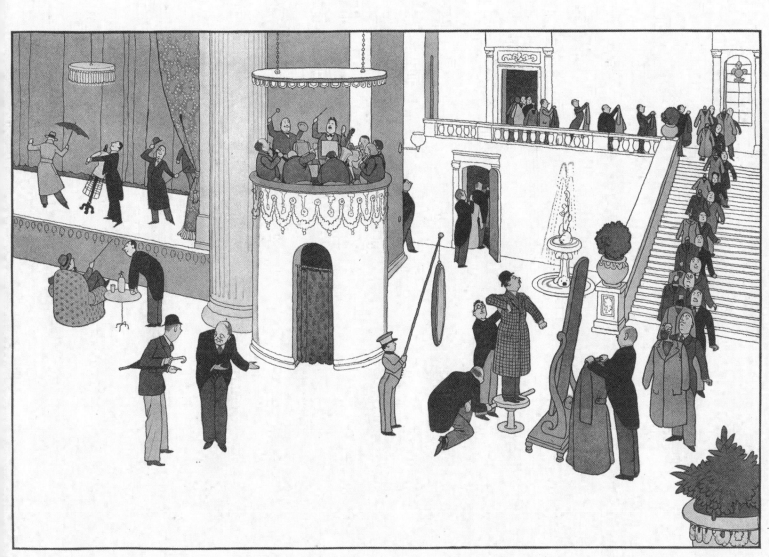

pillars, stage, staircase, etc., etc. . . . But really — it's a very comfortable place in which to choose a suit.

THE BODY BEAUTIFUL

Fine manners and elegant clothes are a start, but unless the body itself is immaculate, the man can never be perfect. Let us begin with a massage.

In his 1794 book about his travels, the Bengali author Sake Dean Mahomet describes the Indian practice of *champu*, in which a man lies back while a "female masseuse/shampooer, with her agile art, runs over his body and spreads her skilled hands over all his limbs". When Mahomet came to London in 1810 he opened the first Indian restaurant in the country. He later introduced *champu* to Brighton, promoting it as "The Indian Medicated Vapour Bath (type of Turkish bath), a cure to many diseases and giving full relief when every thing fails; particularly Rheumatic and paralytic, gout, stiff joints, old sprains, lame legs, aches and pains in the joints". The hair-washing part of the treatment acquired the name shampoo.

Heath Robinson devised a marvellous mutual massage machine for couples and all manner of other ingenious devices for toning and maintaining the body, including a penny-in-the-slot shower cubicle, which is just what you might hope for in the railway station at Crewe – or even more so at Kolkota. In addition, this narrow space might solve the problem that the water in showers is always cooler on the outside than in the middle. This is because the drops on the outside are exposed to cold air and thus evaporate and cool down faster. In this sentry box there is not much cold air outside the curtain of water, so perhaps the outer layers would stay a bit warmer.

Invited to draw a picture to promote Comfort Soap, Heath Robinson ignored the soap and chose to show his notion of perfect comfort. He (or rather a fat middle-aged man) lies comatose in a hammock, suspended in mid-air by magnets, untroubled by the rumblings of traffic or even earthquakes. He listens to the new-fangled radio, puffs contentedly on

a cigarette and has a supply of soda water – or perhaps something stronger – ready at the touch of a foot pedal to pump straight into his mouth.

Desmond Morris began the introduction to his 1967 book *The Naked Ape* as follows: "There are one hundred and ninety-three living species of monkeys and apes. One hundred and ninety-two of them are covered with hair. The exception is a naked ape self-named *Homo sapiens*. This unusual species spends a considerable amount of time worrying about and tending to the small remaining patch of hair on his head."

Men have always wanted to look beautiful – or at least attractive to other people. From the classical elegance of Greek and Roman statues to the film stars of today, beauty has meant a slim, lightly muscled figure and a smooth complexion, often topped with wavy hair. While they still have plenty, some men are inordinately proud of their hair, and go to great lengths to improve its appearance. Schoolboys, on the other hand, get shorn of their unruly thatches to keep them tidy and minimize the habitat for nits.

According to the Greek historian Plutarch, writing 1,900 years ago, "Thin people are generally the most healthy; we should not therefore indulge our appetites with delicacies or high living, for fear of growing corpulent.... The body is a ship which must not be overloaded."

Shakespeare's Julius Caesar thought fat colleagues were lazy, unambitious and therefore safe:

Let me have men about me that are fat,
Sleek-headed men and such as sleep a-nights.
Yond Cassius has a lean and hungry look,
He thinks too much; such men are dangerous.

Heath Robinson himself was slim, and photographs show that he had a fine head of short dark hair, yet

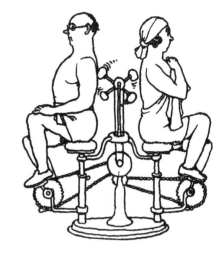

This pedal-operated massage machine for two will help to stimulate the follicles, relieve the occasional ache or pain and maintain the muscle tone essential for good deportment.

A coin-operated shower will enable passengers to remain fresh and fragrant during even the grimiest railway journeys.

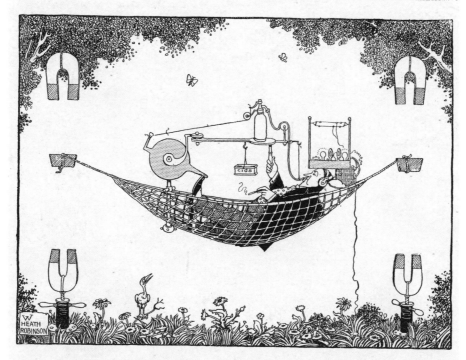

Heath Robinson's idea of comfort

This looks like a lot of trouble for a doubtful degree of comfort, but then, Heath Robinson likes to work for his pleasures.

For us a bath with Comfort Soap is the height of enjoyment. Such a creamy, healthy lather, redolent of the countryside; such a happy glow after the bath with Comfort Soap.

The secret of Comfort is in the pure vegetable oils that make it.

The rich oils, the fresh odour, the natural colour of Comfort are all of vegetable origin.

THE SECRET OF COMFORT
Comfort is an unequalled combination of palm and olive oils, made into soap in the world's greatest soapery at Port Sunlight.

PURITY GUARANTEED
Every cake of Comfort Soap carries the Lever world-wide guarantee of purity. It cannot hurt the softest skin.

If soap had been invented in Cleopatra's day she would have used Comfort. So would Helen of Troy.

LARGEST SALE: HALF THE PRICE
Comfort has already the largest sale of any palm and olive oil soap in Great Britain. And this enables Comfort to be sold at half the price of foreign importations.

You'll love Comfort. Ask your grocer or dealer for your first supply right now.

Lever Brothers Ltd., Port Sunlight

C. 42-34

Heath Robinson designed this magnetic-levitation hammock in 1924 as an advertisement for Comfort Soap. The makers, Lever Bros., claimed that Cleopatra and Helen of Troy would have used Comfort had only they known it.

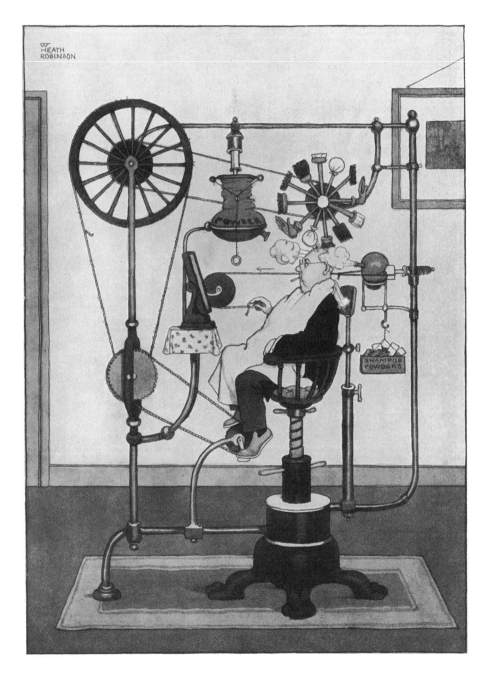

This dry shampoo applicator can be operated at home to ensure that hair – however sparse – remains in tip-top condition.

The Eton crop ensures that pupils' hair is of the regulation length.

*The traditional barber's shop is no match for
Heath Robinson's fully automated, production-
line hairdressing factory.*

in his humorous drawings almost all the men are fat
and balding. Perhaps he enjoyed poking fun at fatties,
or perhaps he was getting at particular middle-aged
friends, family or colleagues. We may never know, but
he certainly had it in for the corpulent. Several of his
pictures show fat men trying to get thin by means of
one contraption or another, but the most extreme is
the Banting Bed.

Born in 1797, William Banting became an
undertaker in London's salubrious St. James's Street.
The Bantings were funeral directors to the royal
family; they buried George III, George IV, Prince
Albert and Queen Victoria. William, however, had a
weight problem. He was only 5 ft. 5 in. tall, but by
the time he was 65 he weighed 14 stone 6 lb. (202
lb. or 92 kg.) and was so fat he could not tie his own
shoelaces. He had to walk down stairs backwards,
and with every exertion he "puffed and blowed" in a
manner most unseemly for an undertaker.

On doctors' advice he took long walks and went
rowing for two hours before breakfast every day
– but this only made him hungry, and he became
heavier. He went swimming, riding and walking by
the sea. He tried 90 different Turkish baths and drank
gallons of patent slimming medicines. None of this
had any useful effect.

When Banting discovered that his sight was
deteriorating and he was going deaf, he went to consult
Dr. William Harvey, who advised him to avoid bread,
butter, milk, sugar, beer and potatoes, which tended to
create fat. Instead he should go on a high-protein, low-
carbohydrate diet, rather similar to today's Atkins diet,
although it did comprise three square meals a day and
included a surprising quantity of alcohol.

In spite of the alcohol, the diet worked; within a year Banting had lost three stones (42 lb. or 20 kg.). He stopped puffing and blowing and could once again tie his shoelaces and walk downstairs forwards. He was so delighted that in 1863 he wrote a pamphlet entitled *A Letter on Corpulence, Addressed to the Public*, in which he wrote, "I have not felt so well as now for the last twenty years".

A Letter on Corpulence was a great success. Thousands of people followed his advice (or, technically, Dr. Harvey's). "Banting" became a household word, and the verb "to bant", meaning to diet, entered the language. Society ladies would say to one another, "You look so well; are you banting, my dear?", and the term remained current in Heath Robinson's day.

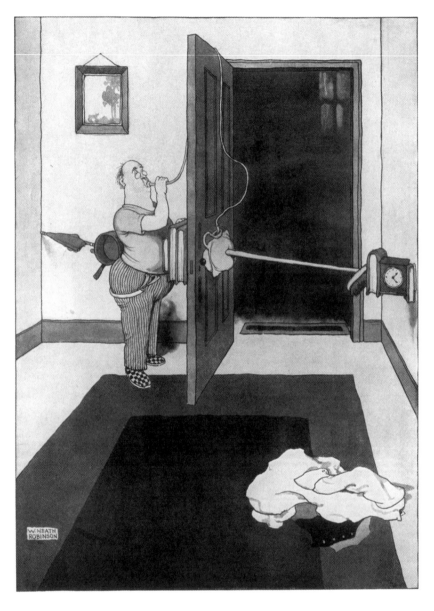

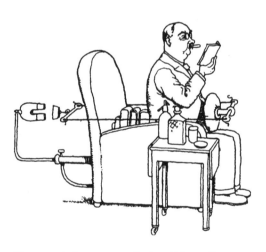

"The magnetic figure preserver for the middle-aged."

A gentleman demonstrates "a simple device for the correction of neglected figures in time for the dancing season".

❝ A mistake made by many men on reaching middle age is that of letting themselves spread in all directions, thus becoming pear-shaped. **❞**

Heath Robinson and K. R. G. Browne,
How to be a Perfect Husband, 1937

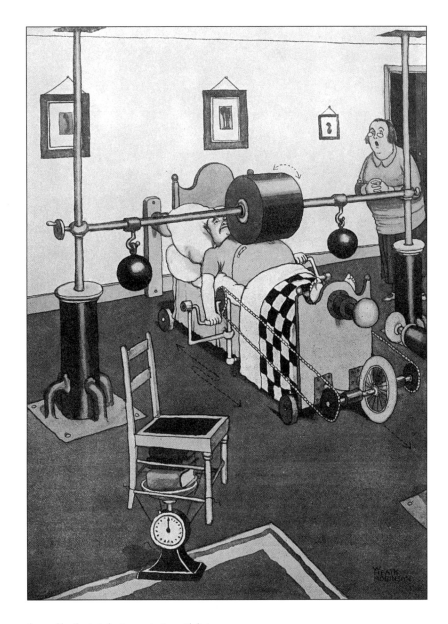

Amused by the popular preoccupation with losing weight, or "banting" as it was then known, Heath Robinson devised the "Banting Bed for Reducing the Figure".

"Facing up to an unrationed world."

"Bathroom exercise for training the legs for running to the station in the morning."

PATENT REMEDIES

Heath Robinson was amused by the patent remedies espoused by dubious doctors and snake-oil salesmen, and drew a number of pictures to lampoon such practices. His Climate Cabinet was designed to prepare the unwary for sudden changes in conditions by providing every sort of weather in rapid succession. No doubt an hour or two in this contraption would generate some illness in even the most robust constitution.

The 'Flu Room was supposed to cure influenza while the patient remained at home. The 'Flu Tank, on the other hand, was designed to effect a rapid cure while the sufferer was on his way to the office.

Toothache was another common ailment that was susceptible to makeshift cures. When I was trying to remove a baby tooth I was advised to tie a piece of string round it, attach the other end to a door handle and then slam the door, or else tie the other end to a stone and throw it out of the window. Heath Robinson's devices for removing a tooth and a wart are hardly more scientific.

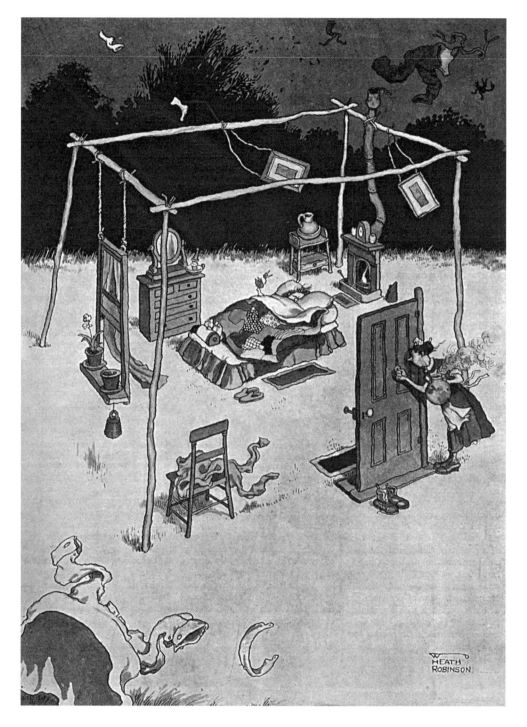

Nothing takes its toll on one's appearance like colds and 'flu, and Heath Robinson had a number of ideas for keeping them at bay, including the 'Flu Room, in which exposure to fresh air would cure the patient. Sweating under a heavy counterpane with one's feet on a foot-warmer would also help.

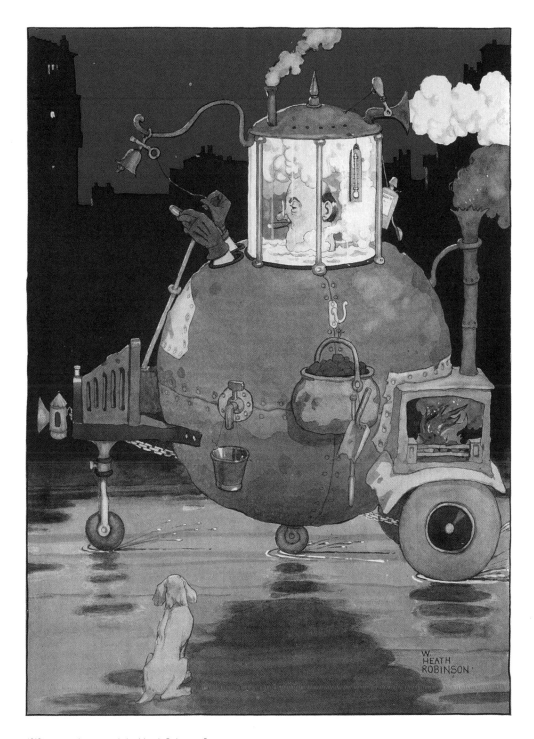

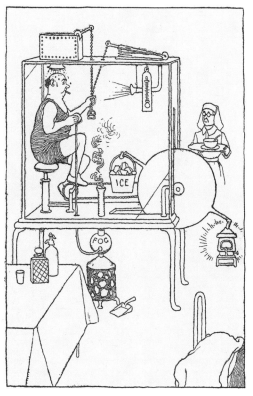

Another homely idea was this "medically approved" glass cabinet to acclimatize the patient to the vagaries of the local weather.

If 'flu cannot be resisted, the Heath Robinson Patent Improved 'Flu Tank allows the sufferer to continue the cure en route and arrive at the office in a regulated environment without passing on germs to others.

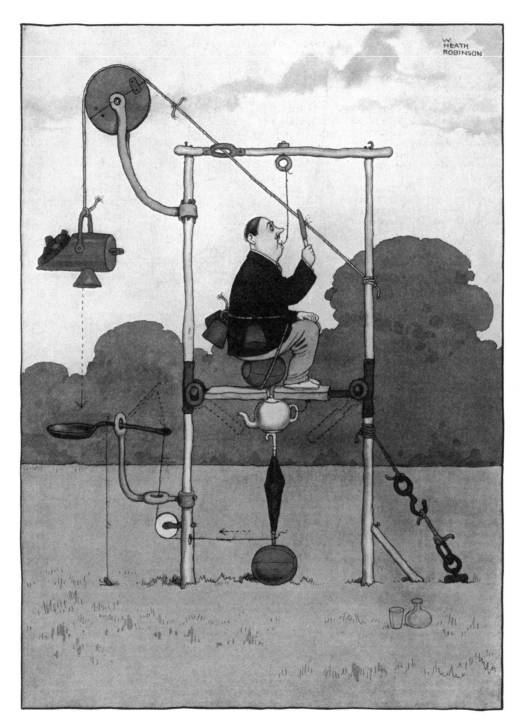

This carefully calibrated mechanism obviates
the need for a trip to the dentist by swiftly and
cleanly extracting a troublesome tooth.

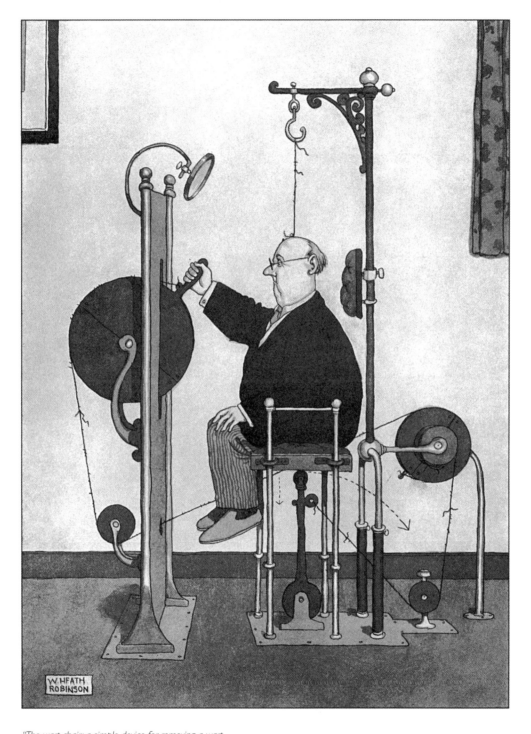

*"The wart chair: a simple device for removing a wart
from the top of the head."*

CHAPTER 3

HOLIDAYS AND PASTIMES

Entertained by the comic potential of the bicycle, Heath Robinson featured them in many of his drawings. "There was a tendency," he noticed, "for the man to be the cyclist." Wives and children were permitted to ride as passengers.

Heath Robinson's tourist is equipped with portable accessories to deal with all weathers and pleasures, from sea bathing to sleeping under the stars.

Until the Industrial Revolution, holiday for most people meant "holy days": Good Friday, Christmas Day and various saints' days, which were the only time most labourers would have off work. With the majority of the population employed in agriculture, there was little appeal in the idea of an "escape" to the countryside. Young aristocrats of the 17th and 18th century would complete their education with a Grand Tour of Europe, and might view the remains of Ancient Greece and Rome, but tourism as we understand it did not exist.

The idea that getting out into nature was good for body and soul was a response to the growth of large industrial cities. Wordsworth celebrated the landscape of the Lake District in his poetry and Robert Louis Stevenson enjoyed great success with his *Travels with a Donkey in the Cévennes* (1879). Even Jerome K. Jerome's *Three Men in a Boat* (1889), a comic tale of a gentle trip down the Thames, begins with his protagonists deciding that they must escape the city for the sake of their health.

As an art student, Heath Robinson had fallen under the spell of the Romantic view of the sublimity of nature: "My idea of the life of a landscape painter was to live in the open air and in lonely communion with nature. To be hardened to all weathers, heat, cold and all climates. To be equally at home in raging storms and under the dazzling sun of the desert… Sometimes, perhaps, in the Swiss Alps or the Himalayan Mountains and Tibet. At other times my wanderings might take me to Greece, to Rome or to Egypt and back again to the Norfolk Broads."

Holidays, as we understand them, came into being as a result of the technological innovations of the Victorian era, especially the railways. Thomas Cook launched his travel company in 1841 with a one-day rail excursion for temperance campaigners from Leicester to Loughborough for a shilling per person, and many rail companies followed suit. In 1855 Cook conducted his first continental tour from Harwich to Antwerp, Brussels, Cologne, Frankfurt, Heidelberg and Strasbourg, ending in Paris for the International Exhibition. By 1890, Thomas Cook & Son had offices all around the world.

For toilers in the dark, Satanic mills of the steam age, rambling in the countryside offered a welcome respite. Many private landowners tried to restrict access to their land, and walking clubs began to campaign for the "right to roam". In 1931, six regional federations joined to create the National Council of Ramblers Federations and the following year 400 walkers took part in an organized trespass on Kinder Scout in the Lake District. On 1st January 1935 the Ramblers Association was officially created.

Heath Robinson remained a lifelong walker, though as a married man with a growing family he set his sights closer to home than in his youth. He and his friends formed their own walking club, which they called the Frothfinders Federation. Meeting near Pinner on Saturday afternoons, they would set off on a long ramble through the countryside on the outskirts of London, which would invariably end "at some hostelry, usually the Crown at Stanmore".

In the many pages he devotes to these walks, Heath Robinson never mentions carrying anything other than a packet of sandwiches. Whether he ever donned or even owned any tourist outfits seems doubtful, but in his drawings he expressed dreams of taking to the road for weeks at a time, equipped with mattress (or at least pillows), lamp, pyjamas, towels, mirror, hairbrush, provisions, wine and a wine glass, camera, telescope, toasting fork, pipe, book, umbrella and everything else that a chap could possibly need.

Another Victorian innovation that liberated ordinary people from the confines of the city was the bicycle. The first such machine was allegedly made by

the Scottish blacksmith Kirkpatrick MacMillan in 1839, but the idea did not catch on for another 20 years when a velocipede known as the "bone-shaker" appeared from Pierre Michaux in Paris. The "penny-farthing" or high wheeler, invented in 1869 by Eugène Meyer, had a huge front wheel for maximum speed, but if you stopped suddenly or hit a pothole, you fell forward with your knees trapped under the handlebars and landed on your head. This was called "taking a header" and cost many young gentlemen their front teeth.

The "safety bicycle" of the 1880s had wheels of roughly the same size with a chain drive to the back wheel. Unlike the penny farthing, you could fall off a safety bicycle without losing your teeth, and ladies were able to ride in comfort and with decorum.

Heath Robinson the intrepid outdoorsman was fascinated by the potential of the bicycle, the tent, the Primus stove and the Swiss Army knife. While the tent had been used by explorers, trappers and armies on the move for millennia, no one in their right mind would have opted to spend a night under canvas before the late 19th century. The founding father of modern camping was a British tailor called Thomas Hiram Holding, who caught the bug as a child when he crossed the American prairies with his parents in a wagon train. A keen cyclist, in 1901 he founded the Association of Cycle Campers, the forerunner of today's Camping and Caravanning Club, and in 1908 published the first edition of *The Campers Handbook*. In it, he wrote that camping teaches self-reliance, patience and tolerance, brings health and peace of mind, keeps old men young, and "enables a man to get away from his family; or his family to get away from him".

In Heath Robinson's world, however, nothing is ever that straightforward, and his unsuspecting holidaymakers in pursuit of simple pleasures are drawn ever deeper into a maze of bewilderingly complex contraptions.

A pram and a dog, not to mention a robust constitution, are indispensible when arranging a family holiday.

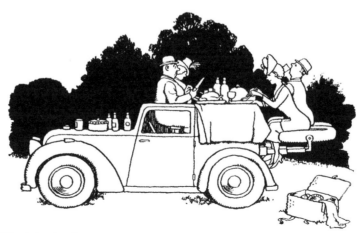

"The picnic saloon."

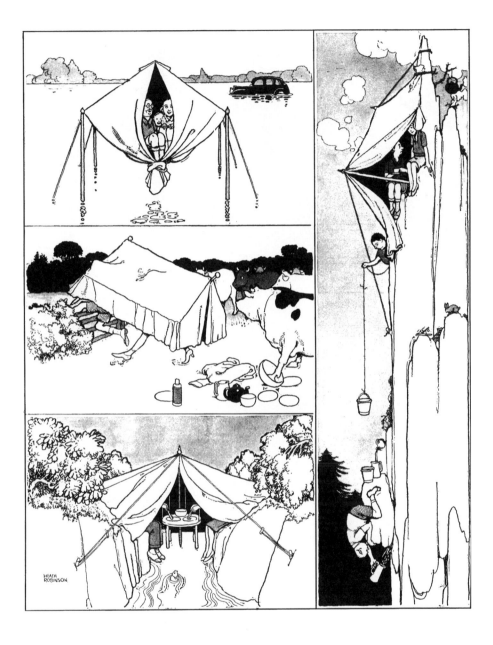

Below: "The trailerette, for touring deserts."
Below right: Foreign touring and caravan life was one of the topics that inspired Heath Robinson in the 1930s. Here he offers his vision of the family caravan, complete with Nursery and Library.

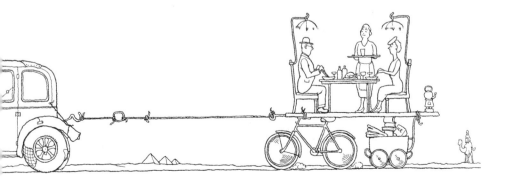

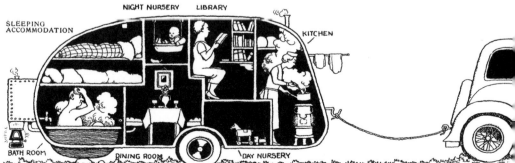

OUTINGS AND EXCURSIONS

Most working-class Victorians spent the week in factories, which meant they were paid wages, and had occasional holidays. Entrepreneurs saw the opportunity of relieving trippers of their cash, and invented the seaside as a holiday destination; resorts such as Scarborough, Blackpool and Brighton sprang up, each with its railway station.

The opportunities for outings and excursions increased after the Liberal M. P. John Lubbock tabled the Bank Holidays Act in 1871, adding four new days off to the calendar: Easter Monday, the first Monday in August, Whit Monday and Boxing Day.

The first works outing was probably the one organized by the philanthropic Bradford mill owner Titus Salt in August 1849, when he chartered a train to take his workers to Bell Busk, a picturesque spot in the Yorkshire Dales. By the end of the 1850s many other industrialists, keen to advertise their benevolence, had followed his example. Though its popularity waned with the advent of longer paid leave and mass tourism after the Second World War, the custom persists to this day.

Many a works outing was ferried to its destination in a charabanc. The term originated in the 1840s, when rich French sportsmen would travel to the races or a shooting party in a *char à bancs*, a horse-drawn vehicle with bench seats on which all

the passengers sat facing forwards. By the early 20th century, motorized charabancs, usually open-topped, were in widespread use. Heath Robinson's Kinecar is a converted charabanc with all the passengers facing backwards, intent on the silent movie being shown on the screen, while a gramophone blares out music for their greater pleasure.

The invention of the internal combustion engine also led to the development of the caravan. Travellers had used horse-drawn caravans for millennia, but as car ownership became more widespread, many town dwellers were tempted by the potential of a mobile home. By the early 1920s, relatively cheap, mass-produced caravans were availiable, and the Caravan Club (founded in 1907) had more than 450 pitches throughout Great Britain and Ireland for its members' use. There is, of course, something quintessentially Heath Robinson about the very idea of cramming all the comforts and conveniences of home into a box on wheels, and he did not fail to rise to the challenge.

Robinson was a sociable man who enjoyed group outings, good beer and good cheer, and his affectionate depictions of collective merriment, whether on a London Underground train or a village green, are suffused with nostalgia for an innocent, less individualistic age.

An alpine touring party has a "narrow squeak" on a treacherous bend, saved by an elastic tyre and an obliging mountain goat.

A bicycle made for six provides an inexpensive family holiday, with catering facilities en suite.

"The Home-From-Home Caravan."

"The Kinecar is a luxurious vehicle fitted with many devices for the comfort and amusement of passengers returning home on winter evenings."

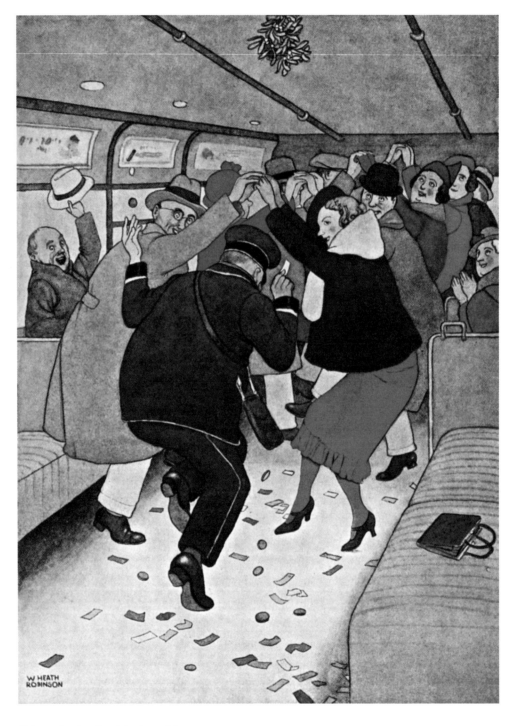

Christmas is a time for celebration, and these merry passengers
clearly think the Underground is as good a place as any for a
knees-up under the mistletoe.

In this nostalgic image of bygone rural revelry, farm workers
in smocks sup from tankards of ale while villagers of all ages
dance on the village green to the tune of assembled musicians.

THE WEEKEND
ALL-WEATHER TANDEM

Heath Robinson responded enthusiastically to a request from Hercules cycles to promote the advantages of the tandem. His full-page storyboard depicted a machine so splendidly equipped that it could transport and shelter a family of three on a camping weekend, come rain or come shine.

The Hercules Cycle and Motor Company was founded in September 1910 at Aston in Birmingham, and by the 1930s had become the world's biggest cycle manufacturer. To show off their products, the firm published elaborate catalogues that they called magazines, enlivened with articles and drawings. They published Heath Robinson's tandem story in an issue celebrating the great outdoors.

The firm was eventually swallowed up in the British Cycle Corporation in the 1960s, and that was the end of the Hercules name – but not of Heath Robinson's. His vision of the perfect picnic lives on, a period piece to be savoured to the last cup and saucer.

On the cover of a 1935 issue of their magazine Hercules promise the freedom of the countryside to young couples seeking escape from the strictness of the suburbs.

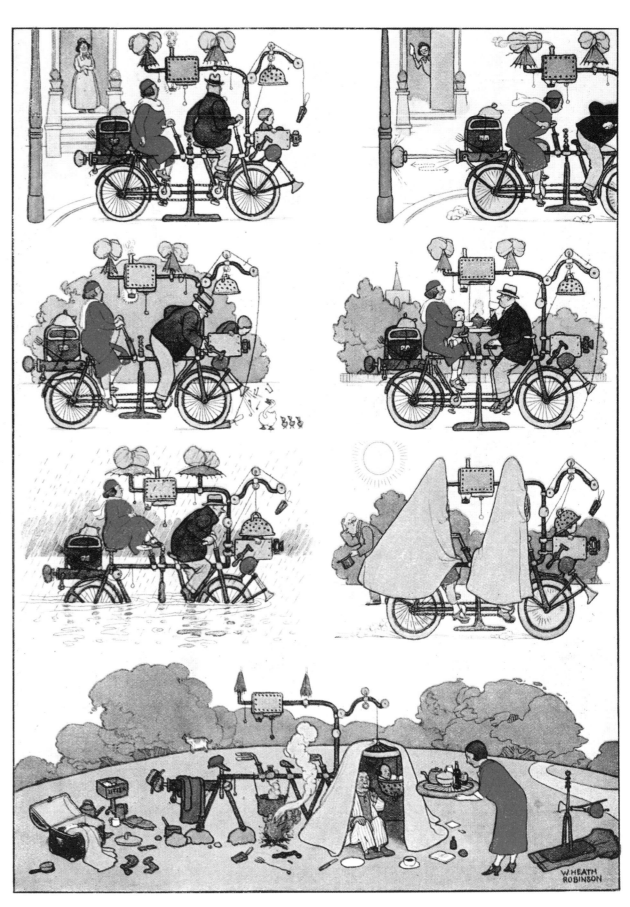

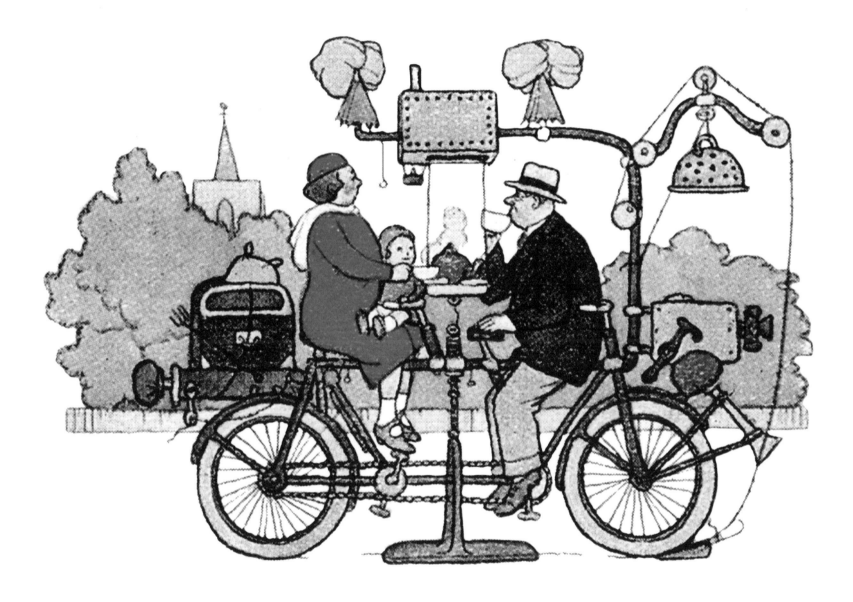

Life with a baby can still be fun on the all-weather weekend tandem, which converts into a tent with cooking facilities, drinking water, cradle and sleeping bags, not to mention tea service.

❝Whenever I see
an adult on a bicycle,
I do not despair for the
human race.❞
H. G. Wells

BESIDE THE SEASIDE

The Robinsons loved trips to the seaside. "As soon as the days grew longer, and summer was in the air, we began to look forward to our seaside holiday, which we usually spent at Ramsgate....The entertainments on the sands were of a simple character. We had no fun-fairs, great wheels, or other Blackpool thrills. We had no concert parties, but were sufficiently amused… by Punch and Judy. The photographer, too, was always busy with his little portable darkroom."

The seaside had long been associated with health as well as pleasure. The fresh air, sunshine and sea-water were all considered beneficial to the constitution. In his 1769 book *Domestic Medicine*, the Scottish doctor William Buchan recommended sea bathing, especially during winter – not for fun, but as a cure for various diseases. The lower the temperature, the more beneficial the effect. Since the book sold 80,000 copies he must have persuaded many people to try it. Heath Robinson was clearly less than enthusiastic, for his drawings show a range of tactics to avoid hypothermia. Others said that immersion in water caused lascivious thoughts, disgraceful behaviour and moral turpitude.

The idea that sea air was good for you became popular after the discovery of the gas ozone in 1839. When passing an electric current through water to separate the oxygen from the hydrogen, the German scientist Christian Friedrich Schönbein noticed a distinctive odour, identified the gas and named it ozone, from the Ancient Greek ὄξειν, to smell. Ozone turned out to be a powerful antiseptic, so it came to be associated with hospitals and doctors' surgeries. Since people thought they could catch a whiff of it at the seaside, they assumed that sea air had to be beneficial. In fact ozone is antiseptic because it is a deadly poison; one good breath and you'd be dead. Fortunately there is no ozone at the seaside; the characteristic smell is actually rotting seaweed. That did not deter the Victorians from developing seaside resorts all around the coastline, many of them equipped with piers so that people could walk out over the sea and breathe the healthy air.

Sometimes the Robinson children were sent to

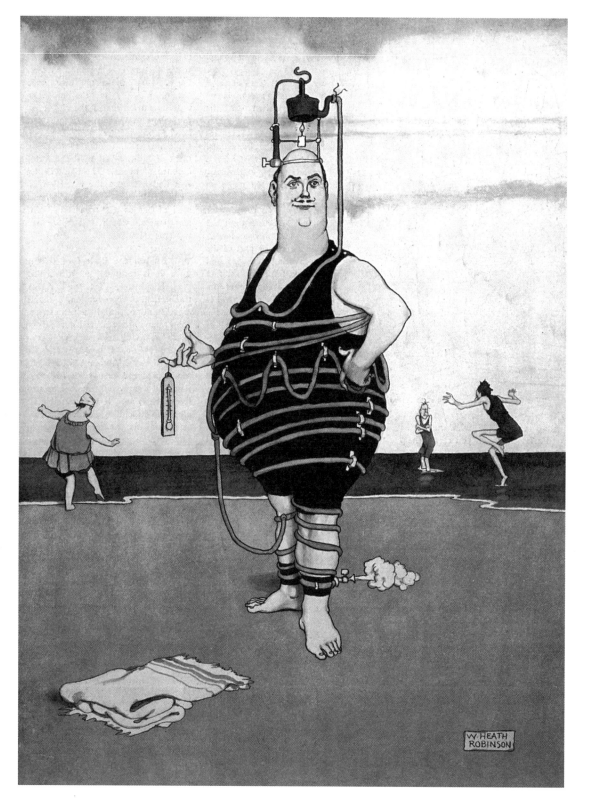

There is no need to fear bathing in chilly water with this centrally heated wet suit.

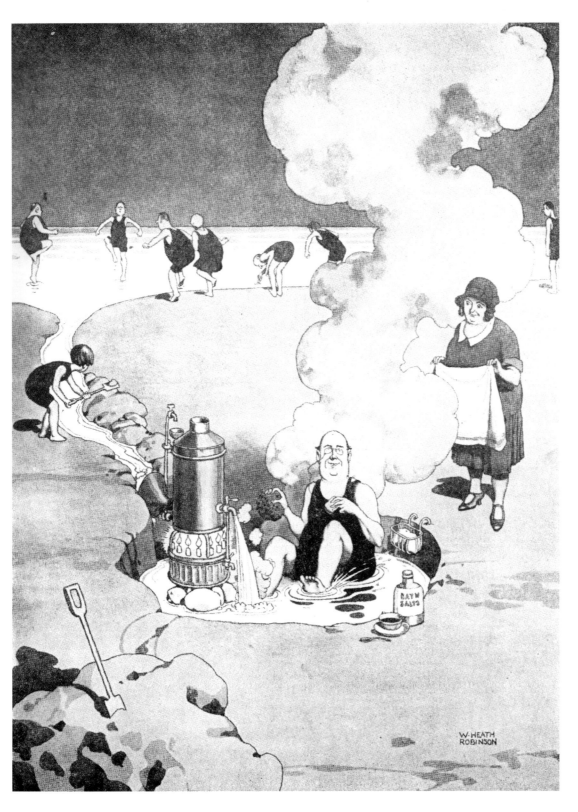

Heath Robinson's waterside geyser allows this bather to enjoy his own heated pool while others shiver.

stay with relatives in Brighton, usually out of season, and William had vivid memories of the pier. "We visited it whenever our pocket money allowed us to do so. Walking between the little kiosks at the bases of the great stanchions that supported the chains was like walking the deck of a ship."

Before the 20th century, exposure to sunlight was thought neither desirable nor beneficial. White people with dark skins were obviously labourers who worked in the fields. The upper classes were careful to keep their complexion pale; ladies even covered their faces with poisonous white lead to affirm their social position. Attitudes began to shift in the Industrial Revolution, when many workers moved out of the sun into factories or mines. In 1903 two medical developments drew attention to the benefits of sunlight. The Icelandic scientist Niels Finsen was awarded the Nobel Prize for the light therapy he used to cure rickets and *Lupus vulgaris*, and Auguste Rollier opened a "sunshine clinic" in the Alps for the treatment of tuberculosis.

In 1910 a scientific expedition to Tenerife extolled the benefits of "heliotherapy", and within a few years exposing your skin to those "actinic rays" – or "sunbathing" – became a respectable activity for the leisured classes. The final step came in 1920 when the fashionista Coco Chanel accidentally became sunburned on the French Riviera, and everyone admired her tanned look.

The new enthusiasm for sunbathing, scientific or otherwise, led to two further inventions: the deck chair and the skimpy swimsuit. There have been folding chairs for thousands of years, but the first mention of "deck chairs" came in the 1860s, when they were used on the decks of ocean liners. Passengers on P. & O. ships in the 1890s were encouraged to bring their own on board. Patents were taken out, including one for the "Hygienic", a rocking chair "valuable for those with sluggish and constipated bowels". Deck chairs are still popular today: in Blackpool in 2003, no fewer than 68,000 were rented out at £1.50 a day.

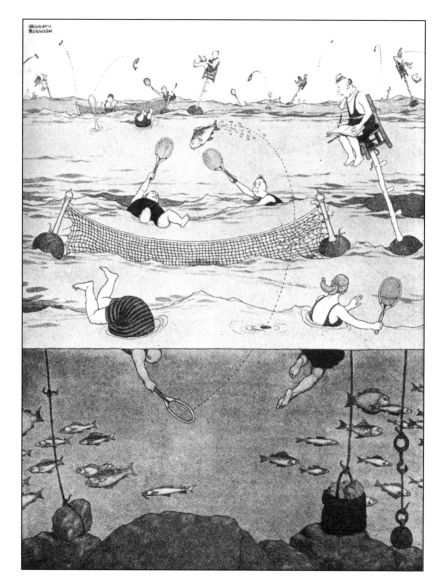

Game, set and splash! Aquatic tennis brings a whole new dimension to an already challenging sport.

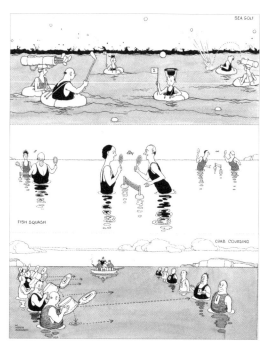

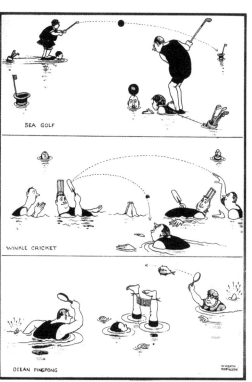

With a little ingenuity, any sport that can be played on land can be adapted to marine conditions (top and above).

" Ocean:
a body of water
occupying two-thirds
of a world made for man
– who has no gills. **"**

Ambrose Bierce,
The Devil's Dictionary, 1911

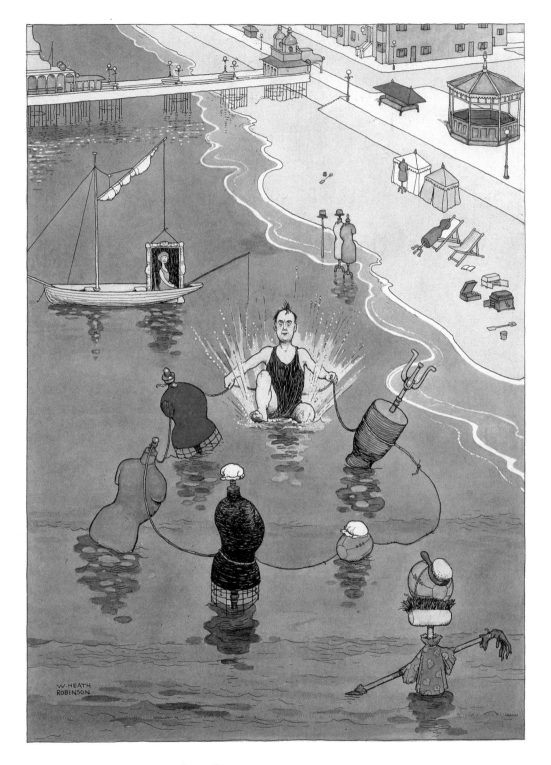

*The last man left at the seaside makes frantic efforts to amuse
himself and relieve his loneliness "by the simple and inexpensive
provision of a mixed insensitive audience".*

BATHING BELLES

"Gent.'s bathing-suit for evening wear."

In Victorian times men and women would rarely swim from the same beaches and women wore enormous, all-concealing bathing costumes. Bathing machines first appeared at Scarborough in 1736. These were wooden huts or canvas tents on wheels in which people could change out of their clothes. The machine could then be taken down to the water's edge so that the bathers could leap in without exposing themselves. Some machines even went right into the sea to allow the bathers to immerse themselves in total privacy. Queen Victoria had a bathing machine installed in 1846 at Osborne House on the Isle of Wight and used it the following year.

In 1907 the Australian swimmer Annette Kellermann was arrested on a beach in Boston for wearing a figure-hugging costume, even though it covered her from neck to ankle. Heath Robinson shows some women in cover-all outfits, but in other pictures has men and scantily-clad women cavorting together. Gradually, costumes became slighter, and some of Heath Robinson's later drawings show women in skinny one-piece outfits. The bikini was not "invented" until 1946, when the French designer Jacques Heim produced the "Atome", the smallest bathing suit in the world, whereupon his rival Louis Réard produced an even smaller one and – anticipating its explosive impact – named it the "Bikini" after Bikini Atoll, where the Americans had just tested the world's first hydrogen bomb.

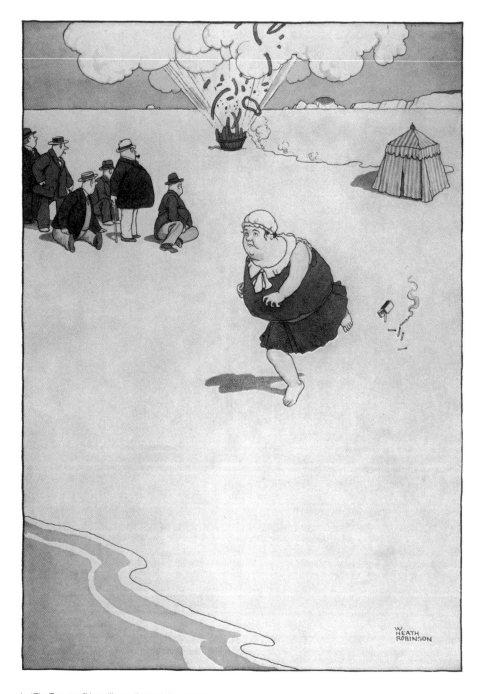

In "The Transit of Venus!" a well-timed distraction serves to divert attention and preserve a lady's modesty.

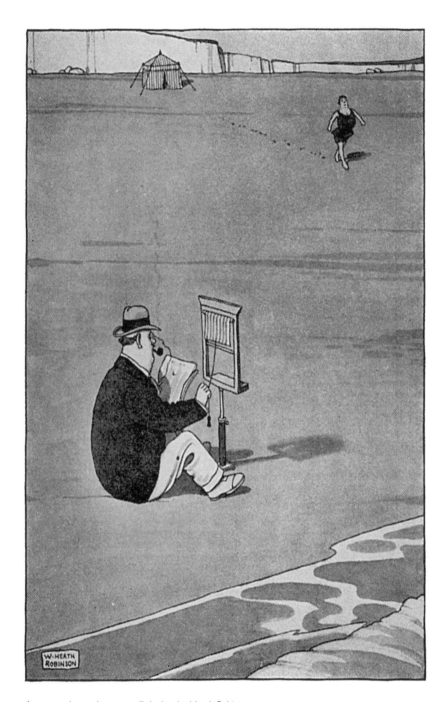

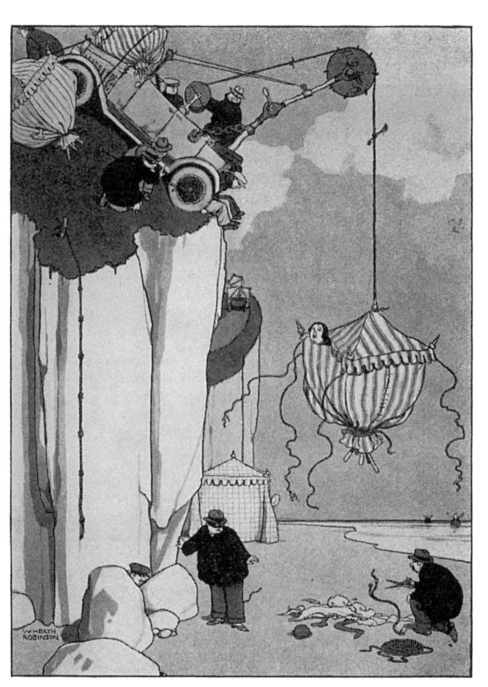

A true gentleman, however, will deploy the Heath Robinson modesty blind when a lady makes her way down the beach to the water.

A ruthless gang of motor bandits kidnap an unsuspecting bathing belle from the beach at Boulogne.

PRACTICAL PRECAUTIONS

While the seaside is a place of innocent delight for many, it is also fraught with dangers. Incoming tides may trap the unwary, currents can carry a swimmer out to sea and inexperienced oarsmen hiring a pleasure craft for the first time may find themselves in difficulty. With safety in mind, Heath Robinson devised an array of practical precautions. Wise gents contemplating a snooze will naturally take measures to avoid surprise immersion by the tide, chills can be averted by prompt and efficient drying, while quicksand can be avoided if one takes to the beach armed with the latest apparatus for testing the supporting power of the surface.

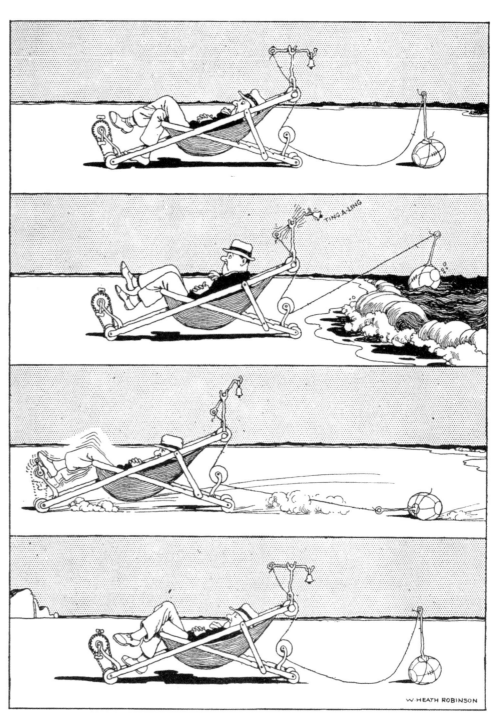

"High-tide."

This "Safety Deck Chair" will alert the somnolent holidaymaker to the approach of an incoming tide and provide the means of timely escape.

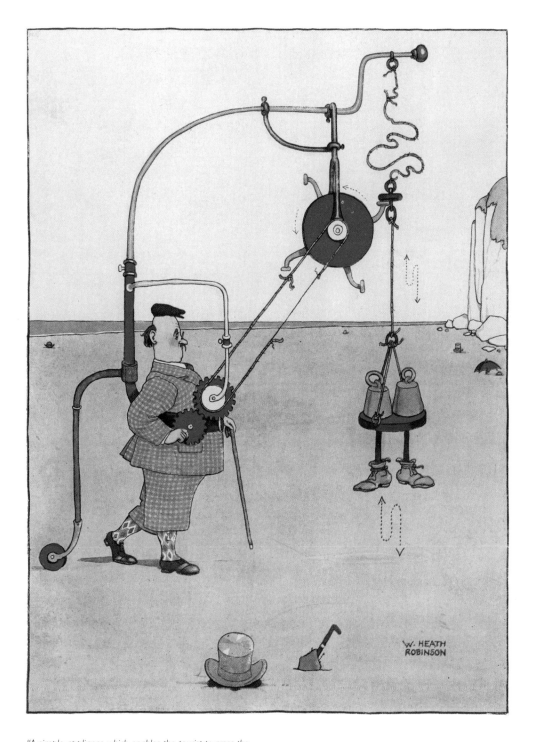

"A simple appliance which enables the tourist to cross the most treacherous quicksands with impunity."

66 We trooped down to the sands to start our campaign of pleasure, with our spades, pails, bathing drawers and towels. 99

Heath Robinson,
My Line of Life, 1938

*An intelligent precaution observed by this old lady in the Sound
of Mull leads to a happy outcome.*

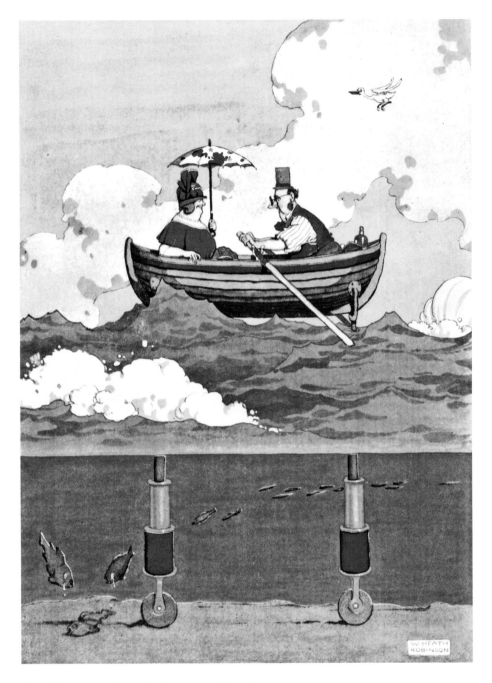

"One of Margate's new 'Neversink' pleasure boats for keeping
an even keel in the roughest seas."

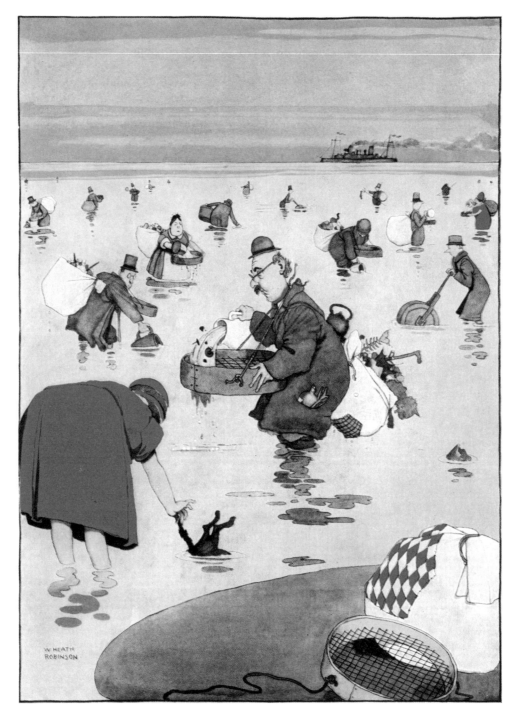

As part of "The Cleaner Bathing Movement", public-spirited
boarding-house owners carefully remove all impurities and
foreign bodies from the water for the convenience of bathers.

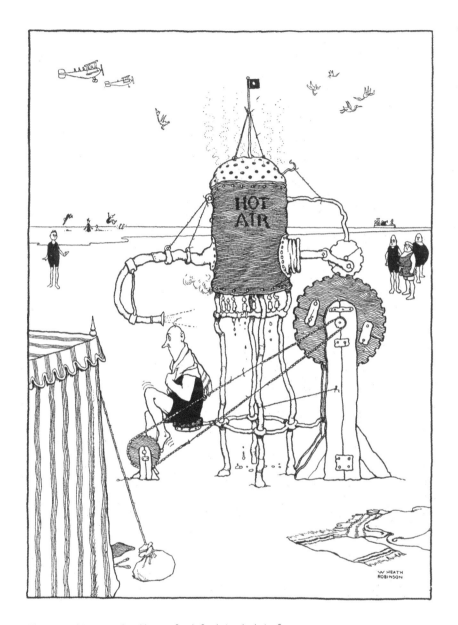

"A new machine erected on Margate Sands for drying the hair after bathing" is designed for *"the husband who wishes to retain esteem and his wife"*.

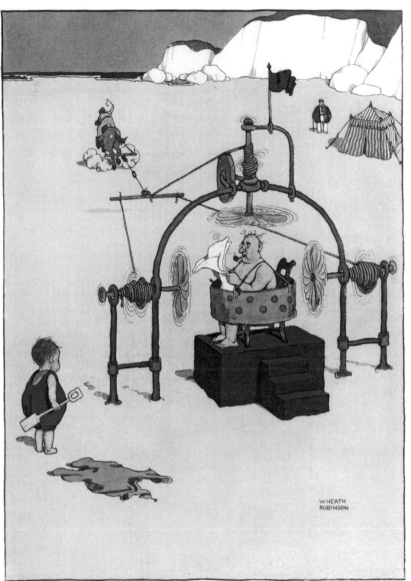

Horse-powered fans allow the bather to dry off quickly, conveniently and in comfort.

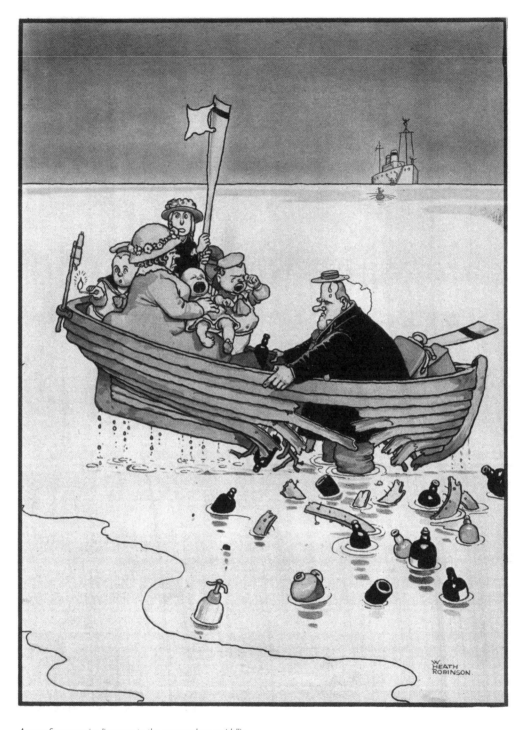

A crew from a cruise liner row to the rescue when an idyllic
boat trip comes to an unfortunate end.

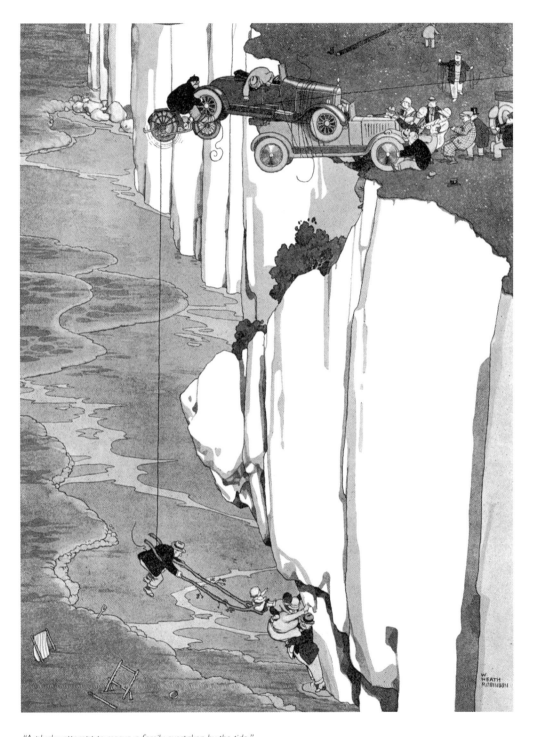

"A plucky attempt to rescue a family overtaken by the tide."

❝At the time these holidays seemed to be full of excitement... My brother Charles was nearly swallowed by a whale, and talked very much about it afterwards.❞

Heath Robinson,
My Line of Life, 1938

TRICKS OF THE CAMERA

Early cameras were large and cumbersome, and the emulsions so insensitive that the subject had to stay stock still for minutes if the result was not to be blurred. "It was difficult to stand still in front of the rickety tripod for so long," wrote Heath Robinson, recalling the photographers who plied the sands on early seaside holidays, "but it was wonderful to have your portrait taken on tin and framed in gold while you waited."

The introduction of "fast" roll film and the Folding Pocket Kodak camera of 1897 made an enormous difference. Suddenly snapshots were possible. To trip the shutter without jogging the camera, professional photographers used a remote shutter release, which became as much part of their stock in trade as crouching under a black hood. Squeezing a rubber bulb sent a burst of air along a tube to a small piston that operated the shutter. Having set up the shot, they could stand up and cajole their audience until the perfect "Kodak moment" arose.

The film may have been called "fast", but it could not cope with the limited light available indoors. To take a photograph of the Christmas lunch needed flash. The flashgun had not been invented; instead the photographer used a handful of "flash powder", which he ignited at the critical moment when the camera shutter was open. The resulting burst of light was enough to provide a clear image on the film.

In Heath Robinson's day flash powder was made by mixing three parts of potassium chlorate with

The Wellington and Ward brochure The Light Side of Photography *includes a genuine photographic print to show the results that can be obtained using the firm's film. "Examined under a magnifying glass," the brochure proudly proclaims, "it shows detail in every part."*

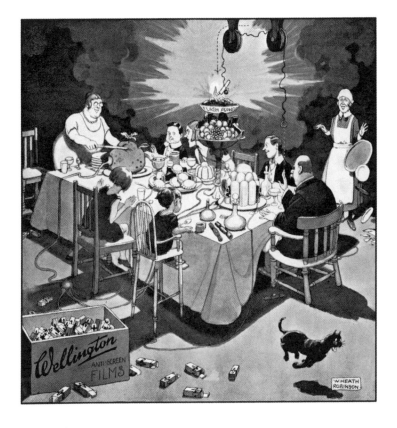

A new world of photographic possibilities is opened up by the remote shutter release. To capture that perfect Christmas moment, the camera and flash powder are triggered the moment the hostess cuts into the pudding, terrifying the parlour maid and the cat.

To obtain surreptitious snaps of the blushing bride, the guests have disguised remote shutter release air bulbs as fruit, incorporated in a policeman's helmet, hidden in handkerchiefs, under a hat, on the end of an umbrella or trailed by a dog.

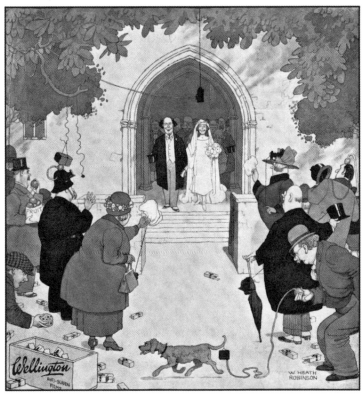

two parts of aluminium powder; today potassium perchlorate is used to provide the flash powder in theatrical pyrotechnics, fireworks and stun grenades, in which confinement of the flash powder means that it goes off with a loud bang as well as a bright flash of light.

Heath Robinson saw entertainment in all these developments, especially the remote shutter release. When he was approached to illustrate a brochure, *The Light Side of Photography*, for the film makers Wellington and Ward in 1925, he instantly grasped the light-hearted opportunities offered by the air bulb. Appealing to the growing number of amateur photographers, he sketched all kinds of novel scenes in which people could get close-ups of wild animals in complete safety, take photographs they really shouldn't and catch people unawares, all the while, of course, using innumerable rolls of film. He foretold the age of the candid camera decades before it happened.

The firm of Wellington was founded in the 1880s by George Eastman, owner of the Eastman Company, and John Wellington, an English photographer and scientist. Ward was added to the name in 1911 to acknowledge the role of the engineering partner. They manufactured an anti-screen film that overcame the need for a yellow filter over the camera lens to control what would otherwise have been excessive sensitivity to blue light. By 1930 both Wellington & Ward had vanished into the Ilford group, but the name of their commissioned artist lived on.

> **❝ There are no bad pictures; that's just how your face looks sometimes. ❞**
>
> Abraham Lincoln

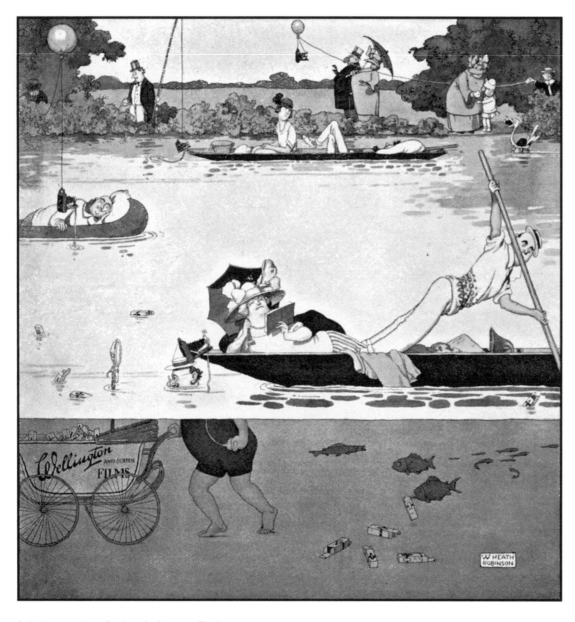

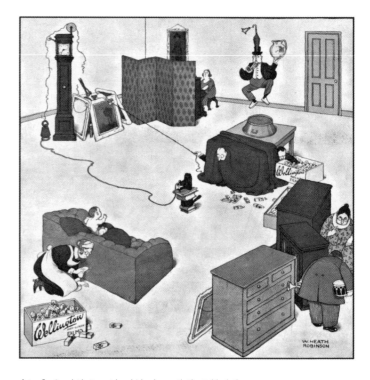

A professional photographer hides beneath the tablecloth
while the family resort to music and circus tricks in an attempt
to coax a smile from a fractious baby.

Intimate moments on the river, whether canoodling in punts,
napping in canoes or strolling on the bank, are all fair game
for the remotely equipped photographer.

To capture the perfect swing, a golfer prepares to strike the air
bulb on the end of the cable – evidently not for the first time.

SELF PHOTOGRAPHY

In this digital age of the point-and-shoot camera, it is easy to take attractive photographs regardless of the weather conditions. Multi-million-pixel resolution and automatic exposure and focusing bring high-quality images within reach of everyone. With front and back lenses selectable at will, you can easily hold a 'phone in one hand and take a self-portrait, or "selfie".

In Heath Robinson's day photography was not so simple. The family camera often had a fixed shutter speed of 1/125 second and a fixed aperture of f/11 or f/16, and films were slow. There was no point in trying to take a photograph in anything less than full sunshine or at worst "cloudy bright" conditions. Furthermore, if the sun was shining, it had to be behind the camera, since the lenses could not cope with flare.

The camera was increasingly part of the holiday paraphernalia of the middle classes, but even the popular folding models that often feature in Heath Robinson's drawings were far too clumsy and awkward to hold in one hand, so shooting a selfie was almost impossible without a mirror or a great deal of ingenuity.

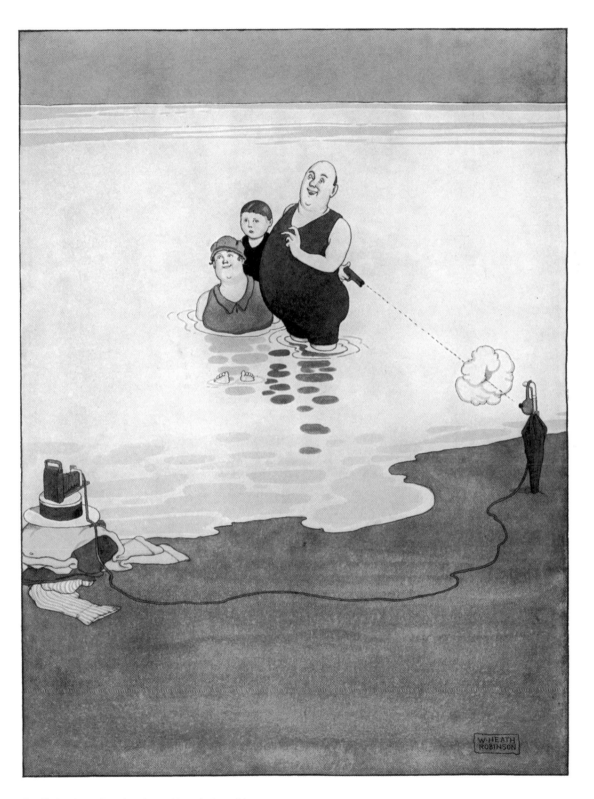

Careful planning and good marksmanship make it possible to take one's own photograph while bathing.

STUDIO SECRETS

The very first "moving pictures" were not moving at all, but a sequence of 12 still photographs, taken in California in 1872. The photographer was an Englishman, Edward Muggeridge, who chose to call himself Eadweard Muybridge because he thought it sounded better. Muybridge was hired to settle a bet for a rich American, Leland Stanford. The question was, "Does a galloping horse ever have all four hoofs off the ground at the same time?" The action is too fast and confusing to see by eye; so Stanford wanted photographic proof.

Muybridge arranged for the horse to gallop past a row of 12 cameras, 27 inches apart, facing across the track, and to fire each camera in turn with a trip-wire. Using a high shutter speed, the cameras delivered 12 sharp photographs, and Muybridge was able to show that at one point in its stride the horse did indeed have all four hoofs clear of the ground. He went on to produce many more such sequences of motion, including people walking and men playing cricket.

Even today, cinematographic "film" comprises a sequence of still pictures, shown one after the other quickly enough – 24 frames per second – to deceive the eye into believing the pictures are moving, but the technology has moved a long way since 1872. During the 1880s and 1890s inventors in several countries experimented with a variety of systems for taking and projecting moving pictures. These pioneers included the Lumière brothers in France, Thomas Edison in America and a Frenchman, Louis Le Prince, working in Yorkshire. Le Prince showed a short film of the traffic on Leeds Bridge in October 1888. He then went to France on business, visited his brother in Dijon and on 16th September 1890 boarded a train bound for Paris. He was never seen again. Some conspiracy theories even blamed Edison for his disappearance.

Muybridge's pictures were taken of a well-trained racehorse. Wildlife photography is much more difficult. Wild animals and birds are almost always shy, and especially afraid of people; so getting close to take good photographs or film them is tricky. The best-known

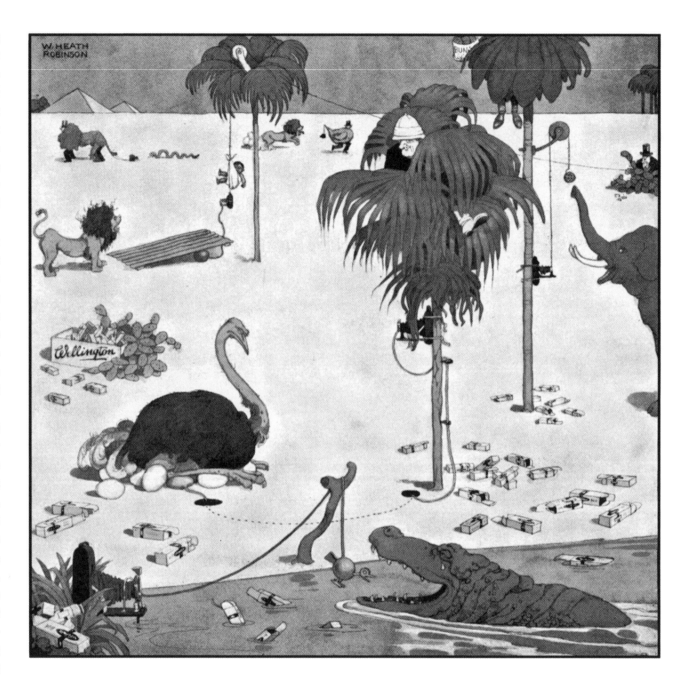

Heath Robinson devises a range of cunning devices to trigger photographs of elusive or dangerous animals in the wild.

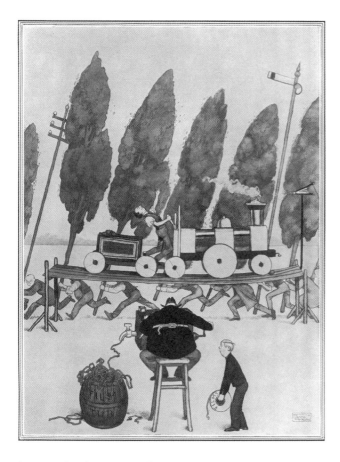

Borne by a fleet-footed crew, conifers, telegraph poles and signals fly past the "runaway express" in a scene from The Girl Who Slipped at the Siding.

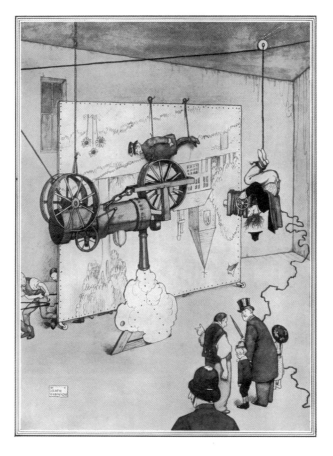

A cinematic ruse is employed to film a nasty accident involving a bishop and a steamroller without endangering the actor.

> ❝ Drama is life with the dull bits cut out. ❞
>
> Alfred Hitchcock

Anticipating Jacques Cousteau, Heath Robinson pioneers the underwater filming of marine life.

pioneers of wildlife photography were the brothers Richard and Cherry Kearton, who lived in the beautiful Yorkshire valley of Swaledale. They used an ox skin to hide from their quarry, with a camera pointing out through a hole in the head. Heath Robinson clearly grasped this difficulty and devised various stratagems for overcoming it, including a steam-powered motor drive, unlikely camouflage outfits and upside-down filming.

Following the pioneers, a stream of film-makers began producing short movies. Early 20th-century films included James Williamson's one-minute film *The Big Swallow* (1901), about a man so annoyed by the filming that he swallows the photographer and the camera, and Georges Méliès's 15-minute epic *A Trip to the Moon* (1902), inspired by the books of Jules Verne.

In 1906 George Tait produced *The Story of the Kelly Gang*, which was shot in Melbourne, Australia, and ran for an hour; this was the first multi-reel film. French and Italian films became the most successful until the industry was abruptly stopped by the First World War, after which Hollywood emerged supreme.

Until 1927 all movies were silent, but in that year Warner's produced *The Jazz Singer*, which had some synchronized speech and singing. Within a couple of years all Hollywood movies were "talkies", and this was really the golden age of cinema.

In 1927 Alfred Hitchcock produced his first thriller, *The Lodger: a Story of London Fog,* which was silent; then in 1929 he made the talkie *Blackmail* at Elstree Studios in England.

Film watchers have always been surprised and delighted by special effects, from the execution of Mary, Queen of Scots in 1895 to the fantastic tricks in *Star Wars* and other such movies today. The father of special effects was Georges Méliès, who used stopped action, double exposure, slow motion and many other tricks to amaze his viewers.

These special effects may well have inspired Heath Robinson's interest in studio filming, and he was intrigued at how cinematographers used extraordinary tricks to present what would appear to be reality when shown on the screen.

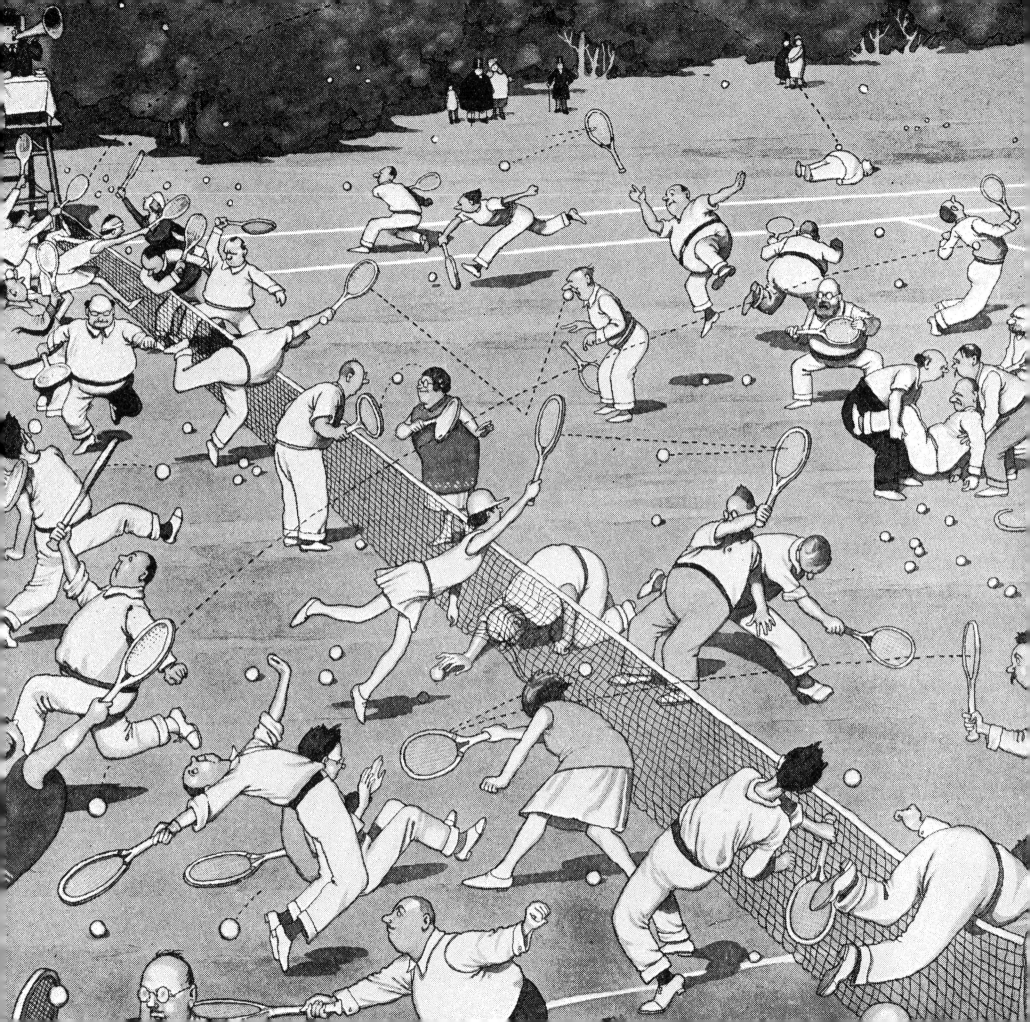

CHAPTER 4

FOR INSATIABLE SPORT LOVERS

"A cleverly conceived contrivance for scaring cuckoos away from golf courses."

Typically irreverent in his approach, Heath Robinson devises a way to inject team spirit into the ancient sport of tennis.

Many of the sports and games we enjoy today have long histories, but were formalized in the late 19th century. Around 2,300 years ago Chinese soldiers played a game called Tsu' Chu, trying to kick a stuffed leather ball into the enemy net. Ancient Egyptians and Greeks had similar sports. In England the first written mention of the game appeared around 1170, but it was later banned by Edward II, who thought it distracted young men from their compulsory archery practice. The magic word first appeared in 1409, when Henry IV banned gambling on "foteball".

The rules of the modern game, however, were not laid down until 26th October 1863, when the Football Association (hence the name "soccer") was founded at the Freemasons' Tavern in London. The F. A. introduced the offside rule in 1866; the first person to be ruled offside was C. W. Alcock on 31st March that year.

The Rugby Football Union was formed in 1871, and the Northern Rugby Football League split off after an argument in 1895 about payment of the players. The N. R. F. L. became the Rugby Football League in 1922. Rugby Union is played with teams of 15; Rugby League with teams of 13.

Test cricket was first played in 1877, although various forms of the game had been enjoyed on village greens all over England for at least 300 years. Lawn tennis was invented in 1874, while the rules of golf had been drawn up more than a century earlier.

When the Second Boer War began in 1899 between the British Empire and the two independent Boer republics, the Orange Free State and the Transvaal, Colonel Robert Baden Powell, of the British Army, was appalled at the lack of physical fitness among his recruits. He decided to do something about it. In 1908 he wrote a book called *Scouting for Boys,* which encouraged young lads to take up camping, hiking and

sport. The beginning of the Scout movement in the U. K., it also heralded a series of keep-fit campaigns. From about 1910 both men and women began lifting weights, riding exercise bikes and performing stretches. In 1929 Nora Reed started The Keep Fit Adventure – a programme of exercises to music that eventually became the Keep Fit Association. In 1930 Mary Bagot-Stack founded the Women's League of Health and Beauty.

In Heath Robinson's drawings the majority of the men – and some of the women – look rather like those Boer War recruits: in dire need of physical exercise. He himself was not an enthusiast. "I tried hard to be interested in the sport of the school," he recalled, "perhaps not very successfully.... Nevertheless, when I was a boy of about nine years of age I had a sporting triumph upon which I have secretly lived ever since.

"My over-arm bowling was never my strong point... so I tried some skilful underhand work... and saved the game for my side. The unsportsmanlike way in which our opponents took their defeat was very disappointing. They made no attempt to contain their rage. They called the balls I had bowled 'Sneaks', and me much worse than that."

Although never an athlete himself, aside from his walking, Heath Robinson found a rich vein of humour in sport, which formed the subject of many of his most amusing drawings. Ever alert to the comic potential of people taking themselves too seriously, he had a keen eye for the idiosyncrasies of a range of sports from golf to skiing. Sometimes he made fun of people playing games, or of the games themselves; at other times he devised gadgets to improve performance; and he took a particular delight in rendering games more complicated by introducing additional obstacles and handicaps, or by combining two or more apparently incompatible sports.

EYE ON THE BALL

As an observer of human foibles, Heath Robinson was fascinated by the rituals surrounding sport – and none is more steeped in tradition and formality than tennis.

Royal (or real) tennis began in France around the 16th century. The name is thought to derive from *tenez*, a warning to be ready for the serve. The game became popular in England during the reign of Henry V, but was championed by Henry VIII, who built a court at Hampton Court Palace and played enthusiastically. The royal tennis court is rather like a squash court, with high walls on three sides and a sloping penthouse. The serve has to bounce off the roof on the left before touching a marked area of the floor. The balls are of heavy, cloth-covered cork, and not very bouncy, and the rackets look as though they have been bent sideways. There are 43 courts in the world today, most of which are in Great Britain.

The game of lawn tennis, and all the thousands of tennis tournaments around the world, were made possible by the advent of two important inventions: Edwin Beard Budding's mowing machine in 1830, and the vulcanization of rubber by Charles Goodyear in 1844. The mowing machine allowed anyone to make a smooth surface with grass cut uniformly short, and vulcanized rubber enabled the production of bouncy balls.

Inspired by a jolly house party he had attended in Wales, a retired major called Walter Clopton Wingfield saw the potential of these developments and invented a brand new sport. In 1874 he obtained a patent for the game of Σφαιριστικη (Sphairistike) or lawn tennis. He clearly thought it would do better with a fancy Greek name. He sold five-guinea boxed sets which contained two rackets, balls, nets (with

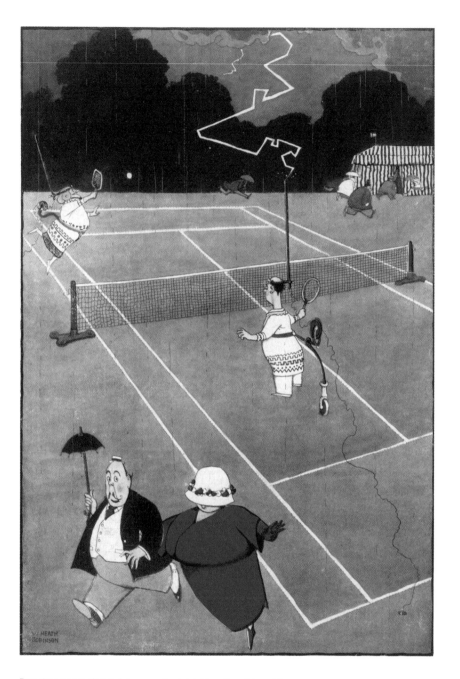

Even the severest electrical storm need not stop play where this mobile lightning conductor is in use.

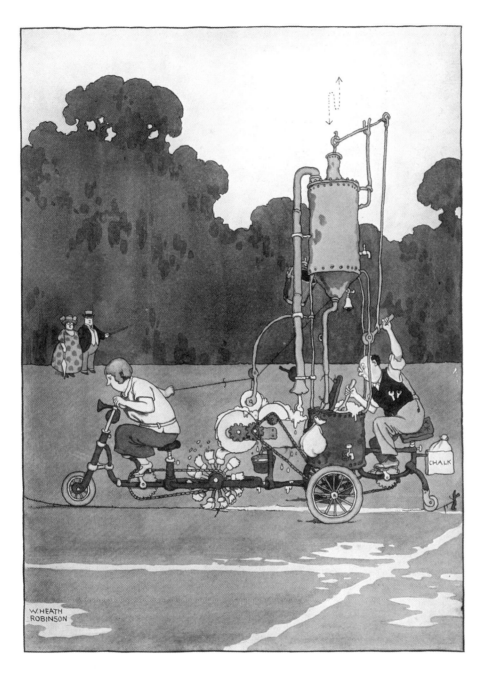

Requiring just two people to operate, this automated lawn marker is a boon to any tennis club.

poles to hold them up) both for the centre and for the back, to stop the balls going too far, and a booklet of instructions and rules dedicated "To the party assembled at Nantclwyd Hall in December 1873". Within a year he sold 1,500 sets, and the game quickly became an important addition to cricket at Lord's, home of the Marylebone Cricket Club (M. C. C.).

In 1877 the All England Croquet Club changed its name to the All England Croquet and Lawn Tennis Club (A. E. C. L. T. C.), and devised a new and comprehensive set of rules for lawn tennis. That year they also launched the first Wimbledon tournament in order to raise money for the repair of their pony-drawn roller. The Wingfield Restaurant at Wimbledon is named after Walter Clopton.

One of Wingfield's officers took a boxed set to Bermuda in 1874, where it was bought by a young American called Mary Ewing Outerbridge. Back home in New York, she played the first American game against her sister Laura, and set up a court at the Staten Island Cricket and Baseball Club (under what is now the Staten Island Ferry Terminal), thus introducing lawn tennis to the United States.

In 1898 the Harvard University tennis star Dwight Davis organized a tournament in which an American team could challenge a British team. The first match was held at Boston in 1900. After his death in 1946, the event was named The Davis Cup in his honour.

The Wimbledon championships were suspended during the First World War, but after 1920 tennis took off as a popular sport. The French star Suzanne Lenglen, who won the women's title six times, played in short skirts without a corset, which

raised eyebrows but introduced a profound change in women's fashions both on and off the court. Men's kit also became less formal; the first man to exchange long trousers for shorts at Wimbledon was Henry Wilfred "Bunny" Austin in 1932, when he reached the final of the men's singles. The brightest star in British tennis was Fred Perry, who won the men's singles in 1934, 1935 and 1936. These great players were the major reason why tennis became so popular between the wars.

Strawberries and cream have been a part of tennis for centuries; apparently Henry VIII served them to his guests when he played real tennis at Hampton Court. According to legend they were introduced at Wimbledon by George V in the early 1900s, and have been a feature ever since. Perhaps such frivolity persuaded Heath Robinson that Wimbledon was just one big funfair. He clearly thought tennis was too staid and simple a game, and needed some enlivenment, though I doubt that even Walter Clopton Wingfield would ever have dreamed of multi-tennis for his house parties.

" Civilization has tended
to complicate and
obscure innocent fun
and games."

W. Heath Robinson and Cecil Hunt,
How to Run a Communal Home, 1943

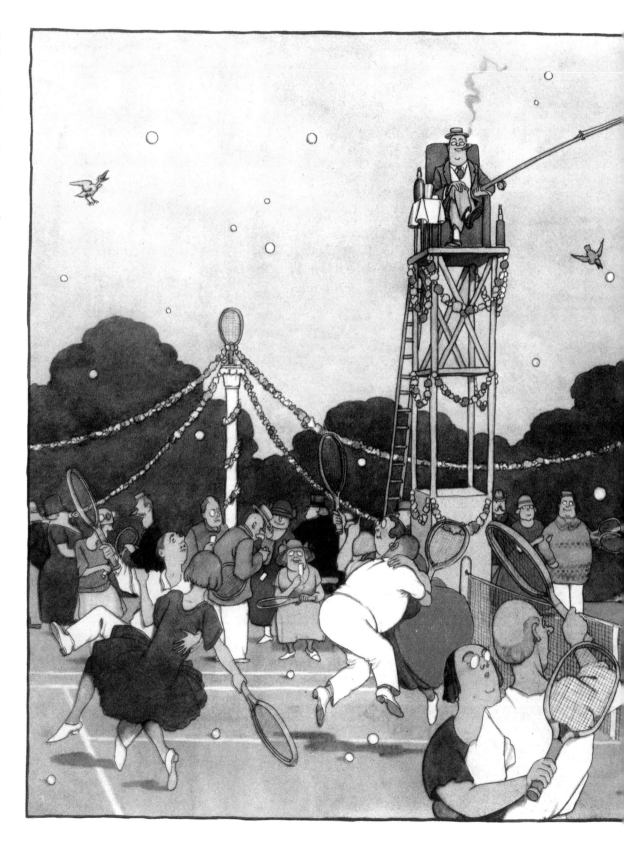

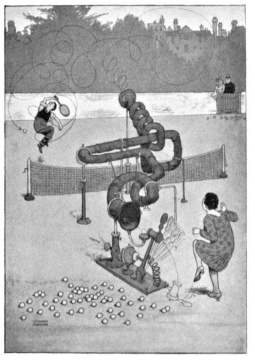

"The Wimbledon Serving Tube" allows players
to perfect their response to the most difficult service.

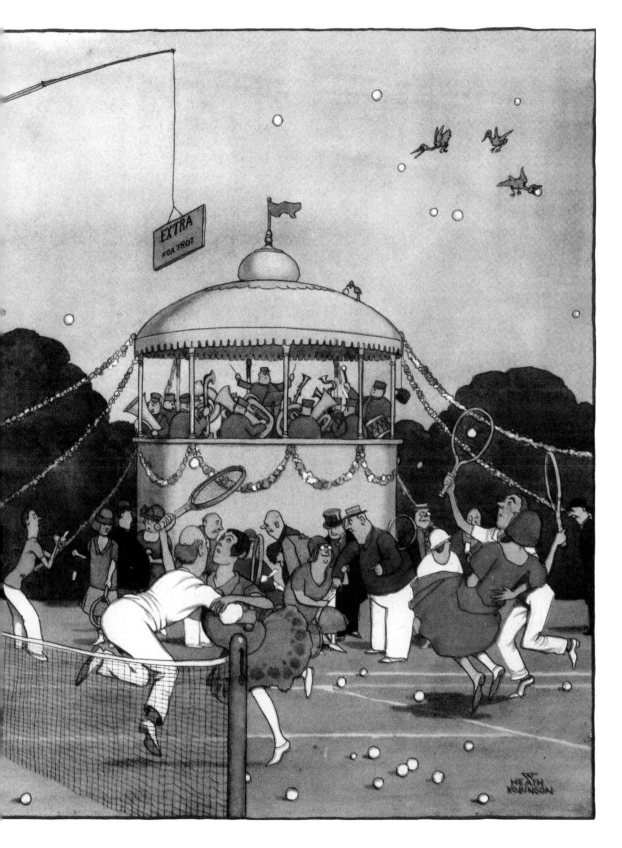

The new craze of Jazz Tennis is caught in full swing
as players dance the foxtrot while the umpire enjoys
a cigar.

FAST AND
SLOW CRICKET

When I was 11 or 12 years old we used to play during school breaks a game with the bizarre name Hot Rice. A single cricket stump was put in the ground as a wicket, and the batsman had to defend it using another stump as a bat, while all around the others would catch the ball and throw it at the wicket as hard as they could. Luckily it was a tennis ball, so serious injuries were rare, but the batsman had to be both skilful and agile to keep the ball away from himself and the wicket.

In the game of beach cricket envisaged by Heath Robinson, there are two batsmen and many balls in play at once, with about ten bowlers, but as in Hot Rice they are defending a wicket from multi-directional attack. This bewildering cricket match has some similarities with a game called Wogle that Robinson played at school. "The wickets," he recalled, "were two circles marked on the road about twelve feet apart... [and] defended with sticks."

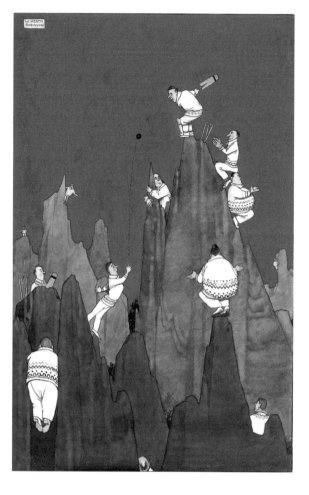

With his characteristic flair for innovation, Heath Robinson saw that the appeal of cricket could be broadened enormously. Why should it be confined to the flat, featureless lowlands when a game played on the Alpine peaks would have such dramatic potential?

For winter evenings, Heath Robinson devised an indoor game of "pill-and-spoon cricket" (top left). For players of middle years, he came up with a sedentary version of the sport (above left), while players craving more excitement could deploy motorcycles and artillery (left).

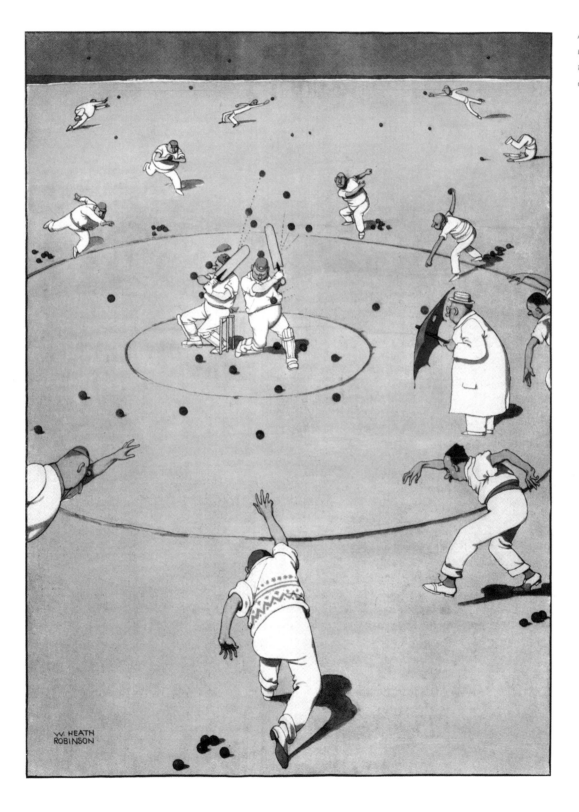

A circular pitch with a single wicket and multiple bowlers keeps the batsmen on their toes and avoids the longuers of the classical game.

66 My over-arm bowling was never my strong point. The ball was liable to take an erratic and dangerous course. 99

W. Heath Robinson,
My Line of Life, 1938

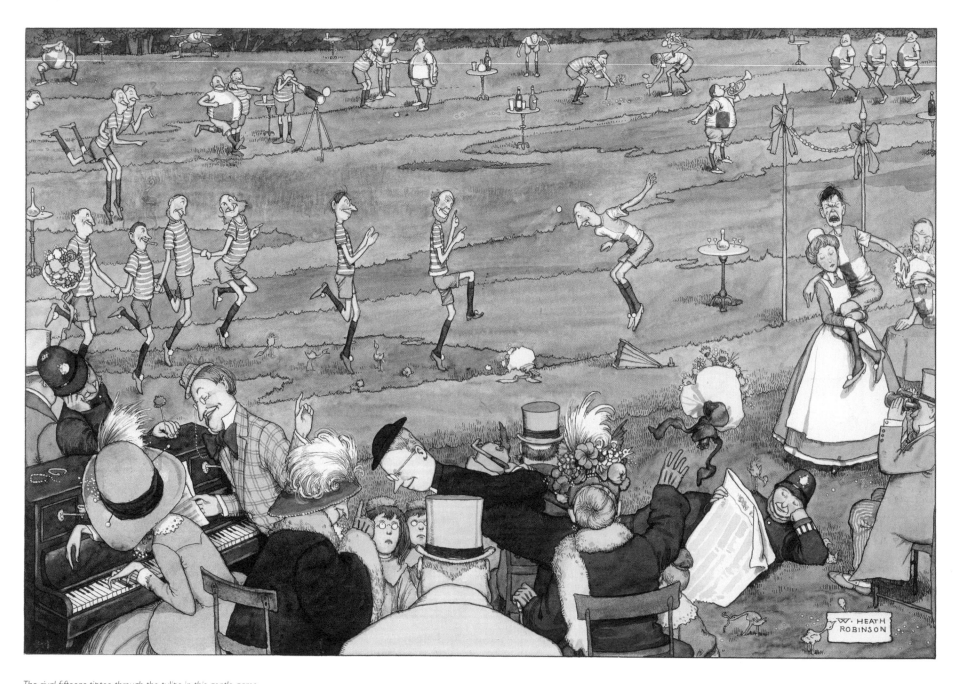

The rival fifteens tiptoe through the tulips in this gentle game of rugby played in the botanical gardens.

" Rugby is a hooligans' game played by gentlemen.**"**

Winston Churchill

IN AND OUT
OF THE SCRUM

Rugger, according to legend, began when William Webb Ellis, a pupil at Rugby School in England, chose to ignore the rules of football (the game he was supposed to be playing at the time), picked up the ball and ran with it to the opponents' goal line. This was in 1823, and by the 1850s Rugby School Football was becoming popular throughout the U. K.

The game is usually played at schools or by fit young adult men and women (although not together), and has a somewhat macho and violent image. Heath Robinson had other ideas, and seemed to think the sport should be open to people of all shapes, sizes and persuasions.

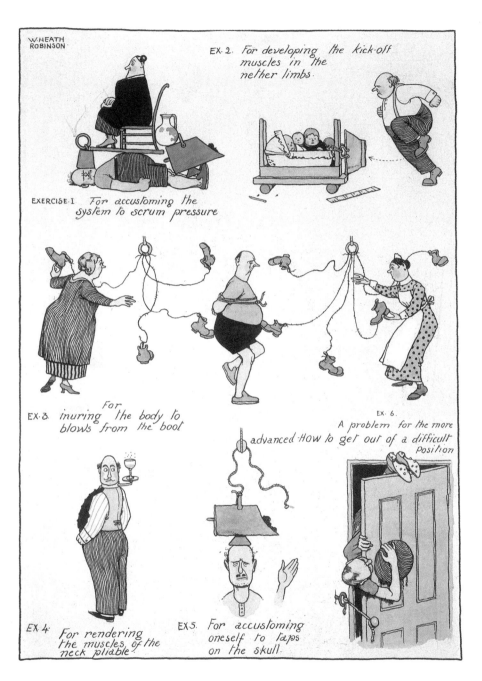

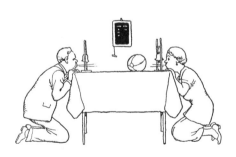

"The new game of blow-rugby."

Rugger is a notoriously challenging sport, so Heath Robinson devised this short course of training for the novice.

THE HUMOURS
OF GOLF

Although Heath Robinson did not play golf himself, the game featured in many of his illustrations for *The Bystander* and other magazines. In 1923, 50 of his golf drawings were collected in a book entitled *Humours of Golf* and published by Methuen, with an introduction by the golf writer Bernard Darwin. Although most of them show absurd devices and events, they are all close enough to reality to suggest that he witnessed some of the joys and horrors of the game.

This enormously popular sport is widely believed to have started in Scotland; many golfers accept that the home of golf is the Royal and Ancient Golf Club of St. Andrews. The Leith Rules, or more precisely Articles and Laws in Playing at Golf, were written for the Honourable Company of Edinburgh Golfers in 1744, and form the basis of today's laws.

In his diary for 20th January 1687, a Scottish medical student called Thomas Kincaid noted, "I found that the only way of playing at the Golve is to stand… bending your legs a little and holding the muscles of your legs and back and armes exceeding bent or fixt or stiffe and not at all slackning them in the time you are bringing down the stroak."

The countries with most golf courses per person are Scotland, New Zealand, Australia, Ireland, Canada, Wales, the United States, Sweden and England, but half the courses are in the United States, where there are some 20 million casual and 5 million serious players.

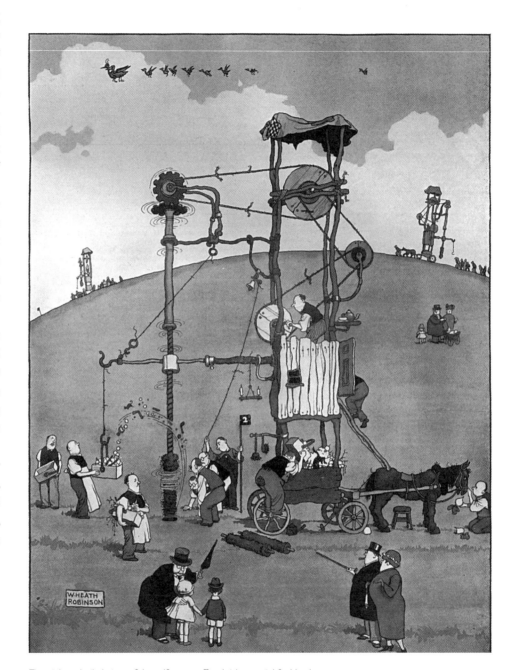

The trials and tribulations of the golf course offered rich material for Heath Robinson's imagination. He designed this "Screw-Em-Out Golf Hole Cleaner" to remove balls and other debris from the holes.

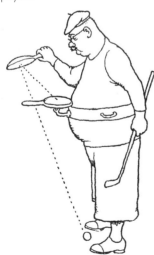

"Locating mirrors for locating the hidden ball."

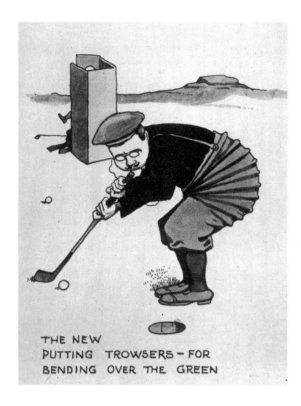

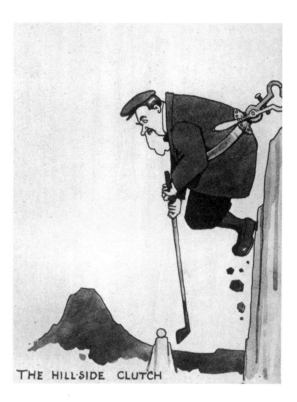

Among Heath Robinson's inventive innovations was this pair of concertina trousers for putting.

This safety harness allows the intrepid golfer to take those tricky hillside strokes without risk of accident.

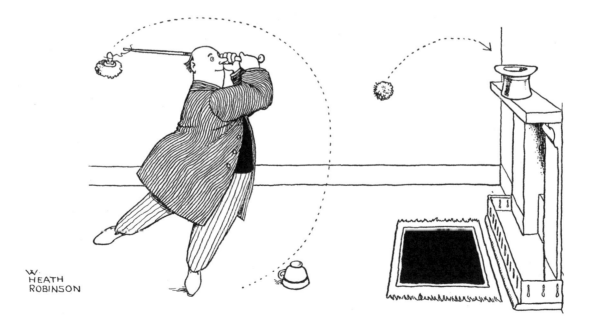

The novice, meanwhile, could practise harmlessly in the drawing room.

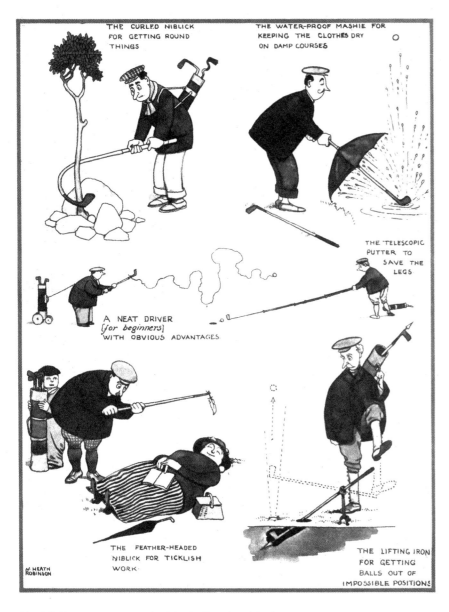

Heath Robinson saw no reason why clubs should not be adapted
to serve a wide range of purposes.

"Strange things that don't happen in golf."

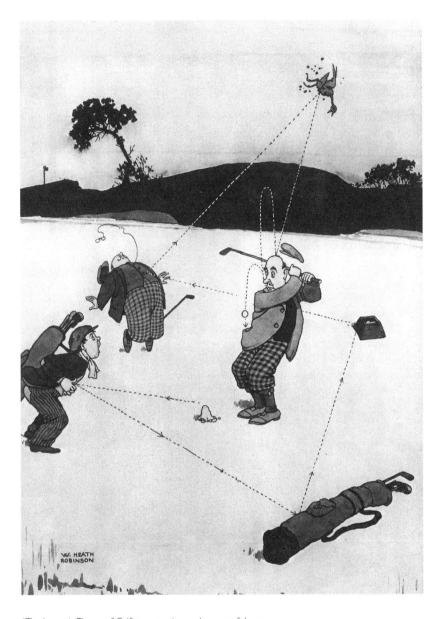

"The Ironstein Theory of Golf: a competitor makes one of those
fancy drives that are so bewildering to the ordinary member
of a golf club." Albert Einstein's theories of relativity were
a source of general bewilderment at the time.

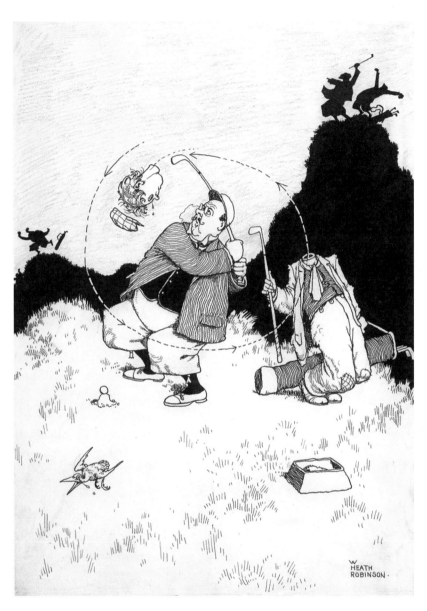

"An unfortunate back-hander at St. Andrews."


“ Championship
golf can be
learned in the
airing cupboard.”

W. Heath Robinson and Cecil Hunt,
How to Run a Communal Home, 1943


MAKING A SPLASH

In south-western Egypt, near the Libyan border, there is a cave with pictures of people swimming the breast stroke, or perhaps doggy paddle. These rock paintings are 10,000 years old; at the time there were trees, fresh-water lakes and pools to swim in, rather than endless desert. Drawings elsewhere in the ancient world show swimmers 4,500 years ago, and the palace at Mohenjo Daro, now in Pakistan, has a 39-by 23-foot swimming pool.

Leonardo da Vinci sketched a lifebelt, and in 1539 a German linguist called Nicolas Wynman produced the first how-to-swim book, which he called *Colymbetes* ("Water Beetles"). A detailed instruction manual with woodcut illustrations, *De Arte Natandi*, was written in 1587 by Everard Digby.

Many more books followed, in various languages, but one of the most useful was Guts

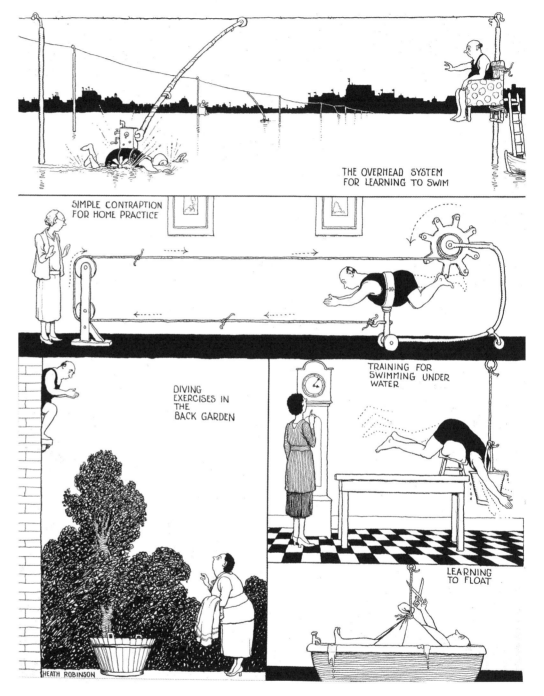

THE OVERHEAD SYSTEM FOR LEARNING TO SWIM

SIMPLE CONTRAPTION FOR HOME PRACTICE

TRAINING FOR SWIMMING UNDER WATER

DIVING EXERCISES IN THE BACK GARDEN

LEARNING TO FLOAT

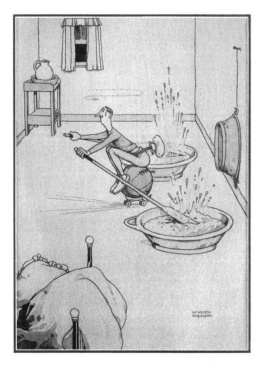

A keen oarsman practises his stroke in the privacy and convenience of his bedroom.

Heath Robinson believed in offering the novice swimmer every assistance, and devised a wide range of training equipment for the purpose. He saw no reason why those without ready access to a pool should not be able to practise watersports at home.

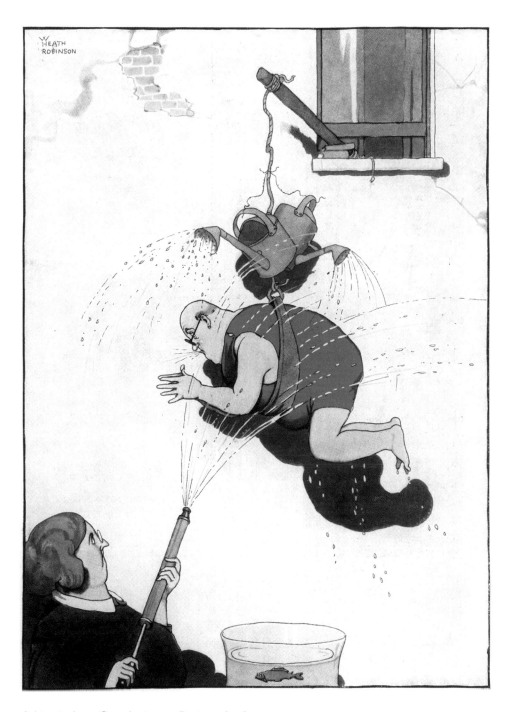

A determined cross-Channel swimmer will go to any lengths to simulate prolonged immersion at home.

Muts's *Kleines Lehrbuch der Schwimmkunst zum Selbstunterricht* (Small Book of the Art of Swimming for Self-Study), published in 1789. Muts proposed three stages in teaching people to swim. First get them used to the water. Second practise swimming movements out of the water. Third practise them in the water. Many of Heath Robinson's ideas run in parallel with those of Muts, particularly the "fishing-rod" method of supporting novices.

Swimming became a popular competitive sport in England in the 1830s; by 1837 the National Swimming Society was holding competitions in six London pools. The British swimmers all used breast stroke, and were horrified when in 1844 a Native American swimmer, Flying Gulf, scooped a medal by swimming 130 feet in 30 seconds using a different stroke. According to *The Times,* his action comprised an unrefined windmill-like motion of the arms and unregulated kicking of the legs, but the front crawl was here to stay.

Diving into the water from the edge of the pool, from a rock or from a diving board has always been tempting and spectacular. The first diving competition in the U. K. was held in 1871, when competitors dived

"The joys of bathing at home."

from London Bridge into the Thames. The bridge, built by John Rennie, was of stone arches, and by Heath Robinson's day was sinking into the river bed; so in 1968 it was sold for $2.5 million to an American entrepreneur, Robert McCulloch, who had it shipped, block by block, to Arizona via the Panama Canal.

For Heath Robinson, any sport that could be played on land should clearly be playable on water, so he devised fish squash, sea golf and winkle cricket among other delights, but he also had plenty of popular water sports to choose from. A brutal game called water rugby developed into water polo in England in the 1870s and became an Olympic sport in 1900. Fishermen have been snorkelling for centuries; the Roman writer Pliny the Elder mentioned snorkelling two thousand years ago, and Leonardo da Vinci designed a high-tech snorkel in the 16th century. Surfing was all the rage in Hawaii in the 19th century, and became popular in California in the 1920s.

Another water sport that caught Heath Robinson's imagination was cross-Channel swimming. The first person to swim the English Channel was Captain Matthew Webb, at his second attempt, in 1875. Using breast stroke, he reached France in just under 22 hours, in spite of being stung by a jellyfish. No one else managed it for 36 years, although there were 80 attempts. The distance from Dover to Cap Gris Nez is only 22 miles, but the tides mean that a swimmer often

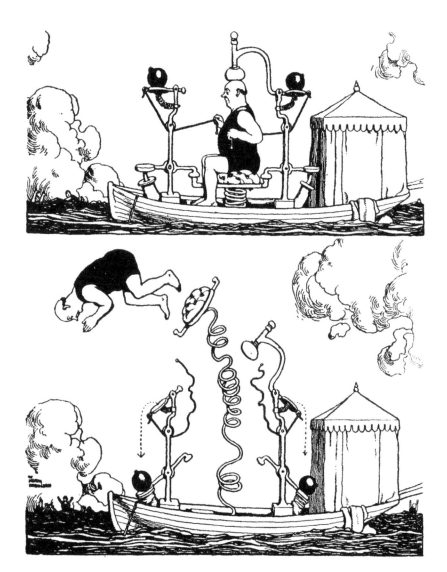

Nervous or inexperienced swimmers could take comfort from an array of ingenious aids: a large fish to provide submarine support (left) and a diving boat to launch reluctant bathers into the water (above).

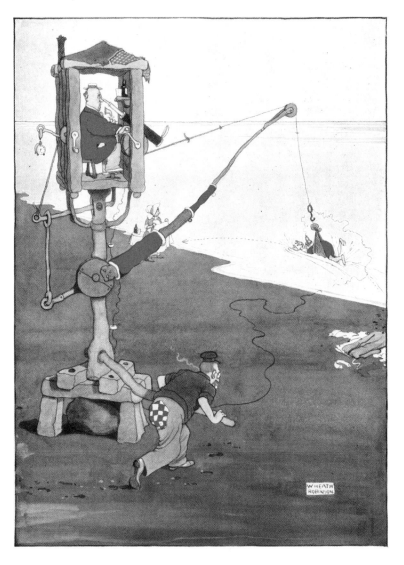

"The new Heath Robinson Swimming Post,
which is acquiring such popularity at our most
fashionable coast resorts."

has to cover twice that distance. Shivering vicariously for these intrepid adventurers, Heath Robinson came up with all sorts of helpful suggestions such as buoyancy aids and support balloons laden with supplies.

The fastest Channel swims so far are six hours 55 minutes by Trent Grimsey in 2012, and seven hours 25 minutes by Yvetta Hlaváčová in 2006. Meanwhile Kevin Murphy has swum the Channel 34 times, and Alison Streeter has done it an astonishing 43 times. They may not have had balloons overhead, but they did have pilot boats alongside to escort and, if necessary, feed them, so Heath Robinson's vision of the perfect swim was not entirely fanciful.

"Gents' economy bathing-suits."

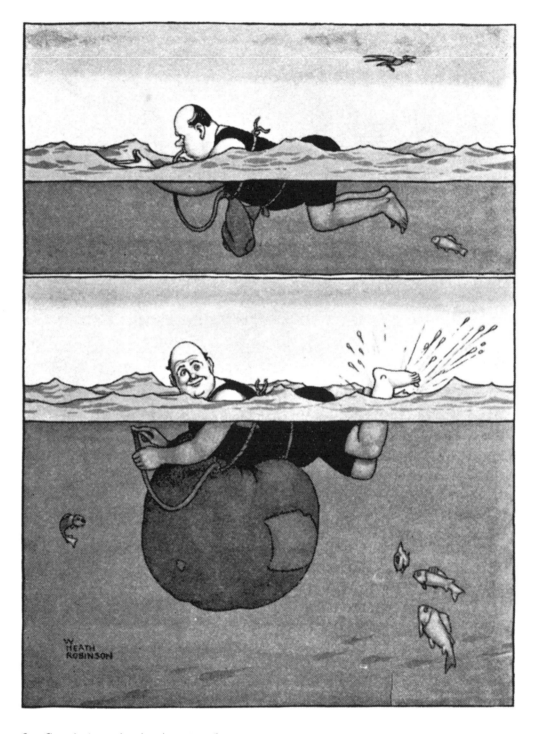

*Cross-Channel swimmers have been known to avail
themselves of this cunning but unsportsmanlike device
to provide additional buoyancy.*

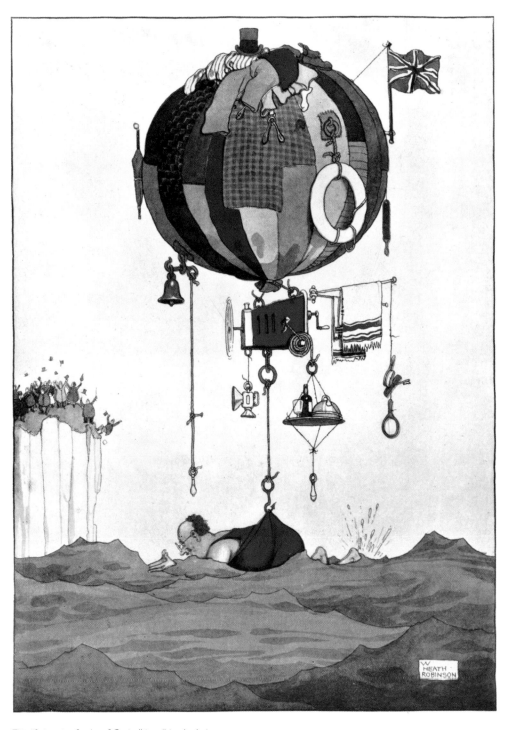

This "Swimming Stroke of Genius" is a "simple device
by which a cross-Channel swim can be rendered both easy
and pleasant – not to mention luxurious". It provides all the
accoutrements of civilized life, including top hat, umbrella
and tiffin and fortifying liquor on a butler's tray.

THE INCOMPLETE ANGLER

"God did never make a more calm, quiet, innocent recreation than angling," wrote Izaak Walton in *The Compleat Angler*, and the title of a series of hunting and fishing illustrations that Heath Robinson made for *The Sketch*, "The Gentle Art of Catching Things", would appear to endorse that idea. But in the world of his imagination, the repose of the fisherman is taken to fantastic lengths, not excluding the provision of a button-back armchair.

Fishing is the most popular pastime in Great Britain; four million anglers regularly dangle their apparatus hopefully in the water. Game fishers in fresh water are after trout or salmon. They generally use a lure which looks like an insect such as a fly, and lay it gently on the water surface, attached to a very light line, in the hope that a fish will rise to the bait. This is fly fishing. Coarse fishers go for species such as carp, perch and roach, and generally bait their hooks with worms, maggots, cheese, luncheon meat or even cat food. At sea, game fishing targets include tuna, tarpon and swordfish, with bait of anchovies, sardines or pieces of other fish.

People have been fishing for more than 40,000 years, and when I am sitting on the river bank, rod in hand, I sometimes think I must have been waiting that long for a bite. With similar thoughts in mind Heath Robinson believed that would-be anglers should be taught patience and schooled to avoid drowsiness; they could be encouraged by having real fish attached to their hooks, even if they came out of a tin.

Angling as a sport developed from fishing for food and survival, but its early history is murky. The Ancient Greek author Oppian of Corycus wrote a treatise on fishing more than 1,800 years ago, and in one passage describes the use of a motionless net:

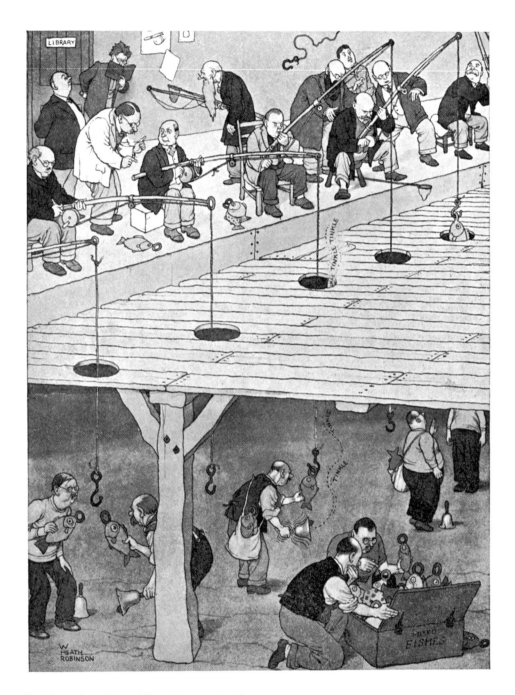

A training session enables would-be anglers to practise without leaving the safety and comfort of the pier.

"Casting for goldfish."

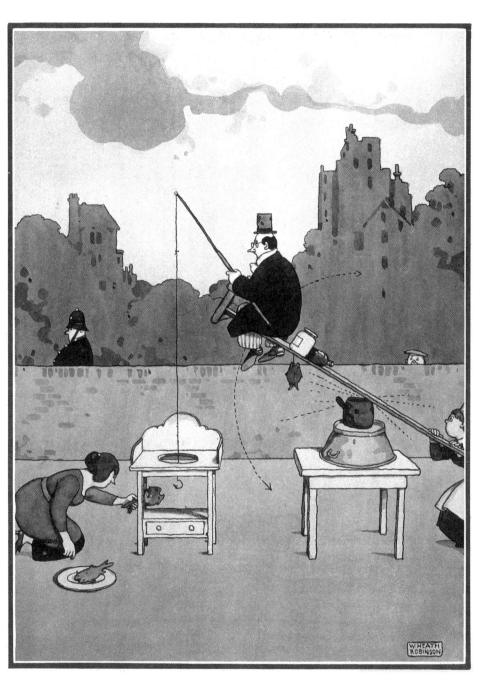

"Before you go away", counselled Heath Robinson, try this "new exercise for encouraging confidence in fishing from an open boat".

Heath Robinson makes the complex art of salmon fishing easy and accessible.

145

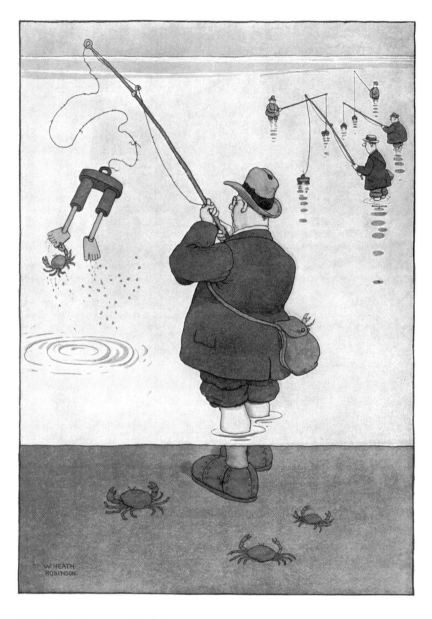

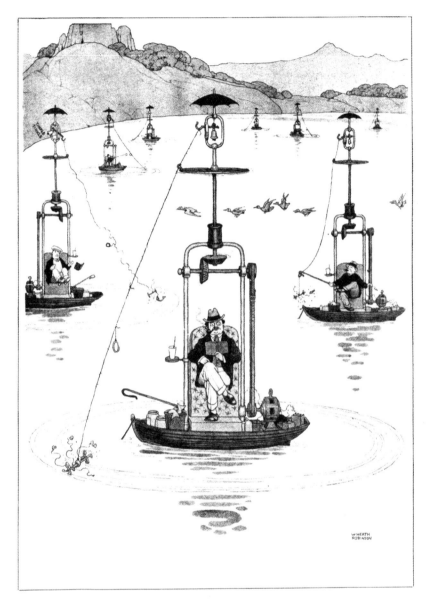

Scientific studies have proved that the human toe is the most effective known bait for catching crabs.

There is no need for a gentleman to be parted from the comforts of his study while fishing; a bell will alert him if a fish bites while he is enjoying his pipe and book.

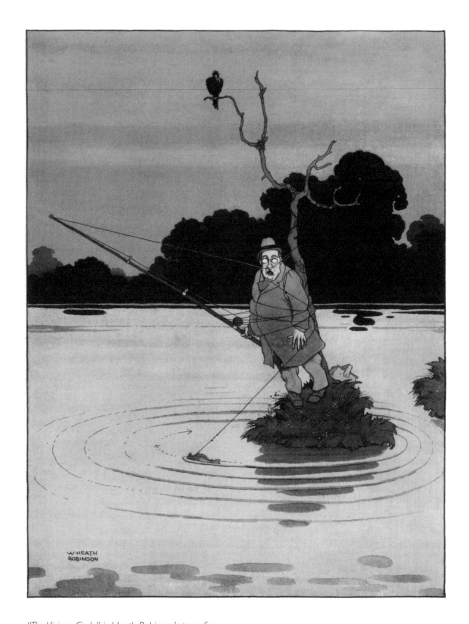

"The fishers set up very light nets of buoyant flax and wheel in a circle round about while they violently strike the surface of the sea with their oars and make a din with sweeping blow of poles. At the flashing of the swift oars and the noise the fish bound in terror and rush into the bosom of the net."

The Compleat Angler appeared in 1653, but the very first essay on the subject in English was printed by Wynkyn de Worde in 1496, soon after the invention of the printing press. This *Treatyse of Fysshynge wyth an Angle* may have been written by Dame Juliana Berners, the prioress of Sopwell Nunnery, and was packed with useful information about how to make fishing rods, where to fish and what sort of bait to use.

In his thorough, analytical fashion, Heath Robinson saw the fish's point of view as well as the angler's. Stories of fish biting back are rare, but one extraordinary report from Papua New Guinea claims that a giant 26-pound Pacu fish attacked two men by biting off their testicles; the bleeding was so severe that they died. In future I shall avoid swimming in Papua New Guinea.

A few years ago a fisherman was lying on a jetty in Florida holding bait in the water to tempt fish to come close when a large tarpon came rocketing up from the deep and grabbed his arm. The fish had his hand inside its mouth, and its jaws clamped on his forearm above the wrist. It almost managed to pull the man into the water, but luckily he was able to get back on to the jetty, and there wrestled for a whole

"The Vicious Circle" is Heath Robinson's term for "unsportsmanlike conduct by a trout during trouting season on Hampstead Ponds". The man is already immobilized and the vulture waiting above is clearly expecting a meal soon

minute with the great fish, before it let go and flipped back into the sea. He was left with blood streaming down his arm from the savage bite.

The trout is a lot smaller than the tarpon, but in Heath Robinson's opinion it clearly has the same goal in mind, if fish have minds: death to the fisherman. Given half a chance, it will truss the angler in his own twine.

In Heath Robinson's ideal world, the fisherman should be provided with all the comforts of home when he is off on a trip. I am not entirely convinced by the idea of fishing in total luxury. I rather think that the point of fishing is the sense of eager anticipation – the eternal hope that a fish is going to bite at any moment. The gentleman who is sitting back reading a book and smoking a pipe cannot be enjoying that state of ever-hopefulness. In the unlikely event of his actually catching a fish, he would find it difficult to maintain his elegant appearance and spotless clothes while removing his catch from the hook and putting on fresh bait.

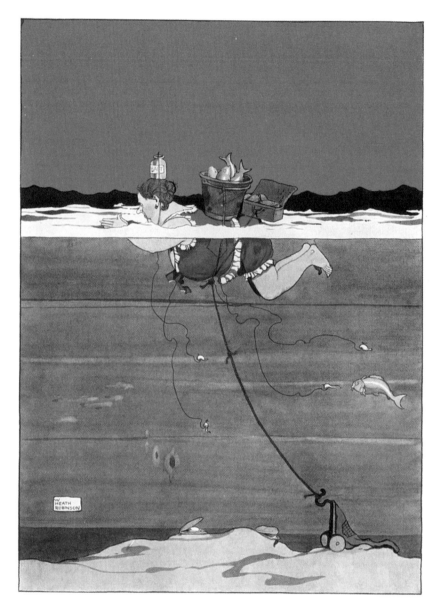

"Getting Fed Up": a seaside landlady trawls for cod and oysters to feed her guests.

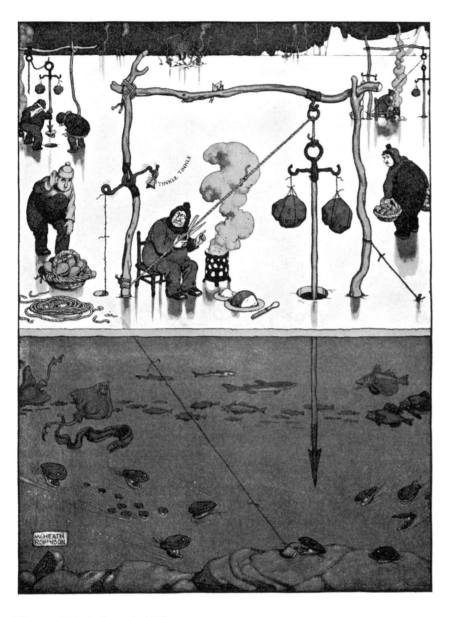

"Clam spearing in the frozen North." Clams are generally caught in fresh-water estuaries from Maine to India. They can be found as far north as Alaska, although the inhospitable location somehow adds joy to this early picture from The Sketch.

A poacher adopts a cunning expedient to avoid detection while fishing in forbidden waters.

HUNTING FOR CADS

In the P. G. Wodehouse world of cads and bounders, Heath Robinson found himself disgracefully at home. Far from gently catching things, at times he revelled in the most outrageously dishonourable methods for trapping and despatching prey.

For *The Illustrated Sporting & Dramatic News*, a sister paper of *The Illustrated London News*, he produced a series of drawings entitled "Very Patent Aides to Sport!" in which he demonstrated how salmon are tinned in Scotland, chipmunk bagged in Brazil and polecats trapped in the Catskill Mountains of up-state New York. While polecats have a deservedly poor reputation for their foul smell, other victims of Heath Robinson's *noir* humour included the harmless giraffe, which appeared to be fair game in a most ungentlemanly sport.

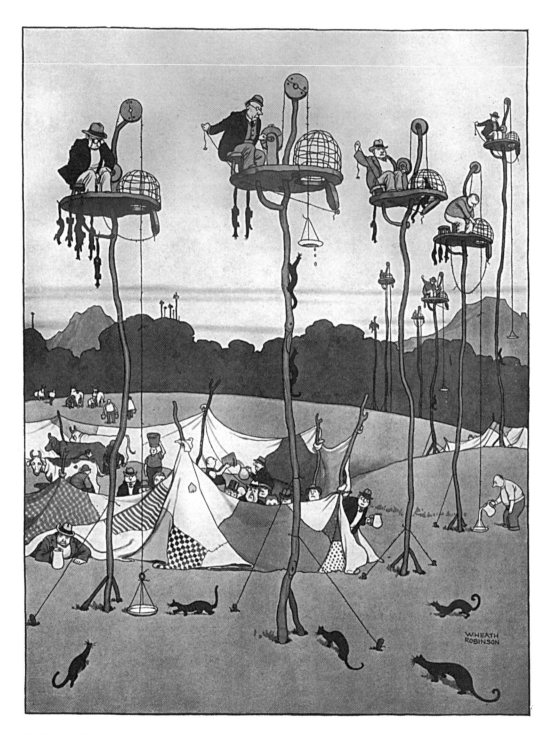

The "Cow-and-Plate" polecat trapper, seen here in the Catskill
Mountains, uses fresh milk to lure these pests to their doom.

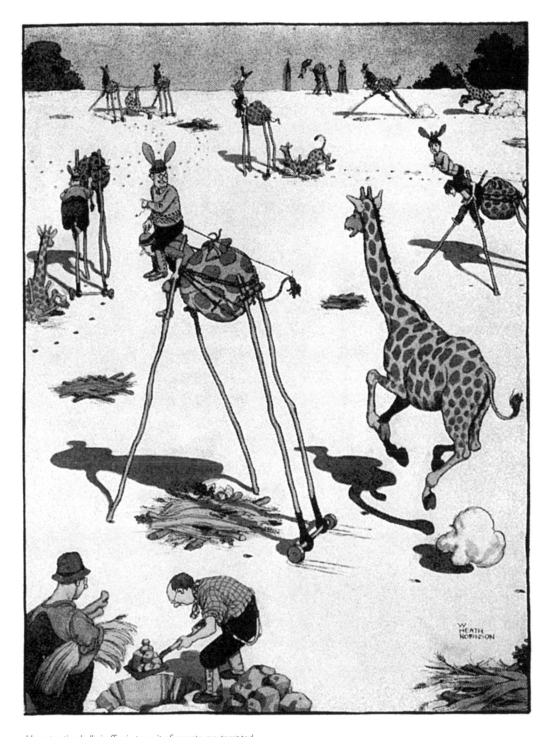

Unsuspecting bull giraffes in pursuit of a mate are tempted

into a pitfall trap by the patented "Lifelyke" stilted giraffe lurer.

WINTER WHEEZES

On the rare occasions when I try ice-skating I find some difficulty in standing up; my feet have a tendency to slide out from under me. Once I start moving I feel much more confident: leaning forward and pushing gently with alternate feet, I lurch slowly along, trying to ignore all the children whizzing past at 30 m.p.h., sometimes going backwards.

I would therefore hate to be pushed or pulled along, but that is what Heath Robinson suggests. He is inordinately fond of magnets and proposes that novice skaters might be guided by powerful magnets under the ice, operated by divers; I should lose my balance at once, although I guess that the magnets might prevent my skates from sliding away uncontrollably.

Another Heath Robinson idea is self-propulsion using a personal propeller. When I tried riding a tricycle with jet propulsion, I was worried that it would catapult me off at terrifying speed, but in fact, on a level airfield, it just felt as though I was going down a gentle hill all the time. The only

Heath Robinson's overhead rail provides support for skaters on thin ice that might otherwise break under their weight.

This fan-driven propulsion pack will speed a skater across the ice – but he will need the horn to warn others of his approach.

problems were that it took three engineers to rig it up, and the noise was deafening.

I also had some difficulty turning a sharp corner, since doing so at 20 m.p.h. does tend to throw you off sideways. The same might apply to the magnetic skaters – a sudden and unexpected change of direction might prove unsettling, to say the least.

On the ski slopes Heath Robinson was also full of ideas, suggesting magnets to pull yourself uphill. The idea is most alluring. Perhaps I should try it for my bicycle? For warm winters he envisaged a personal snow-making machine, producing just enough for a single ski. Why do those ski resorts have vast machines running all the time to make the stuff in tons? This would be so much cheaper.

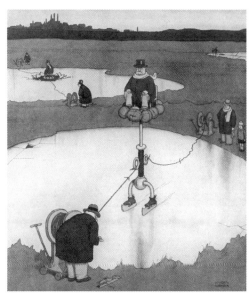

Skaters glide effortlessly and gracefully, without risk of collision, thanks to a system of magnets submerged beneath the ice.

The New Safety Ice Tester will measure the capacity of a frozen pond to bear the weight of the average skater; the tester's safety is ensured by a raft of floats.

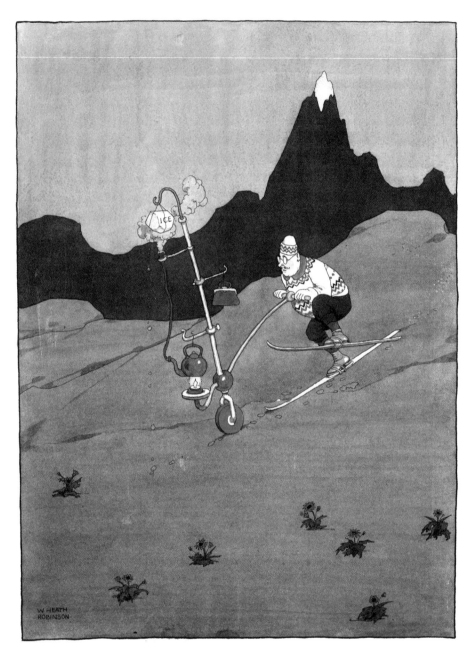

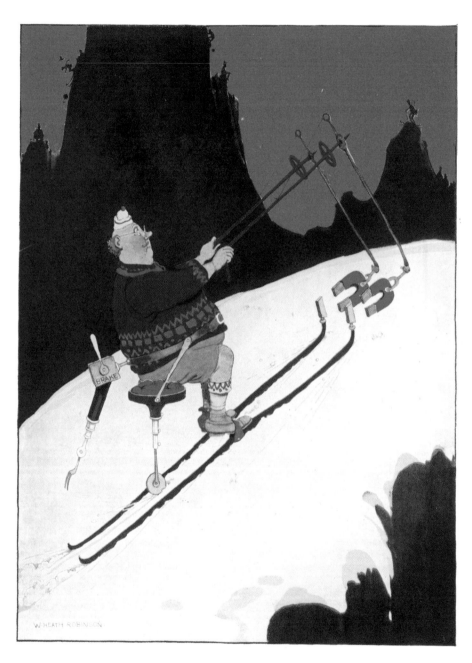

This simple device enables skiers to make their own snow
as they go along, avoiding the disappointment of a "green
winter" in Switzerland.

With their telescopic emergency brake, these patent
magnetic skis are ideal for uphill work.

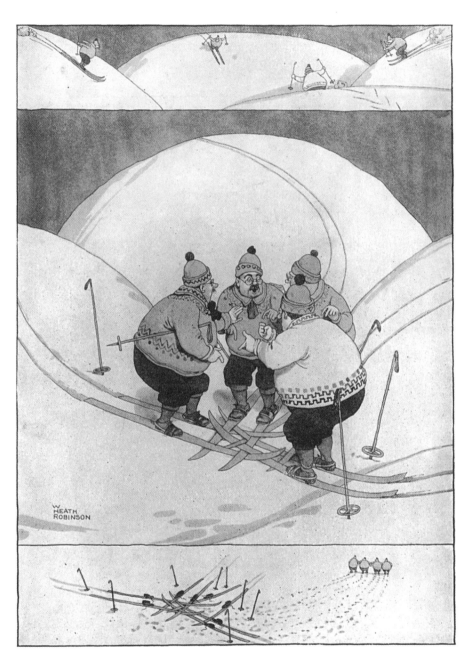

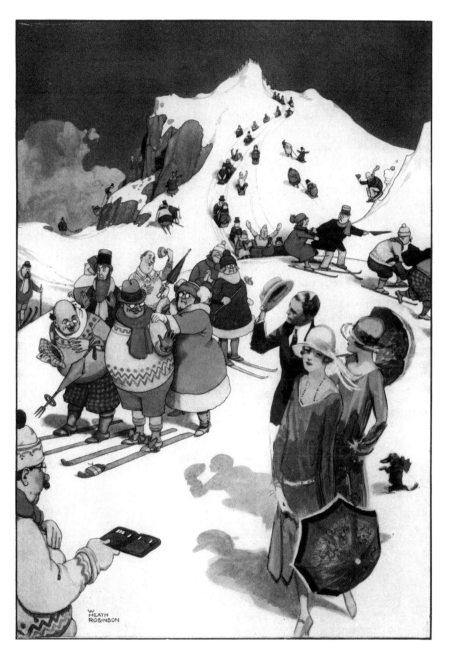

When skiers are at cross purposes, there is only one way
out of their predicament.

"Sorry, but this was bound to happen." The illustrator
Howard K. Elcock specialized in French Riviera
scenes. In this rare collaboration, a group of his chic
holidaymakers have wandered on to a piste peopled
by Heath Robinson's more homely types.

COMBINATION GAMES

Just as with tennis, Heath Robinson seemed to like the idea of complicating various sports to make them more interesting. In his imagination, croquet can be made to provide its own musical soundtrack, while snooker and ping-pong can be played simultaneously on the same table, the snooker by men and the ping-pong by women.

His sport of "Rug-tennis" combines rugby and tennis, while "Cue-Ball" seems to be a combination of snooker and rugby, and looks as though it would lead to ferocious arguments and quite possibly fisticuffs.

In real life games tend to sub-divide and become more specialized rather than combine. So football evolved to spawn a new species, rugby football, which in turn divided into Rugby Union and Rugby League. Real tennis evolved to generate a new game, lawn tennis. This in turn produced another variant, table tennis, otherwise known as ping-pong after British Army officers in India wanted to carry on playing during the monsoon and invented an indoor game using the lids of cigar boxes for bats and a rounded wine cork as a ball.

So in combining sports Heath Robinson is flying in the face of evolution, but that is typical of his whimsical attitude to games, and to life in general.

Heath Robinson spots the potential of the unused air space above a snooker table to combine the game with ping-pong in a new, three-dimensional challenge.

Musical hoops and mallets enliven the hush that often prevails during a game of croquet.

> **"** It is well known that more mental murders were accomplished on the croquet field than anywhere else outside bridge parties. **"**
>
> W. Heath Robinson and Cecil Hunt,
> *How to Build a New World*, 1940

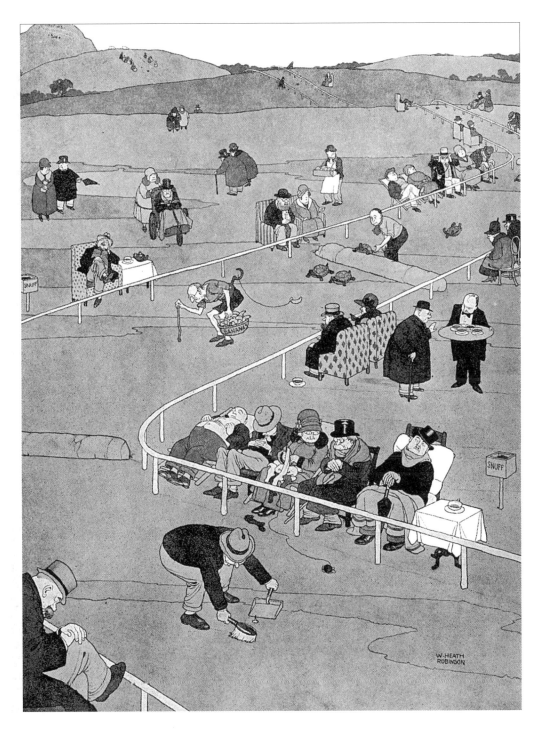

Race-goers for whom greyhounds are a little too hyperactive
may find tortoise coursing more to their liking.

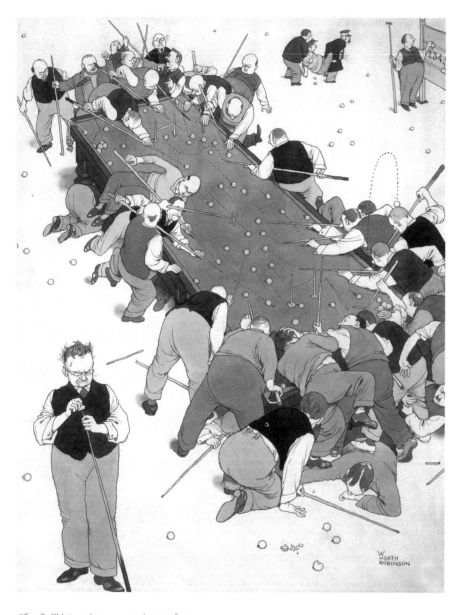

*"Cue-Ball" brings the energy and pace of a contact
sport to the otherwise leisurely game of billiards.*

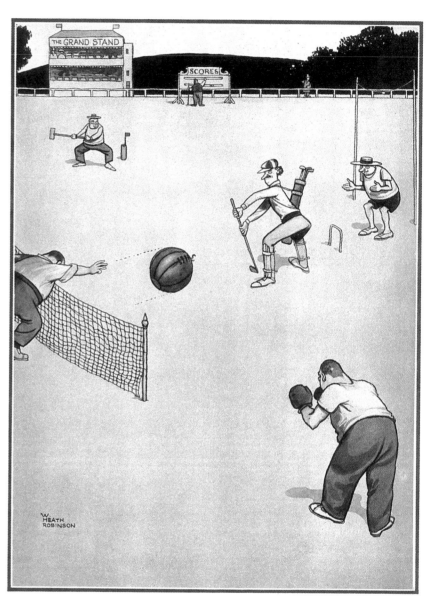

*Heath Robinson combines the most exciting elements
of golf, tennis, rugby, cricket, croquet and boxing
in a dynamic new "Combination Game".*

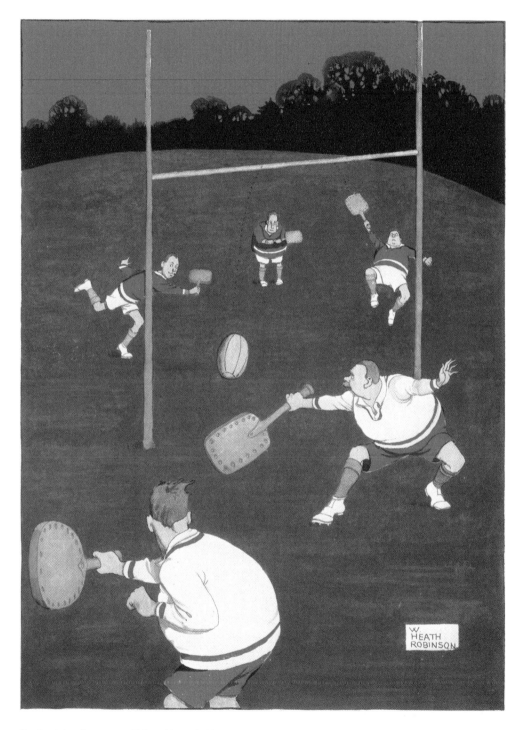

Rug-tennis is a "new game which enables rugby players to avoid getting stale at half time", but it looks impossibly difficult because of the weight of the ball.

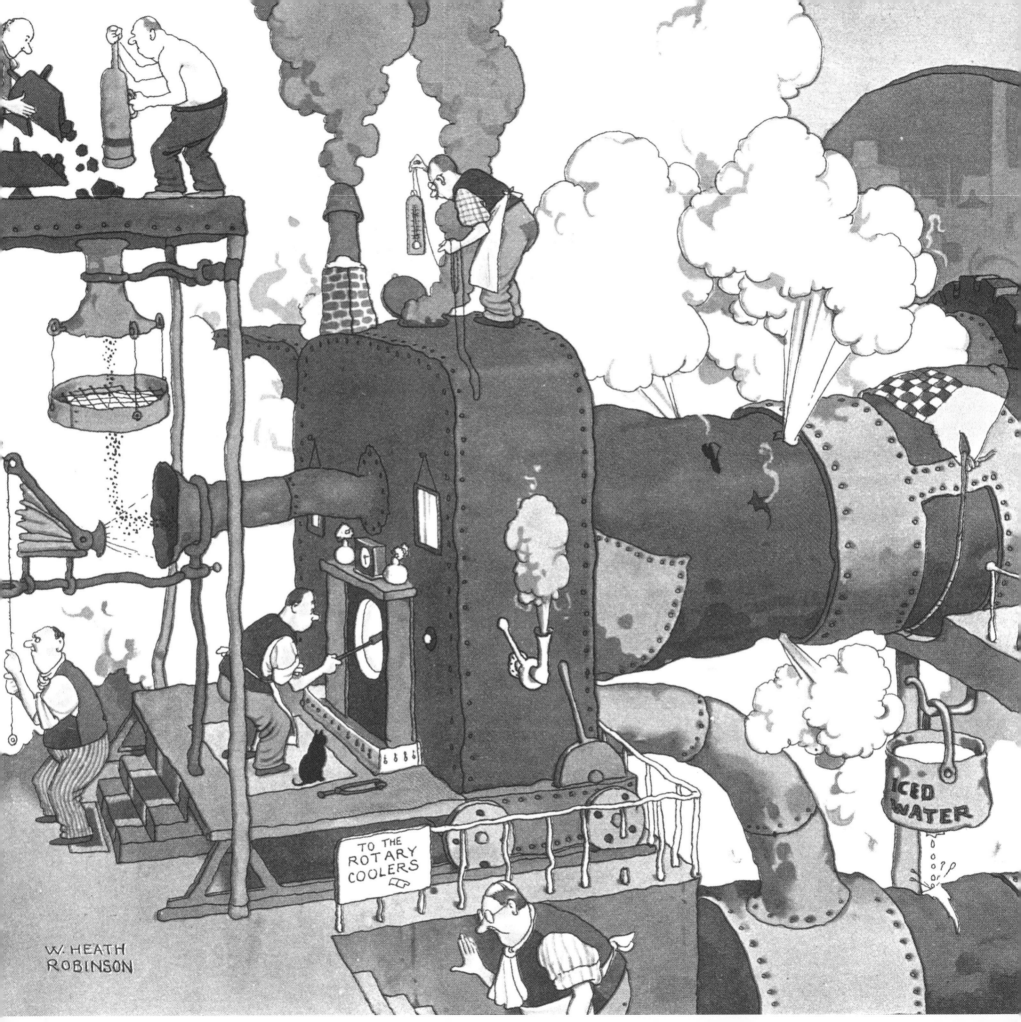

TO THE
ROTARY
COOLERS

ICED
WATER

W. HEATH
ROBINSON

CHAPTER 5

MAN AND MACHINE

Heath Robinson's 1925 book The Wonders of Wilmington contained five full-page illustrations giving his impression of G. & T. Earle's cement works at Wilmington, Hull, East Yorkshire. The book measures 11 by 16 in., is beautifully printed in gravure and bound in hardback, with the eponymous pelican of the brand emblazoned on the front cover.

In this detail from a scene at G. & T. Earle, a patchwork quilt is used to prevent steam escaping from a rotary kiln, whilst middle-aged men clamber around and a cat sits on the mat in front of the fire.

Under the influence of Mr. Spodnoodle, the imaginary friend who helped him invent ever more gloriously complicated machines, Heath Robinson made such a name for himself that big business came calling. With a view to producing eye-catching advertisements, he was invited to tour a range of factories making everything from asbestos cement to biscuits and toffee. He clearly enjoyed these visits, which gave rise to a stream of superb pictures. They provide us with his vision of manufacturing technology at the beginning of the 20th century.

By the time Queen Victoria died in 1901, British industry was highly mechanized. For more than a hundred years factories had been built around machines, powered at first by water wheels, then by steam engines and finally by electricity. Heath Robinson, however, preferred to suggest that much of the work was still done by human power.

Typical of the early machines was the water frame, invented by the failed wig-maker Richard Arkwright and installed in his purpose-built cotton spinning mill at Cromford in Derbyshire in 1771. Before he came along, one spinster could spin one cotton thread at a time, or a highly skilled operator with a Spinning Jenny could spin 12 or more, but if one broke she would have to stop the machine while it was mended. Using the water frame, so called because the whole mill was powered by a water wheel, an unskilled teenager could spin 96 threads simultaneously, and if one broke she could leave 95 spinning while the broken one was repaired.

In 1766, the entrepreneur Matthew Boulton had taken the brave step of building a "manufactory" at Soho in Birmingham. There under one roof he installed tinsmiths, coppersmiths, blacksmiths and carpenters. The whole building was powered by a waterwheel, and the idea of bringing all these artisans together was so novel that people came from far and wide to see it.

In his influential 1776 book The Wealth of Nations,

Adam Smith wrote about the manufacture of pins, and explained in detail how much more efficient the process would be with division of labour, each worker doing one simple task. In China, the procedure had been deployed hundreds of years earlier in the manufacture of weapons and agricultural implements. Early in the 12th century the ship-building managers of the Venice Arsenal ran what amounted to an assembly line, which could actually produce one ship a day, but the idea did not catch on further west.

The principle of the assembly line is to keep each worker in one place, and bring the parts to him or her on a conveyor belt or from above by gravity. He or she performs one simple operation and then passes the unit on to the next person. By doing the same thing again and again the worker is bound to become more efficient and therefore speed up the process.

Oliver Evans built an automated flour mill in 1785. Marc Isambard Brunel, the father of Isambard Kingdom, invented a sequence of 22 iron machine tools, built by Henry Maudslay, to make pulley blocks for the Royal Navy, which needed 100,000 of them every year. Arguably the first automated metal assembly line, his Portsmouth Block Mills opened in 1803, and made all the Navy's blocks for some 150 years.

Henry Ford's famous assembly line of 1913 reduced the time needed to build an automobile from 12.5 hours to 93 minutes. He claimed credit for the system, but actually got the idea from William "Pa" Klann, who had seen a "disassembly line" at a slaughterhouse in Chicago. Each man removed just one piece of the carcass, and they all became extremely proficient. The production of the Model T Ford was so fast that painting became a bottleneck. The only paint that would dry fast enough was Japan black, which was why Ford famously said that his customers could have "any colour they like, as long as it's black".

What is fascinating about Heath Robinson's factory scenes is that neither modern power nor the assembly line has arrived. Surely by the time he visited his factories in the early 1900s the machines in them must have been driven by steam engines, if not by electricity? Water wheels had been in use for thousands of years. In his imagination, however, human power was enough, even for grinding asbestos.

Only occasionally does Heath Robinson show us glimpses of assembly lines – in the making of Christmas crackers, for example – and the use of gravity feeds and conveyor belts. Was he deliberately ignoring these innovations, or nostalgically thinking of a simpler age? Was he trying to turn back the clock and pretend that life would be better without modernization? Or was he simply poking fun at the industrialists? Whatever his reasons, his drawings clearly caused amusement rather than offence, for he kept getting commissions. One company, the curriers Connolly Bros., asked him to produce ten separate booklets during the 1920s and 1930s containing more than 200 drawings.

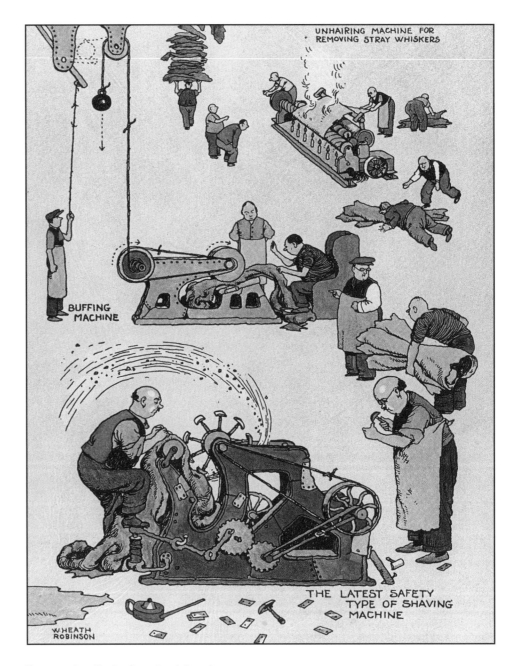

The preparation of leather for use in upholstery, luggage, harnesses, footwear and clothing at Connolly Bros. Ltd. required machines to boil, dry, shave, buff, press, soften, split, colour, emboss and enamel the hides, attended by innumerable apron-wearing operatives.

"I can't improve on that," said Heath Robinson when he saw
a hide-measuring machine at Connolly's. Rather than redraw
an already complicated piece of equipment, he simply added
a portrait of himself and his cat Saturday Morning.

❝ In spite of their
absurdity, these inventions
of mine were reputed to
be mechanically sound.❞

Heath Robinson,
My Line of Life, 1938

163

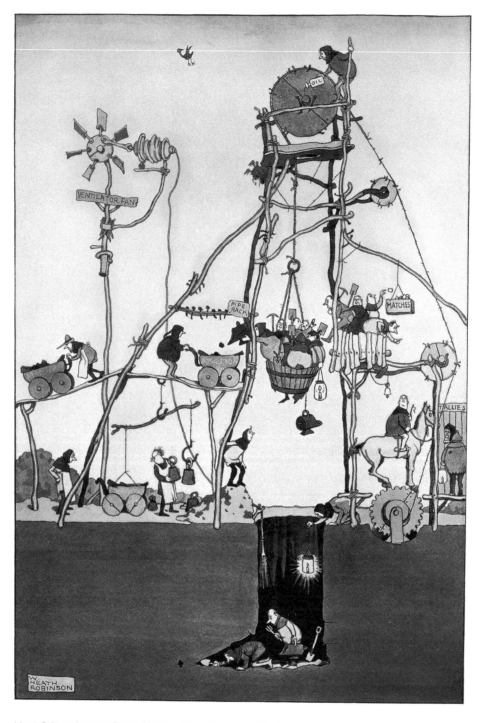

*Heath Robinson's vision of an early colliery pithead is characteristically
ramshackle, its lift a half barrel and its winding gear operated by a horse.
The scene is pleasantly domesticated through the provision of household
coal scuttles and a pipe rack.*

MIGHTY MOVING MACHINES

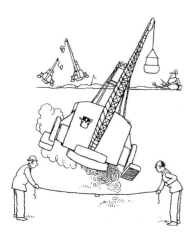

In a scene from The Gentle Art of Excavating, *produced in 1930 for Ruston-Bucyrus Ltd., walking excavators show their paces in the annual Lincolnshire handicap. The firm is still trading as R. B. Cranes.*

Among his industrial clients Heath Robinson counted miners, civil engineering firms and manufacturers of building products whose activities were largely unknown to the population at large. Somehow he had to weave stories out of the most unpromising material, but by dint of conscientious research and clear presentation he succeeded in taking his audience back to the very roots of the Industrial Revolution.

Coal was already in use for glassmaking and domestic heating, but it became a major factor in the Industrial Revolution after 1709, when Abraham Darby discovered that he could smelt iron using coke rather than charcoal. This dramatically increased the production of iron after he built blast furnaces at Coalbrookdale. There was a major problem of flooding in the coal mines, but Thomas Newcomen's steam engine of 1712 solved it. The Newcomen engine was inefficient, and was used only to pump water, not to operate winding or other machinery, but as long as there was coal it could keep running, and as long as it kept running more coal could be mined. The iron made by Darby and others was used to make steam engines, and they all used coal as fuel. These positive feedback loops propelled the Industrial Revolution. In 1905 the U. K. produced 236 million tons of coal, compared to Germany 121, France 36, Russia 19 and Japan 11; only the U. S. A., at 351 million tons, produced more.

Around the world coal has been used as a fuel for thousands of years; there is evidence that the Chinese were mining it and using it domestically five and a half thousand years ago, and to smelt copper three thousand years ago. The Greeks used coal for metal-working more than two thousand years ago. The Romans used coal in their hypocausts, or under-floor heating systems.

Coal was often found on the beach, known as

sea coal or seacole, or elsewhere on the surface. Until the 18th century it was mined in drift mines, which were tunnels dug horizontally into the coal seam, or in bell pits, which were short tunnels dug radially from a shallow vertical shaft. Using early history as a way of presenting unpalatable subjects, Heath Robinson chose to depict the "first colliery" with rickety pit-head equipment. His colliery looks like a bell pit under development; the excavations would be pushed sideways in all directions from the bottom of the vertical shaft, until the edges began to collapse. In some ways this one is rather advanced, with its horse-powered winding gear and its ventilation system, which was certainly not invented in the days of bell pits.

Coal has always been a useful fuel because it occurs in concentrated and fairly pure seams, so that it is relatively easy to mine; and it burns strongly and slowly, giving out plenty of heat and some light. It can readily be converted to coke by baking at a high temperature without oxygen; coke has fewer impurities and is therefore a cleaner fuel.

Coal, coke and steam power combined to produce a generation of powerful machines that took the Industrial Revolution to a new level. The turning point was the application of rotative motion to the reciprocating action of the Newcomen engine, solved by William Murdoch and James Watt in 1781 with their sun-and-planet gears, which enabled them to build engines capable of "giving motion to the wheels of mills or other machines".

By Heath Robinson's time, steam power was in motion everywhere: on the railways, the roads, the docks, the quarries and in open country ripe for development. William Otis of Philadelphia, Pennsylvania, was a cousin of Elisha Otis, inventor of the safety elevator. In 1839 William patented

the steam shovel, which soon became the most important piece of technology for moving large quantities of earth and rock. By 1880 one of the major American producers of steam shovels was the Bucyrus Foundry and Manufacturing Company in Bucyrus, Ohio. No fewer than 77 Bucyrus shovels were used in the building of the Panama Canal, starting in 1904. In 1930 Bucyrus joined forces with Ruston & Hornsby, which had been making steam shovels in Lincoln, England, since 1874, to form Ruston-Bucyrus Ltd., and it was from this company that Heath Robinson received one of his most satisfying commissions, to produce a booklet entitled *The Gentle Art of Excavating*. These shovels clearly appealed to him – wonderful great lumbering contraptions, shovelling rocks and snorting steam.

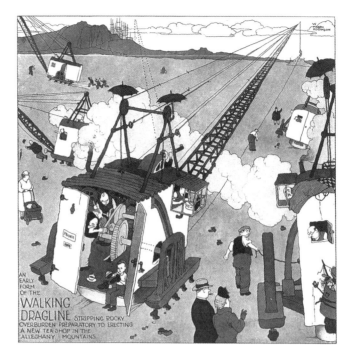

A walking dragline moves on pontoons as the weight of the machine is so great that caterpillar tracks would compress the ground. Heath Robinson takes the idea literally and shows his dragline walking on booted feet.

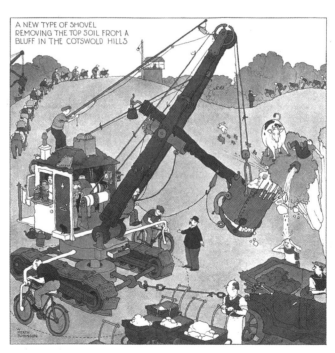

This mighty excavator is operated by man and pedal power, while the topsoil it scoops up is carried away by a train of perambulators.

> **"** Machines were devised not to do a man out of a job, but to take the heavy labor from man's back and place it on the broad back of the machine. **"**
>
> Henry Ford, 1930

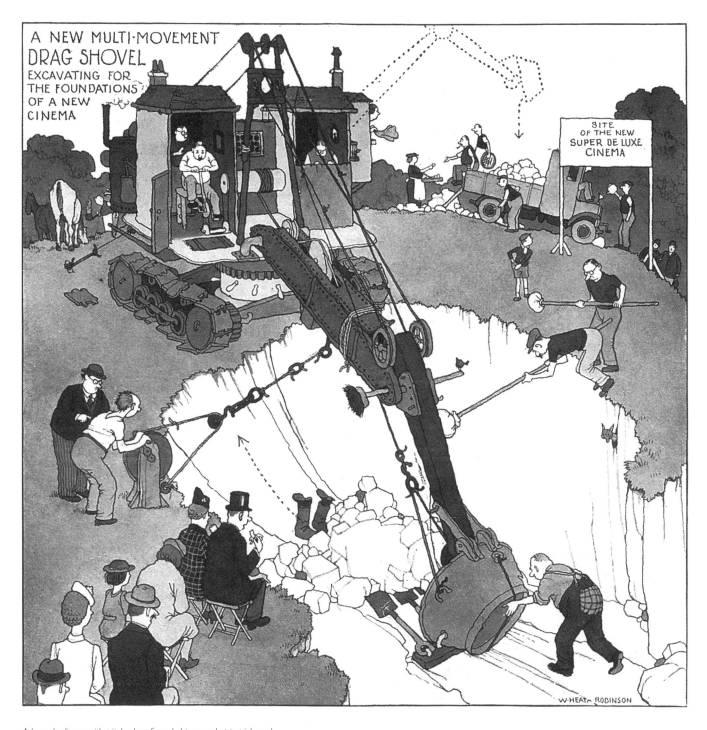

A homely digger with pitched roofs and chimneys, kept spick and span by womenfolk, begins work on excavations in preparation for the building of a new cinema, whose customers are already queuing for tickets.

BEFORE
IT WAS BANNED

Asbestos is a type of rock that has a long and chequered history, because of the fact that, unusually for a mineral, it consists of tiny fibres, which can be spun into yarn and woven into cloth, or mixed with cement to make tough sheets. In eastern Finland it was used to strengthen cooking pots 4,500 years ago, and Egyptians and Romans used it to make cloth, and in various other ways.

During the 1870s asbestos began to be mined in large quantities in the Canadian province of Quebec, and later in Russia, Italy and South Africa. Builders began to use it, often mixed with cement, to make pipes, fireproof screens, fireplaces, tiles, roof sheets and so on. The advantages were that asbestos is cheap, easy to handle, relatively tough and completely impossible to burn; so it is excellent for fireproofing.

In 1924 Nellie Kershaw, who had worked for seven years in a factory spinning asbestos into yarn, died from what the pathologist Dr. William Edmund Cooke showed was asbestosis. The fact is that inhaling

"A patent double-action grinder for mashing the asbestos fibre" was drawn for the promotional book The Making of Asbestos-Cement Roofing *in 1936.*

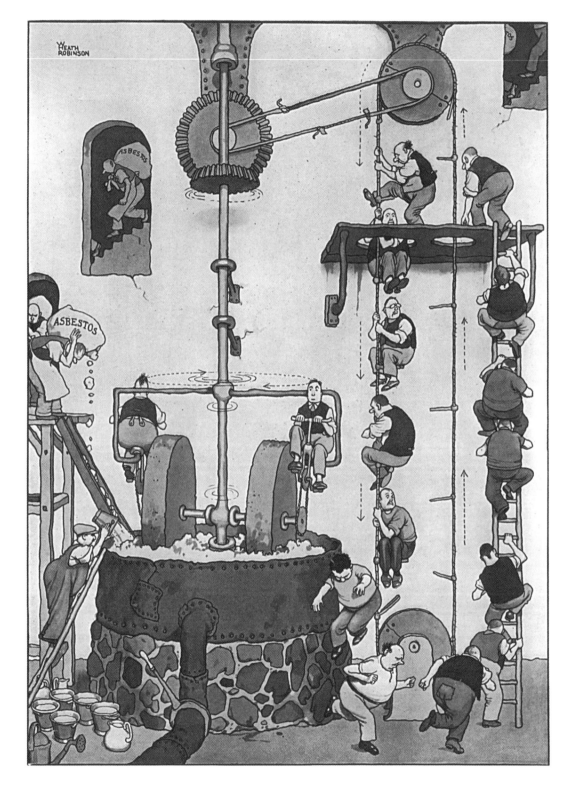

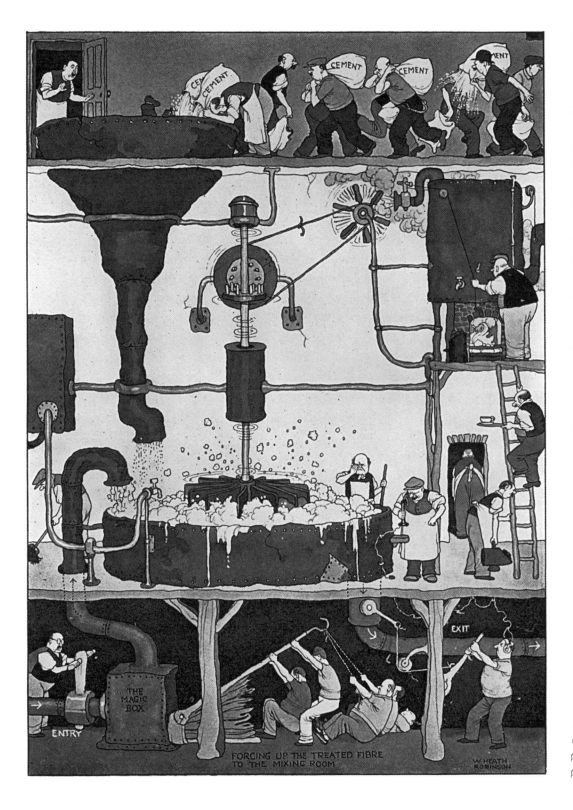

ENTRY

THE MAGIC BOX

FORCING UP THE TREATED FIBRE
TO THE MIXING ROOM

EXIT

W. HEATH ROBINSON

the tiny fibres is lethal, since once they get into the lungs they can cause mesothelioma and lung cancer, but this was not clearly understood until the 1970s. There were many stories during the middle of the 20th century about asbestos factories where the air was full of the pretty white fibres, floating about like dust particles or little snowflakes. The workers must have been breathing them in all the time. More than 100,000 American shipbuilders died from inhaling asbestos fibres.

Asbestos has now been banned as a building material in the U. K., but about half of all the buildings in the country still contain some of the material. Asbestos roofs and tiles and pipes are perfectly safe – you cannot inhale roofs or pipes – but panic has caused thousands of buildings to be torn apart to remove asbestos, and it becomes dangerous when it is sawn or otherwise mistreated, since the fibres are then released; so arguably removing asbestos from buildings is more dangerous than leaving it in place. In many developing countries asbestos is still used as a cheap and effective building material.

Armies of labourers power an "efficient plant for the successful mixing of treated asbestos fibre with cement". There appear to be plenty of fibres floating about, but the workers are not taking any precautions against them.

THE PELICAN
IN THE FACTORY

Heath Robinson and cement are not words that naturally go together, but it is little surprise that he wove a good story out of it, having also succeeded in deriving entertainment from asbestos, steel girders and warehouse logistics. The starting point, as so often in his industrial work, was a factory visit. In 1925 he was invited to go round the G. & T. Earle cement works in Wilmington, north of Hull, and see how the raw materials located on the site were turned into bags of cement. He was then to illustrate the process.

In the 1990s I myself visited such a factory, run by Rugby Cement. I was amazed by what I saw. Chalk and clay came from the same quarry on conveyor belts and were then mixed with water, heated, ground and packed with incredible speed in one gigantic production line. I came away with vivid impressions and lasting memories.

Cement has a long history; there is a building in Croatia with a concrete floor 5,000 years old. The Romans made excellent cement of various types and constructed walls of flints embedded in lime mortar. These can be found in various places around England and are still as tough as stone. The roof of the Pantheon in Rome is made of cement with aggregate of lightweight pumice stone, which is one reason why it is still there.

Most types of cement are based on chalk. The Portland cement produced at Wilmington is made by heating a mixture of chalk and clay to a high temperature, and was invented by mistake in 1824. Its origins can be traced back to when a Leeds bricklayer, Joseph Aspdin, decided to make his own lime mortar and bought an old glass factory. He put in the chalk and clay, fired up the furnace and went to the pub. In order to make quicklime, precursor to lime mortar, he needed to heat the mixture to around 1,000°C. What he had not realized was that his glass furnace went up to 1,400°C. The chalk and clay reacted together to make a new material which he did not

Heath Robinson presents a wonderfully humanized depiction of digging for chalk, one of the starting materials for cement.

like at all, because it would not slake, as quicklime should. Nevertheless he realized it might be useful and patented the process, calling the stuff Portland cement, after Portland stone. It is now the most prized building material in the world.

G. & T. Earle started trading in 1809, established a cement factory on the bank of the River Humber in 1821 making Roman cement and moved to Wilmington in 1866. By 1925 they were producing 150,000 tonnes of Portland cement a year, roughly 4.5 per cent of the U. K. total. They were known for their high standards and marketing capability. "For over forty years", wrote one of the directors in 1925, "it has been the established policy of this business to put quality before everything else."

In approaching an artist as well-known as Heath Robinson they reasserted their determination to go for the best. Heath Robinson, having learned how cement was made, turned an industrial process little known outside the building trade into a minor publishing sensation, producing a wonderful set of drawings which were printed to the highest quality and bound into a large book *The Wonders of Wilmington*. Earle's cement was marketed under the brand name Pelican, and the bird not only appears on the cover but observes proceedings in each of the drawings.

The volume proved so popular that when stocks were exhausted Earle had postcards made of the illustrations to give out to customers. The book was reprinted in a smaller format in 1949 as *Earle's Early Etchings*, and again in 1984 by the successor company Blue Circle.

Heath Robinson showed every stage in the cement-making process right through to the testing of the finished product for strength – which needed numerous frock-coated operatives and complicated machines, not to mention horses, cars and motor bikes specially roughshod to replicate heavy road wear. It is a *tour de force*, as impressive today as it was a century ago.

TWISTER!

In order to make high-quality cement, the chalk and clay have to be mixed as thoroughly as possible. After being ground they are made into a slurry with water, which is then continually stirred by a set of rotating arms to prevent solids settling.

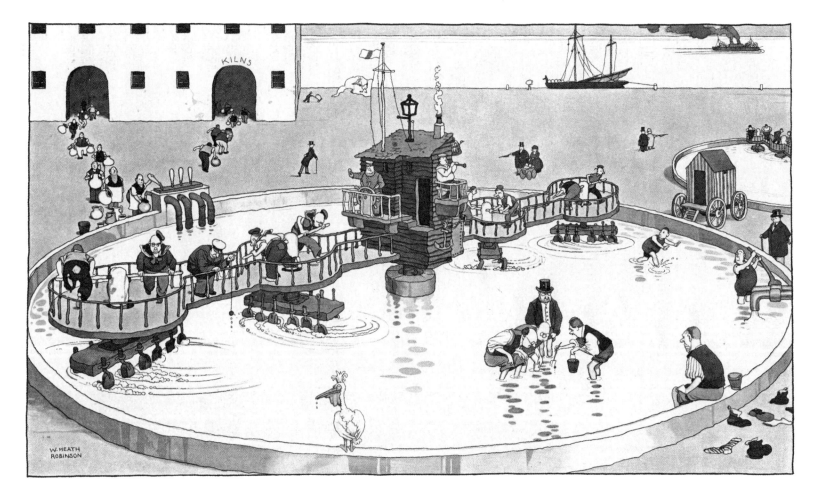

A seaside atmosphere attends this slurry mixing tank, built like a fairground Twister but powered by uniformed sailors, commanded by a captain and piped by a bosun.

" A wonderful bird is the pelican,
His bill will hold more than his belican,
He can take in his beak
Enough food for a week
But I'm damned if I see how the helican! "

Dixon Lanier Merritt, 1910

HEAT AND FURY

After being mixed with water, the chalk and clay are heated together in enormous rotating kilns. These giant cylinders reminded me of space rockets when I saw them in action. They are slightly tilted so that the material gradually trickles downhill, and they become hotter towards the furnace at the lower end. Standing a few feet away, I thought my clothes would catch fire. After reacting in the high temperature, the resulting clinker falls out of the kiln into cylindrical coolers.

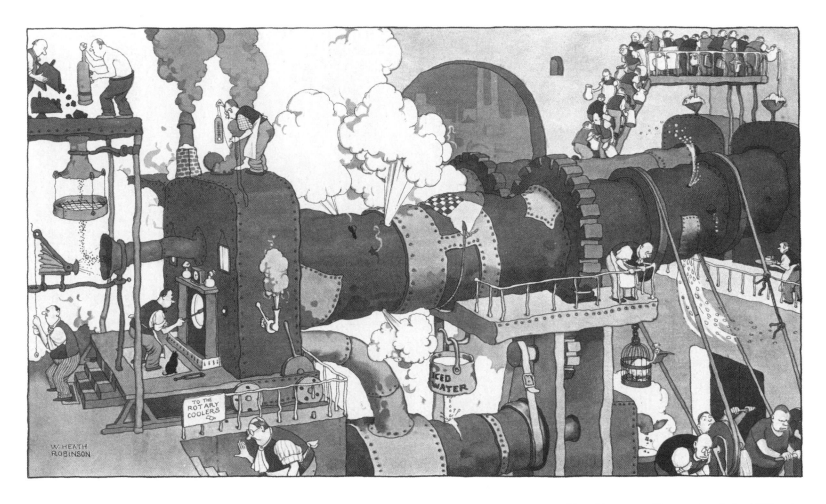

Two of these rotary kilns were installed in 1906 and two more in 1913 and 1920, making the works highly efficient, albeit not equipped with a domestic fireplace.

> **"** I was invited to study
> the real machines and processes
> before my imagination was
> allowed to play with them.**"**
>
> Heath Robinson,
> *My Line of Life*, 1938

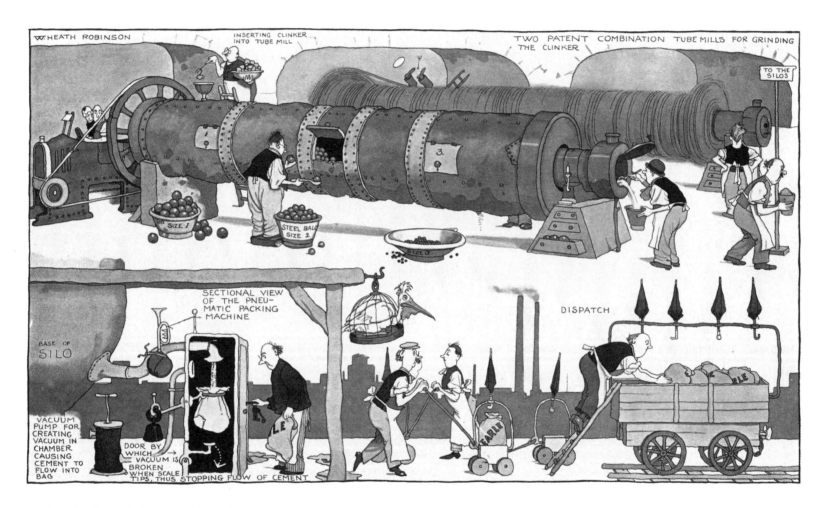

"Grinding and packing Portland cement." Clinker, steel balls
and vacuum pumps combine to produce sacks of cement,
with umbrellas to protect them in case of rain.

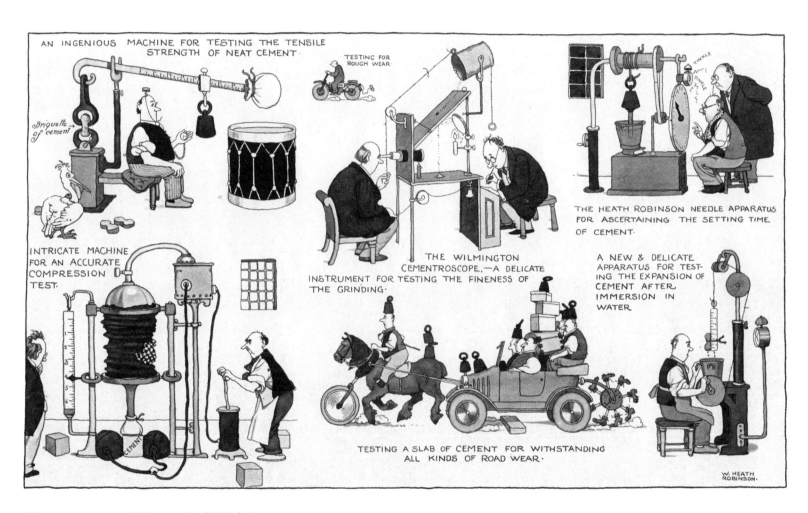

"Some severe tests to which cement is submitted at Wilmington." All kinds of ingenious instruments are employed for testing, grading and analyzing the finished product, including the Cementroscope.

KEEPING THE
STORE CUPBOARDS STOCKED

In addition to his depictions of heavy industry, Heath Robinson did work for a number of food manufacturers, including biscuit makers, millers and the producers of sauces and sweets. The opportunity to combine light industrial processes with domestic cosiness clearly appealed to him.

William Crawford started making and selling biscuits in a small shop in Shore of Leith, Scotland, in 1813. He was highly successful; the company expanded and occupied larger premises, and in 1897 opened a new factory in Liverpool: the Fairfield Biscuit Works, packed with the latest and most up-to-date equipment, a scene which Heath Robinson made the most of when he was asked to paint it. His colourful view, completed in 1933, is all wheels and pulleys, bustle and steam, with hordes of workers at every point on the production line. It is hard to believe that a new factory would have, as its main

source of power, one man pedalling and another winding a handle, but that is how Heath Robinson saw it. The man on the handle is wearing a kilt, a subtle reference to the company's Scottish origins.

The hygienic precautions so important in food manufacturing offered plenty of scope for Heath Robinson's imagination. All the workers on the shop floor are wearing aprons and chef's hats, apart from the poor chap pedalling the paddles. Curiously, all the workers are men. During the late 19th century many women went to work in the cotton mills in Lancashire, and you might expect to find some in a biscuit factory. Almost all the men are middle-aged and on the tubby side, a Heath Robinson trademark as recognizable as Beryl Cook's fat ladies a quarter of a century later.

A long line of men is seen staggering upstairs with sacks of flour, sugar and yeast – at least ten times

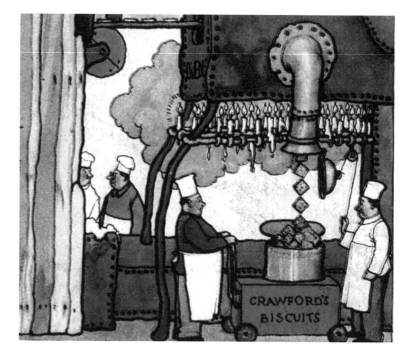

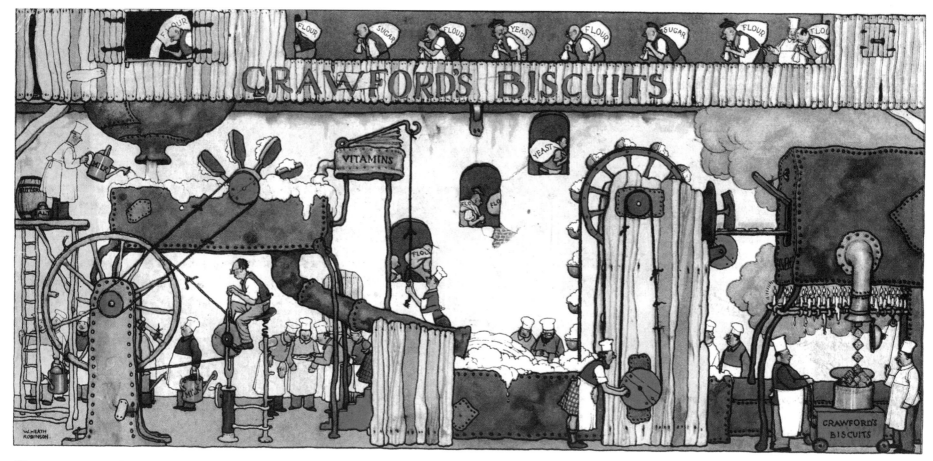

as much yeast as would be needed – but on the shop floor only four men are actually doing anything. All the others are just watching, or perhaps supervising. At a time when automation was already reducing the use of labour and raising productivity, Heath Robinson preferred to see the world going in the opposite direction. Why is the only source of water a chap with a watering can? The entire system is improbable, a scaled-up version of a suburban household, but perhaps it might work: typically Heath Robinson.

In the 1920s and 1930s, novelty biscuit tins were a popular way of promoting a company's merchandise, and Heath Robinson was asked to create one for Peek Frean, manufacturers of well-known varieties such as Garibaldi, Marie and Bourbon. His was an elaborate design with a seaside golf scene on the lid and a miniature golf course inside. The tin dates from about 1925, when the company was a household name. Founded in 1857, Peak Frean moved into a purpose-built factory in Bermondsey, south-east London, in 1866 and continued to produce biscuits there until they were closed down in 1989.

"Mr. Heath Robinson's Conception of a Modern Biscuit Plant" (left) was drawn in 1933 for use in press advertisements and packaging. Although the company was acquired by United Biscuits in 1960, production continues today under Crawford's name. At the end of the production line, scores of candles provide the heat for baking the biscuits as they pass through the oven, en route to the tin (above left).

"The Heath Robinson Golf Course", produced for Peek Frean in around 1925, was one of the most elaborate novelty biscuit tins ever designed.

FROM STONE AGE
TO TOFFEE TOWN

One of the big names in inter-war baking was Hovis. They were keen to emphasize their healthy credentials and create an impression of long-established traditions. In 1933 they engaged Heath Robinson to illustrate *An Unconventional History of Hovis*, a booklet written by S. C. Peacock purporting to trace the firm's origins back to the Stone Age. Hovis is a type of flour rich in wheat germ that was patented in 1886 by a miller called Richard "Stoney" Smith. The brand was developed by S. Fitton & Sons Ltd. of Macclesfield, who sold the flour and baking tins to bakers. The name was adopted in 1890 when Herbert Grime proposed it in a national competition held by Fitton and won. It comes from the Latin phrase *hominis vis*, "the strength of man", a theme which Heath Robinson was able to develop in virtuoso fashion.

If pre-history lacked the desired advertising punch, Heath Robinson could always play the latest-machinery card. It was a matter of pride for manufacturers to claim they had all the newest technology, and Heath Robinson humoured them, here devising a "machine adopted by all the most up-to-date sauce makers" and there a whole department for measuring the number of drops in a bottle of relish, not to mention an entire town devoted to the making of toffee. Whether the product was bread, biscuits, sauce, toffee or sherry, Heath Robinson was able to describe each stage in the manufacturing process without prompting a single yawn, from the factory floor to the final taste test.

An Unconventional History of Hovis contains a selection of recipes using Hovis flour, including veal and ham rissoles, scones, baked ginger pudding, orange jelly and crumpets.

Romans land from their triremes bearing gifts of Hovis to win over the Ancient Britons, in a delightfully implausible scene from the advertising booklet An Unconventional History of Hovis, illustrated by Heath Robinson.

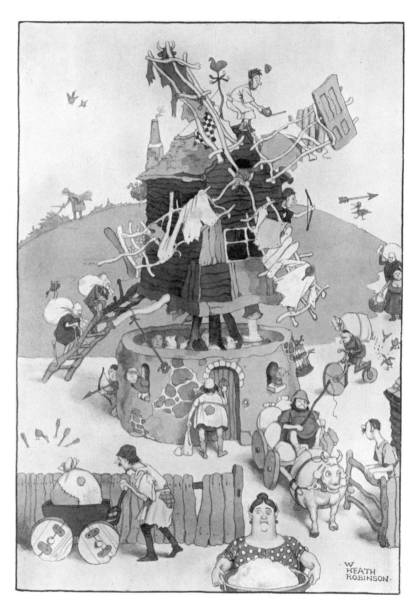

The invention of the windmill in the Middle Ages was a turning point in the history of flour making and bread production, and few machines have lent themselves better to a flight of Heath Robinson whimsy.

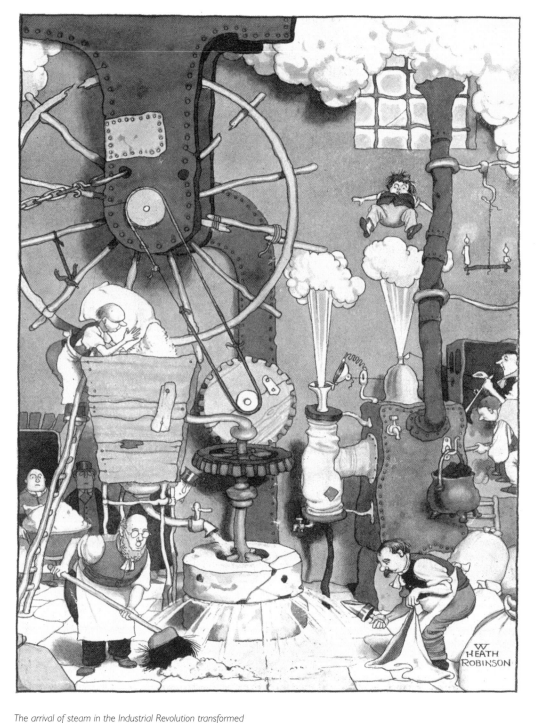

*The arrival of steam in the Industrial Revolution transformed
the industries of corn-milling and baking. In Heath Robinson's
depiction of the first steam mill, a small boy sits on a vent
to raise the pressure until the force of the steam sends him
flying though the air.*

66 When steam was young
Did little boys sit on the vent,
To keep it shut and raise the pressure?
What happened when too high it went
And shot aloft their little weights
Right through the roof
and broke their pates –
Did mother lose her treasure?
When steam was young. 99

S. C. Peacock,
An Unconventional History of Hovis, 1926

This magazine advertisement, which was also published as an illustration in the Hovis booklet, humorously contrasts a thin, miserable and fractious family who do not eat Hovis with the plump, jolly inhabitants of the Hovis Home. The difference extends to the cat, dog, bird and even the pot plants.

Heath Robinson spills the secrets of a chutney sauce bottling plant, from "adding the final ping to the flavour" to "an ingenious and handsome apparatus for shaking the bottle and pouring out the sauce".

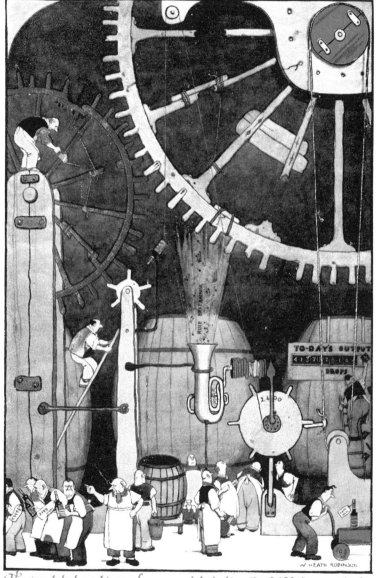

Yorkshire Relish was a spicy sauce made from pickled fruits by Goodall, Backhouse & Co. of Leeds, who commissioned this advertisement from Heath Robinson in 1922. A procession of regretful men carry away the bottles that have been rejected because they contain fewer than the prescribed 2,400 drops of sauce, but every time the target is hit, the factory is filled with strains of Rule Britannia! They continued making Yorkshire Relish until the 1960s, albeit without the fanfare.

Heath Robinson's advertisement for the toffee makers John
Mackintosh and Sons of Halifax appeared on the front page of
the Daily Mail in October 1921, and depicts the entire production
process, from boiling and cooling, via chocolate coating to "testing
the smile value".

Heath Robinson's humorous depiction of the sherry-making process was created as a laminated tin-plate advertisement for Domecq, designed to stand on off-licence counters. It probably dates from the early 1930s.

CRACKING ON
WITH CHRISTMAS

Half-crowns have been associated with Christmas since the reformed Scrooge offered that sum to a passing boy to order a turkey for Bob Cratchit. The half-crown was for hundreds of years the biggest coin in Great Britain. It was worth one eighth of a pound; that is two shillings and sixpence, or 12½ pence in today's money. The first half-crowns were made of gold, during the reign of Henry VIII. In Heath Robinson's day they were made of silver and were a worthwhile find when hidden in a Christmas pudding. By about 1950, when I was old enough to remember, half-crowns did not feature in my Christmas pudding; all I could hope for was a sixpence. The last half-crowns were made in 1970.

As usual in Heath Robinson's factory scenes, the workers making goods for Christmas are all middle-aged men, and most of them are fat and

In Heath Robinson's mythical corner of the Mint, workers in the half-crown department ensure that the supply is adequate for the coming festivities. I worry for the safety of the chap in the middle, whose weight, with some additional lumps of lead, will cause the dies to stamp the pictures and words on to the front and back of each coin. I also find it hard to believe that he could haul himself up and drop again quickly enough to fill all those buckets with coins.

balding. Furthermore they are all deadly serious in their work; rarely if ever can you find anyone smiling. He actually explains this in his autobiography: "Whatever success these drawings may have had was not only due to the fantastic machinery, and to the absurd situations, but to the style in which they were drawn. This was designed to imply that the artist had complete belief in what he was drawing. He was seeing no joke in the matter, in fact he was part of the joke. For this purpose a rather severe style was used, in which everything was laboriously and clearly defined. There could be no doubt, mystery, or mere suggestion about something in which you implicitly believed, and of this belief it was necessary to persuade the spectator. At the slightest hint that the artist was amused, the delicate fabric of humour would fade away."

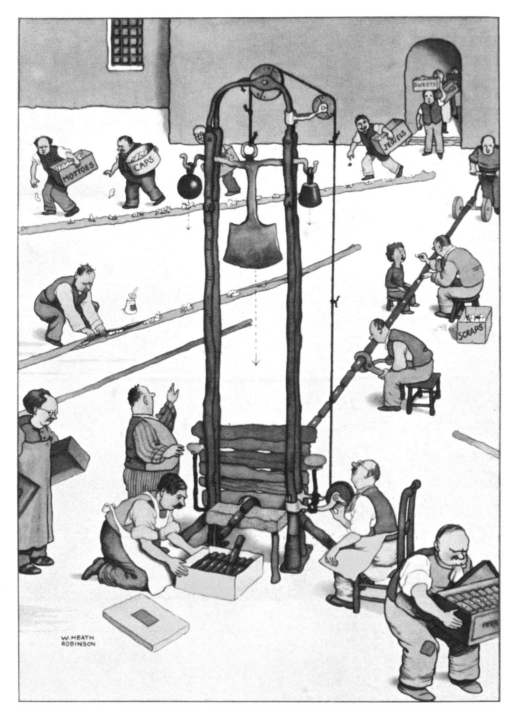

Men at the Christmas cracker factory are working overtime to cope with the expected demand, operating a rare example of a Heath Robinson assembly line.

LIVENING
UP LEFT-OVERS

In taking us behind the scenes in an old bun works, Heath Robinson is picking up a joke that was well-known in his time, about the dreadful quality of railway food. This began in the days of Isambard Kingdom Brunel, who wrote in the 1850s about the disgusting coffee served at Swindon station, and was still going a hundred years later, when comedians were continually pouring scorn on British Rail sandwiches. We are luckier today; the food on trains is frequently edible, and sometimes excellent.

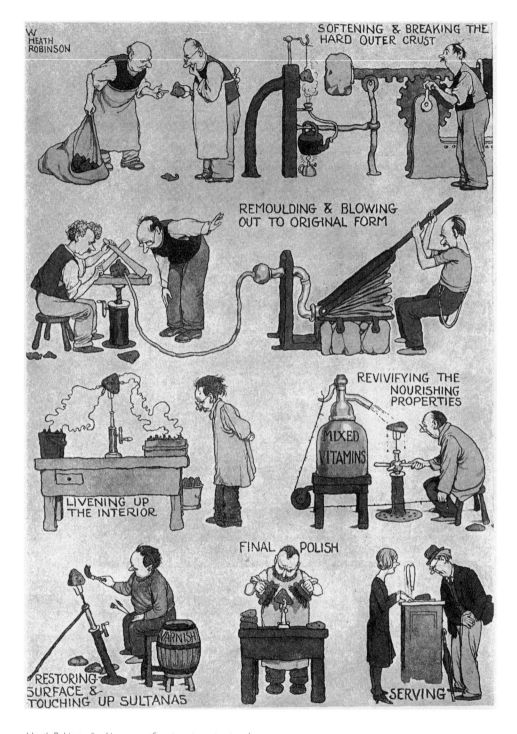

Heath Robinson lived in an era of waste not, want not, make do and mend. Here, he investigates a little-known industry devoted to resuscitating scones that have grown stale in the railway station buffet.

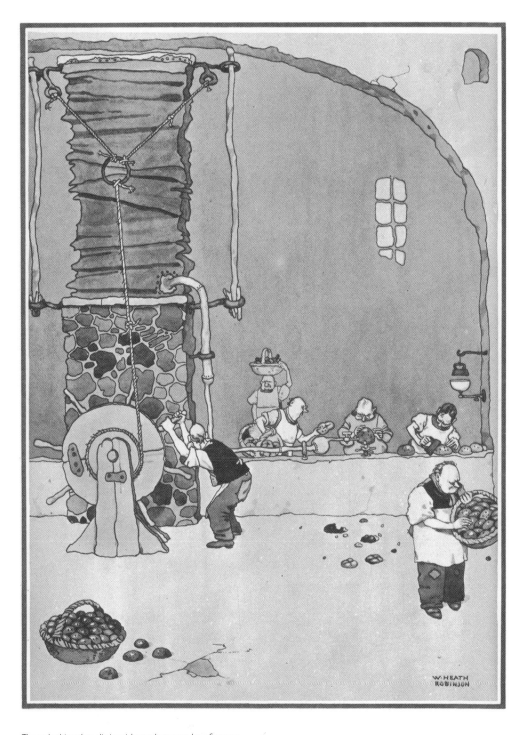

The only thing that distinguishes a hot cross bun from an
ordinary currant bun is the cross itself, but it has the unfortunate
effect of rendering the item unsaleable once Easter has passed.
Needless to say, Heath Robinson has an ingenious solution for
removing the telltale mark.

TARTAN INDUSTRIES

In 1930 Heath Robinson spent three or four days at Clydebank, west of Glasgow, and on this and other visits to Scotland he clearly imbibed something of the Scottish way of doing things. As he wrote, "I had been received with friendliness by everyone with whom I came into contact in Glasgow. But a note of triumph was sounded for me at the close of my visit. I had previously been interviewed by one of the leading newspapers. On the day before my departure it came out with an article on myself and work. A photograph was reproduced and a headline which announced in large letters that 'THE GADGET KING IS HERE'".

The life of the Highlands figures prominently in Heath Robinson's drawings. Tartan-wearing clansmen, whisky and grouse moors appear in advertisements he created for a Scotch Mist Cloth sold by the Rogers Peet clothing company in New York, Tar MacAdam road surfacing, a silver fox farm in Dumfriesshire and various brands of whisky.

When Heath Robinson was asked to create an advertisement for Sandy Macdonald Scotch Whisky, he adopted a historical approach, as he had done with Hovis, going back to the very first drop of whisky. Sandy Macdonald was popular in the early 20th century, but was swallowed by the Distillers Company, and then in turn by Diageo. You can, however, still buy a bottle of Sandy Macdonald whisky for around £650.

In 2011 the American scuba diver Leon Dehoyan found a case of Sandy Macdonald whisky in the wreck of a boat on the bottom of the Detroit river. He jumped to the conclusion that this was a favourite tipple of Al Capone or one of the other smugglers of alcohol during Prohibition. This may not be entirely fanciful, since a vast quantity of illegal liquor was smuggled hither and thither by the bootleggers of the era.

Sandy Macdonald whisky was produced at the Glendullan Distillery, which opened in 1898 in Dufftown on the River Fiddich. Heath Robinson's idea of how the whisky was made is wonderfully whimsical, employing ancient Macdonalds and prehistoric barley cutters.

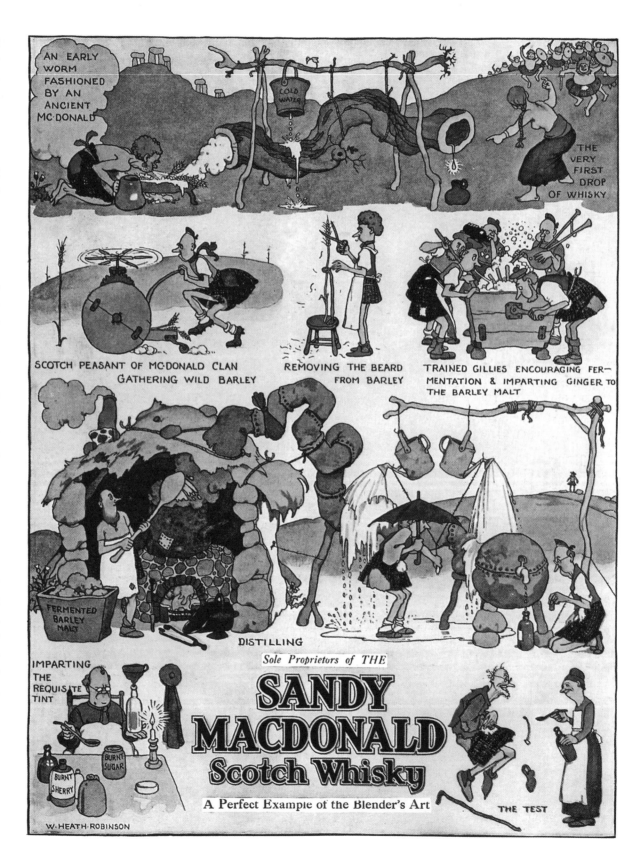

As Sandy Macdonald whisky was on the wane, fur farming appeared in Scotland. People have domesticated animals for thousands of years: cats for mouse control; dogs for hunting; cattle for meat and milk; sheep for wool; and chickens for eggs. One of the more recent domestications was the silver fox.

The silver fox is a melanistic – black-coloured – form of the red fox, and has been highly prized for its beautiful, silky, silver-grey fur, especially where people loved to wear fur coats. In the fur-trapping areas of north-eastern North America, and especially in Prince Edward Island in the late 1890s, the best skins were worth up to $1,000 each. The finest fur came from pure-bred silver foxes, but in the wild, silver foxes would mate with red foxes, and most of the cubs would be fiery red with black markings, so few pure silver foxes were born. Farmed silver foxes were better than wild ones, partly because they had a better diet, but mainly because they could be guaranteed pure.

Between the two World Wars fur farming grew in popularity. At Thornhill in Dumfriesshire, Thomas Melrose started a silver fox farm and expanded the business rapidly, acquiring other farms and advertising nationally and overseas for investors. He produced lavish prospectuses with illustrations by a number of artists, including H. M. Bateman, Arthur Watts and Heath Robinson, and offered his clients free shooting over his grouse moor. It was all to no avail. The business failed and Melrose was declared bankrupt in 1939, but we still have Heath Robinson's illustrations showing just how well Melrose cared for his foxes.

Heath Robinson documents an ancient and ingenious method for applying tartan to kilts in the Scottish Highlands.

During the 1920s and 1930s, the Nithsdale silver fox farm flourished at Thornhill, in Dumfriesshire. The proprietor, Thomas Melrose, commissioned Heath Robinson to produce this advertisement, showing how they wined and dined the animals, for Fur Farming magazine in 1932.

TESTING, TESTING

Whenever a new product or material is invented, it must be tested. An engineering professor at M. I. T. tells his students, "If you haven't tested it, it doesn't work". Heath Robinson was well aware of the importance of testing, and saw a wide variety of tests in his factory tours. He came away with a rich fund of ideas, and many of his drawings — especially sequences of drawings of the same industry — show rigorous if improbable testing and quality control, from road surfaces to the strength of braces and the waterproofness of mackintoshes.

Professional testing was still relatively new in Heath Robinson's day. In 1866 the Scottish engineer David Kirkaldy started his own testing business. He had been working in a foundry where boilers for high-pressure steam were about to be made using a new type of steel, and he realized that no one really knew how strong this steel was.

Using his own money, he set up a workshop in Southwark Street, London, not far from where Tate Modern stands today, and installed an enormous hydraulic tensile test machine to measure the strength of materials. The building is still there; now called the Kirkaldy Testing Museum. Over the door is his philosophy for testing, carved in stone: "FACTS NOT OPINIONS".

He described himself as the first person in the country who was paid to break things, and according to *The Engineer* magazine became the most hated man in the country, when he condemned various materials as being sub-standard. But it also called him "cautious to a degree; enthusiastic past belief; honest as the sun; outspoken and fearless as a Viking".

The need for testing was dramatically illustrated not long after Kirkaldy started his business. At 7.13 p.m. on Sunday 28th December 1879 occurred the worst engineering disaster Great Britain had ever seen. A train was heading north for Dundee and had to cross the River Tay using the bridge designed by Thomas Bouch. Opened just under two years earlier, at two miles long, it was the longest bridge in the world, and it had performed faultlessly so far. But that night there was a terrible storm. Afterwards, it was estimated that

THE HYDRAULIC TEST FOR THE STRENGTH OF WAISTCOAT BANDS & BUCKLES

THE DRUM TEST FOR COAT LOOPS AND CHAINS

TESTING CAPACITY OF OVERCOAT POCKET LINING

W. HEATH ROBINSON

the wind was force 10 or 11 — perhaps gusting to 80 miles an hour. Even with that wind blowing directly across the structure, the bridge stood firm.

The centre of the bridge consisted of 13 "navigation spans", crossed by the "high girders", 88 feet above the water, to allow ships to pass. As the train went over the high girders, there was a violent gust of wind. The high girders collapsed; the train with its six carriages plummeted into the river below, taking as many as 90 passengers and crew to their deaths. The disaster was commemorated the following year in a long poem by William McGonagall, widely celebrated as the world's worst poet.

What shocked the engineering establishment was that everyone thought the bridge was safe. The design had been approved by the Board of Trade; Thomas Bouch — who had been knighted for building it — was an experienced bridge builder. At the time

Waistcoat bands and buckles may often be subject to severe stress, particularly after a good meal, as may coat loops, while keys and small change may wear through pockets. It is therefore essential to test their strength before sale, as in this scene drawn for Moss Bros. of London.

❝Beautiful railway bridge of the silv'ry Tay; Alas! I am very sorry to say That ninety lives have been taken away On the last sabbath day of 1879 Which will be remember'd for a very long time.❞

William McGonagall, 1880

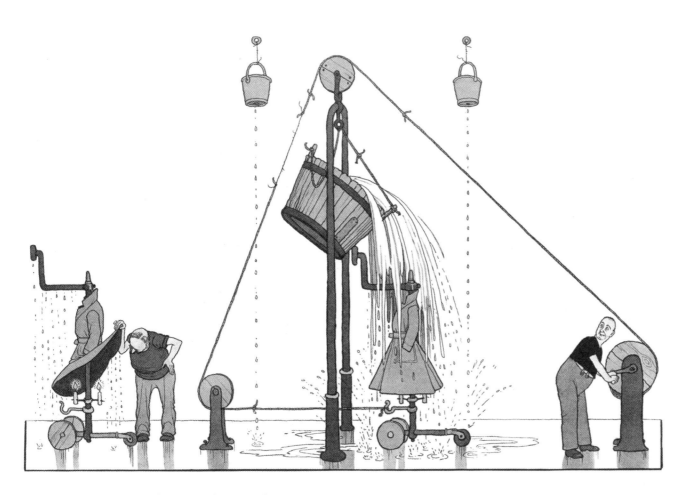

How waterproof is your waterproof? Purchasers of this rigorously tested overcoat can be confident that it will protect them from the heaviest shower.

"Testing the battery."

of the disaster, he was working on the new Forth Rail Bridge. Samples of the cast iron and wrought iron from the Tay Bridge were sent to Kirkaldy for testing, and he found that although the cast iron was immensely strong in compression it was relatively weak in tension. As a result it was also weak in bending, because the outside edge of a piece being bent must be in tension, and therefore liable to break. Technically, the cast iron lugs holding the wrought-iron tie bars had been poorly made; there were defects such as blow holes in the cast metal. The lugs varied in strength, but some failed at only 20 tons of tension, rather than the 60 tons which had been specified.

The bridge builder Bouch had assumed the iron would always be in compression, from its own weight and the weight of a train, both pushing downwards with gravity. He had not taken seriously the possibility of bending, and may have been following misleading advice on wind pressure from George Airy, the Astronomer Royal. The severe gale, and the violent gust, had pushed the bridge structure sideways, causing it to begin to bend, and the weight of the train had completed the process. Once the cast iron began to break the entire structure gave way.

Safety issues on the roads arose with the surfacing, which needed to be durable and smooth but not slippery. John Loudon McAdam was a Scottish engineer, who in 1816 became Surveyor to the Bristol Turnpike Trust at Bristol, England. Following the example set by his fellow Scot Thomas Telford, McAdam devised a method of making roads with a smooth surface that was not quickly ruined by rain. Unlike Telford, he said that a base layer of big rocks was not necessary. According to McAdam's essays of 1816 and 1819, the first eight-inch-thick layer should consist of stones no larger than three inches across. The labourers were told that if a stone would not go into their mouths it was too big. The top two inches should be made of stones no more than three-quarters of an inch across. The important thing was that they should be much smaller than the iron carriage tyres.

The road should be six feet wide, slightly raised above the ditches on either side, and three inches higher in the middle than at the edges. When the stones were compressed by the traffic rolling over them, they would form a smooth surface, more-or-less impermeable to rain, which therefore drained off into the ditches.

This system was highly effective, and after McAdam was invited to build roads in London, the word "macadamize" entered the language as a method of road building. McAdam's son James followed him into the business, and became known as The Colossus of Roads. The first macadamized road in the U. S. was Boonsboro Turnpike Road, completed in 1822.

Curiously, although McAdam had previously been involved in the tar business, he never tried putting tar on the surface of his roads in order to bind the surface and keep down the dust. Roads in Baghdad were paved with tar 1,200 years ago, but the idea was slow to catch on in the West. According to legend, it was first tried by John Henry Cassell in Millwall, England, in 1834.

In 1901 a tar barrel fell from a lorry and burst open on a road near Denby Ironworks in Derbyshire, and someone from the ironworks was sent to cover the sticky black mess with a layer of waste slag from the nearby furnaces. The Nottinghamshire county surveyor, the Welsh engineer Edgar Purnell Hooley, saw that the resulting surface was smooth and free of dust. He investigated, developed the process and patented Tarmac the following year. In 1903 he set up the Tarmacadam Syndicate Ltd., which later became The Tarmac Group and in 2014 Lafarge Tarmac.

Today most roads are surfaced with a layer of aggregates of sand mixed with asphalt. Asphalt (from the Greek meaning "non-slip") is essentially the same as bitumen, pitch or tar, a thick, sticky, black liquid which occurs naturally and can be obtained from crude oil. The resulting road surface is called tarmacadam, or "tarmac", and "blacktop" in the U. S.

The Tarmac patent ran out in due course, and other companies moved in to take a share of the ever-growing business of building roads. One of them was Newton, Chambers & Co., a large company with ironworks and collieries based in Thorncliffe near Sheffield. They manufactured a road surface called Duroid which they

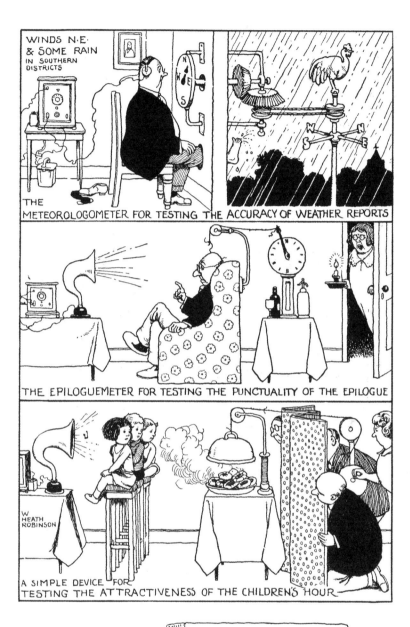

Founded in 1922, the fledgling B. B. C. is subjected to a barrage of tests to measure the accuracy of its weather forecasts, the punctuality of the Epilogue and the ability of Children's Hour to compete with rival attractions.

When testing whether safety matches live up to their name, the most stringent precautions are necessary.

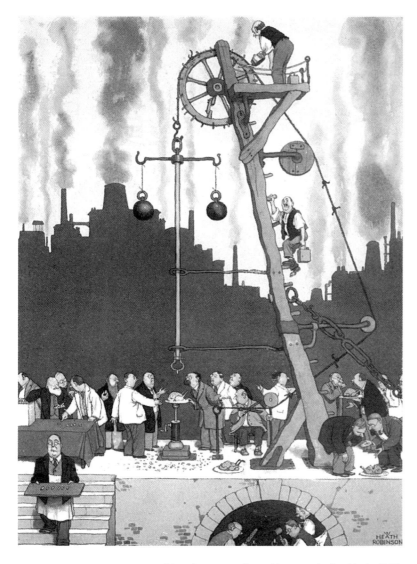

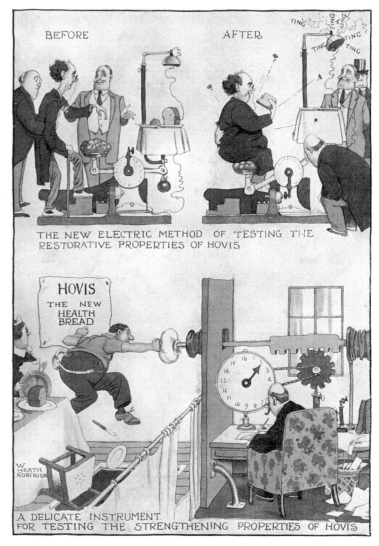

THE NEW ELECTRIC METHOD OF TESTING THE RESTORATIVE PROPERTIES OF HOVIS

A DELICATE INSTRUMENT FOR TESTING THE STRENGTHENING PROPERTIES OF HOVIS

Dentures must be equal to any eventuality – even rubbery chicken. Only a small proportion of false teeth come through this ordeal intact.

claimed was non-slip and immensely durable. In 1935 they commissioned Heath Robinson to produce drawings advertising their new wonder road-surfacing material. These were printed on desk blotters to be sent to local government councillors and showed all kinds of imaginative tests designed to demonstrate the superior qualities of Durold. Durold today is a composite material of ceramic or fibreglass and Teflon (P. T. F. E.) used as an insulator for electronics in aircraft, radar and missile guidance systems.

By the 20th century the process of testing was becoming well established and manufacturers were beginning to make products to meet specifications and standards, especially when they were for

government contracts. Frederick J. Schlink and others thought that there should be a similar system for ordinary consumers, so that they could buy products according to their real merits, rather than according to bogus advertising claims. In 1927 Schlink and Stuart Chase produced a book called *Your Money's Worth*, which became a best-seller, and started a consumer protection movement called Consumer Research, later Consumer's Union. In the book they argued for "the principle of buying goods according to impartial scientific tests rather than according to the fanfare and trumpets of the higher salesmanship".

In the work he did for food and drink manufacturers Heath Robinson embraced the

Hovis go to great lengths to measure the restorative and strengthening power of their acclaimed flour.

principle of testing as an integral part of the production process and most of his sequence drawings invariably end with a test of one kind or another: the "smile test" when children were invited to taste toffee or sugar, the "hydraulic test for the strength of waistcoat bands and buckles", an "armoured chamber for testing safety matches for safety" or an entire production line for testing new cocktails.

As a scientist, I approve strongly of the principle of testing, and of Schlink's philosophy, but I love to think that in some industry, somewhere, a gang of earnest middle-aged men are still using Heath Robinson's methods.

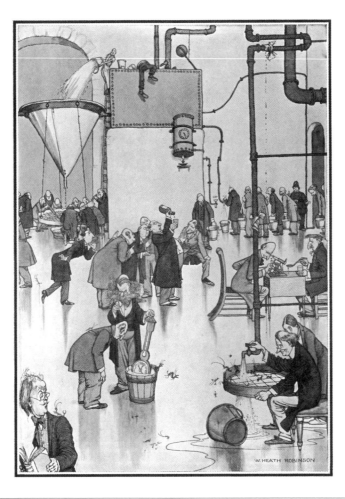

The Metropolitan Water Board spares no effort or expense to guarantee the purity of the water it provides to the public.

Part of the mural Heath Robinson painted in the cocktail bar of the R. M. S. Empress of Britain was devoted to an elaborate test for the restorative, or possibly ruinous, properties of a new cocktail recipe. Gently does it is the watchword.

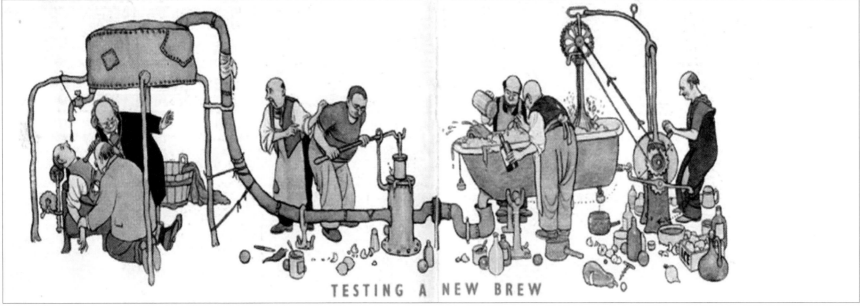

TESTING A NEW BREW

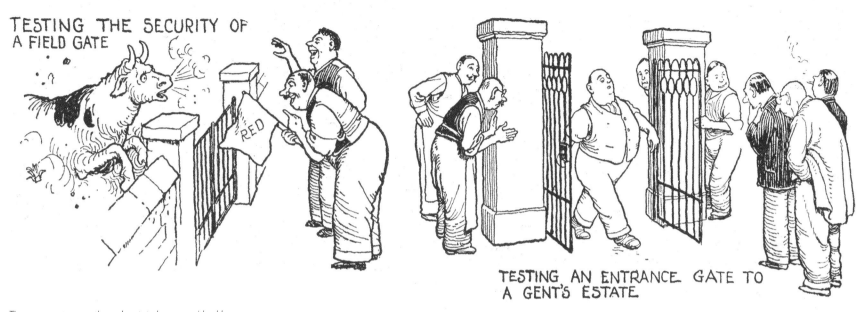

TESTING THE SECURITY OF
A FIELD GATE

TESTING AN ENTRANCE GATE TO
A GENT'S ESTATE

*The entrance to a gentleman's estate has a considerable
influence not only on his security, but also on his standing in the
world. Its effectiveness can be measured by a few simple tests.*

*The benefits of Duroid road surfacing are assessed
by driving a charabanc from an ordinary bumpy surface
on to the smooth new road.*

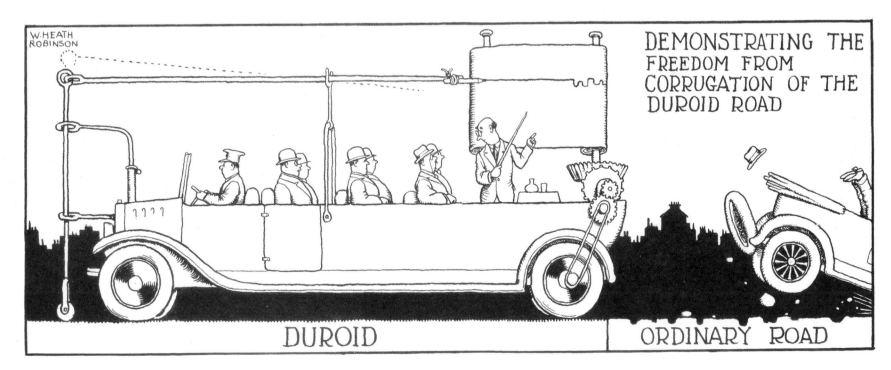

DEMONSTRATING THE
FREEDOM FROM
CORRUGATION OF THE
DUROID ROAD

DUROID

ORDINARY ROAD

CHAPTER 6

CARS, 'PLANES AND FLYING TRAINS

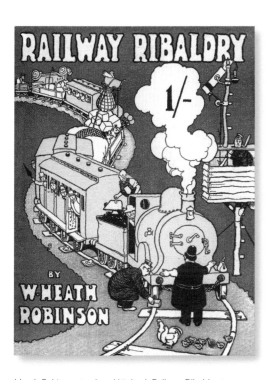

Heath Robinson produced his book Railway Ribaldry *to celebrate the centenary of the Great Western Railway in 1935.*

As a gust of wind funnels down The Strand, two passengers yield to temptation after what seems like hours stuck in a Christmas traffic jam.

Heath Robinson lived through an era of unprecedented progress in transport. Railways had already revolutionized travel in the mid-19th century, and the network went on growing in the 1900s. The first cars and motor buses appeared in the 1890s. Travel across seas was greatly improved by the invention of the steam turbine by Charles Parsons in 1897, which gave rise to a new generation of fast steamships. Most important of all was the development of passenger aircraft after Orville and Wilbur Wright made the first controlled, powered flight in a heavier-than-air machine in 1903. New and more advanced models were being introduced up to and throughout both world wars.

The world's first dedicated passenger train ran from Liverpool to Manchester on 15th September 1830. The day was a triumph for the engineer George Stephenson, and the locomotive *Rocket*, built by his son Robert. It was also a tragedy for the M. P. William Huskisson, who rashly crossed the line to talk to the Duke of Wellington, was run over by *Rocket* and died from his injuries.

The merchant venturers of Bristol observed Stephenson's work with trepidation. They worried that a railway connection with London might make Liverpool a more important port than Bristol, and decided they needed a railway of their own; so in 1833 they formed the Great Western Railway company or G. W. R. – sometimes known as God's Wonderful Railway – which received its enabling Act of Parliament in 1835.

To build the railway, the merchants turned to 21-year-old Isambard Kingdom Brunel, who had spent a year in Bristol recovering from an accident in the Thames Tunnel in 1828, and had made major improvements to the docks there. They told him at an interview that they were going to ask four engineers each to survey a route for the railway, and would choose the cheapest.

Brunel, already arrogant in spite of his youth, said that under those conditions he was no longer interested. If he

were to survey a route, it would be the best route, but certainly not the cheapest. And he walked out. A fierce argument ensued, and the merchants decided by a single vote to give Brunel the job. This was by far his biggest project and, refusing to delegate, he surveyed every yard of the route himself, and even went so far as to design the lamp posts for Bath railway station.

By the end of the 19th century, most major cities were linked to the rail network, although in London the railway companies were not allowed to carry their noise and smoke into the centre; so the stations lie mainly in two rows, north and south of the centre. Once the train had brought you to your destination, therefore, there was urban traffic to contend with – already a problem long before the advent of the internal combustion engine.

In the 1890s, when Heath Robinson was in his 20s, manure was a nightmare. London had 11,000 cabs and several thousand buses, pulled by a total of 50,000 horses. Each horse produced 20 pounds of manure per day; New York had 2.5 million pounds per day to shift. In 1894, *The Times* of London predicted that by 1950 the city's streets would be buried under nine feet of manure. So serious was the problem that an international urban planning conference was held in New York in 1898 to discuss the issue, but since none of the delegates could see any solution, they gave up after three days and went home. Yet within a few years the problem had entirely disappeared. Electric trams and then cars and motor buses led to a rapid collapse in the horse population; in 1912, traffic counts in New York, London and Paris all showed more cars than horses for the first time, and most cities had experienced their first motor traffic jams by 1914.

These new and exciting developments in transport inspired Heath Robinson's own idiosyncratic view of how trains, ships, motor cars and 'planes operated – a cornucopia of churning pistons, tooting whistles and smoke-billowing engines.

EARLY DAYS ON THE RAILWAYS

The very first steam locomotive was built in 1804 by the fiery Cornish wrestler Richard Trevithick. The first person to build high-pressure steam engines after James Watt's patent expired in 1800, Trevithick soon realized that they could be put on wheels to travel – literally – under their own steam. Sam Homfray, the boss of the Pennydarren iron works in South Wales, where one of Trevithick's engines was operating, bet a rival a thousand guineas that the "Puffing Devil" could pull ten tons of pig iron from the iron works ten miles through the Taff Valley to the wharf at Abercynon. On 21st February 1804 the great trial began, and in addition to the pig iron, 70 men climbed aboard the wagons. The journey took about two hours, and there were various problems on the way, but the engine triumphed, and the iron was delivered to the wharf. The steam locomotive was born.

Having learned from Trevithick, George Stephenson built several engines for moving coal around the pits near Newcastle and from there to the coast. One drawback with early railways was that they ran on flat cast-iron plates, which were brittle and tended to break under the weight of the engines. Stephenson was one of the pioneers to use tougher wrought-iron rails, which could take the weight.

At the G. W. R., the first locomotives were designed by Brunel, the most flamboyant of Victorian engineers. They were not a success. They proved under-powered and unreliable, and Brunel had the sense and humility (rare for him) to hand over the engine design to Daniel Gooch, who was then working for Robert Stephenson in Newcastle. Gooch went on to become a close ally and friend of Brunel's, and rescued the G. W. R. when it got into financial difficulty. When Brunel died in 1859, Gooch wrote in his diary that he was a "man with the greatest

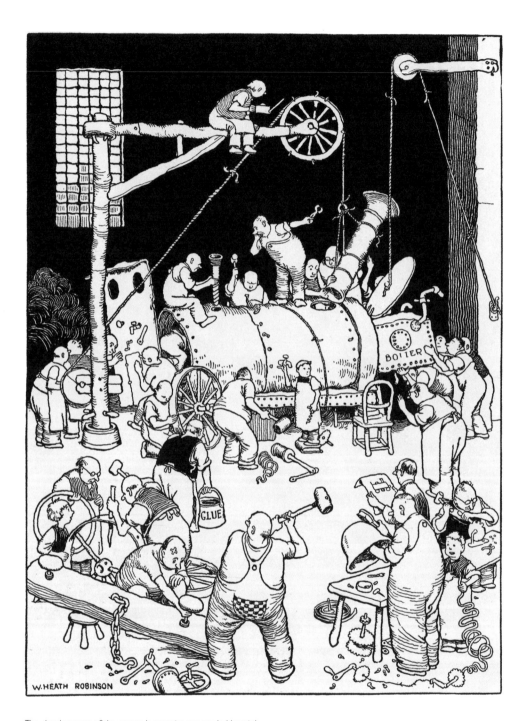

The development of the steam locomotive proceeded by trial and error, but it is unlikely that such hard-headed entrepreneurs as Trevithick and Stephenson engaged in the kind of improvisation envisaged by Heath Robinson.

originality of thought and power of execution, bold in his plans but right. The commercial world thought him extravagant, but although he was so, great things are not done by those who sit and count the cost of every thought and act."

In 1935 the G. W. R. celebrated its centenary. To mark the occasion, and to ensure that the "celebrations should really celebrate", the company turned to Heath Robinson to draw a whole series of illustrations. The result was a book entitled *Railway Ribaldry* which depicted the development of trains, combining railway truths with railway humour. But, as Heath Robinson learned, "a railway is not merely a matter of railway trains, but of stations, signals, waiting-rooms, booking and lost property offices, tunnels and no end of other things".

One of the elements of railway history that Heath Robinson depicted was the installation of the electric telegraph. In the 1830s, as railways were snaking across the U. K., the track-laying operation provided a convenient opportunity to put up telegraph wires alongside the lines. The railway companies needed a signalling system to make sure that when a train set off from a station, the line was clear and there was no train coming the other way on the same track. The world's first commercial telegraph system was laid down in 1838 for the 13 miles from Paddington along the G. W. R. tracks to West Drayton.

The electric telegraph, patented in the U. K. by Wheatstone and Cooke in 1837, and in the U. S. by Samuel Morse in 1847, allowed operators to send instant messages along wires. British telegraph machines used a system of swinging needles to convey a message, while Americans used a system of long and short pulses – the Morse code – which eventually became the world standard.

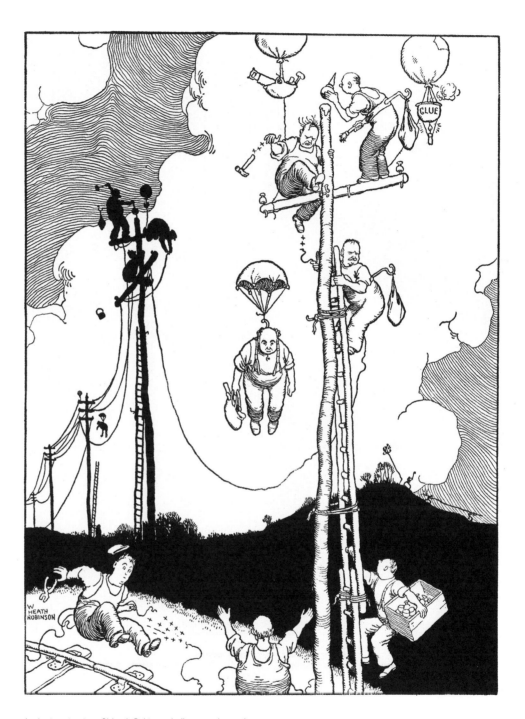

In the imagination of Heath Robinson, balloons and parachutes were indispensible to the installation of the electric telegraph along the first stretch of the G. W. R. out of Paddington.

MOVING FORWARD

The most difficult part of the G.W.R. route between Paddington and Bristol was the Box Tunnel, just east of the village of Box and ten miles from Bath. The tunnel, almost two miles long, was dug mostly by hand – men using pickaxes, shovels, wheelbarrows and gunpowder – and took five years to complete. The eastern end goes through soft clay, and had to be lined with 30 million bricks. The western end had to be blasted through hard Bath stone; every week the tunnellers got through a ton of candles – their only source of light – and a ton of gunpowder. The lethal combination of candles and gunpowder led to a number of fatal accidents.

By Heath Robinson's day, tunnels were usually dug by Tunnel Boring Machines, or T. B. Ms. Their use became widespread in the 1880s; one was used in 1883 to dig a ventilation shaft seven feet in diameter for more than a mile under the River Mersey between Liverpool and Birkenhead. A T. B. M. is like a huge railway locomotive, more than 300 feet long, with a "cutter head" of whirling teeth in front, chewing its way through sand, gravel or rock. The spoil of excavated material is taken by conveyor belt through the machine and back along its track. Heath Robinson was clearly aware of this machinery, but still had to find jobs for teams of navvies.

For his original stretch of railway between London and Bristol, Brunel had followed convention and used steam-powered locomotives to pull his trains, but he was a sucker for new ideas and inventions, and

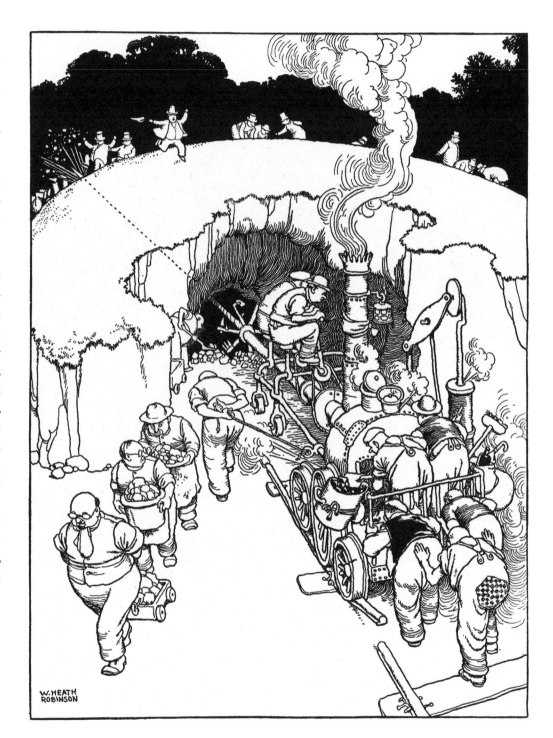

Left: A railway pioneer tests an early experiment in atmospheric propulsion, which more closely resembles a bicycle than a train.

Above: Heath Robinson's "early type of rotary excavator" looks like a missing link between the picks and shovels of Box Tunnel and the T. B. M. The cutting head appears to be steam-powered, but the rest of the work is done by the usual balding, tubby men.

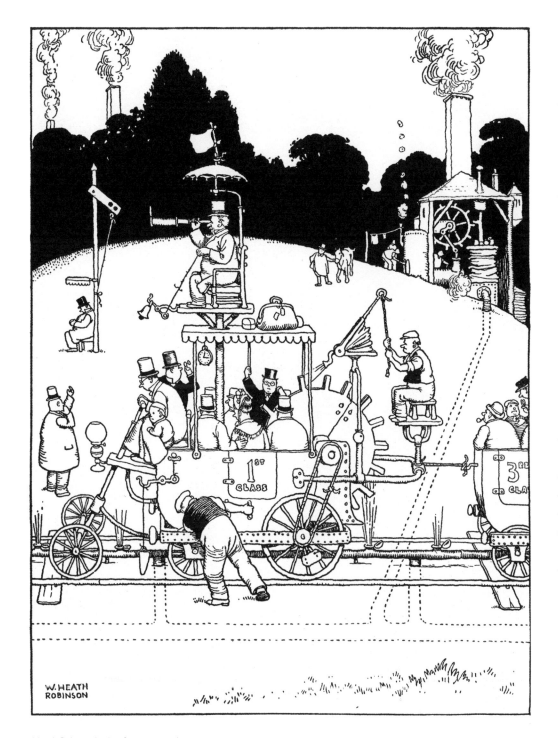

Heath Robinson's plan for an atmospheric system was to use
a steam engine to generate high-pressure air. Blasts of this air from
a pipe between the rails would push the blades of a huge fan and
thus propel the locomotive.

when he heard about the atmospheric propulsion system he at once determined to give it a try. This was five years after the G.W.R. had reached Bristol; he had extended the line to Exeter, and had won the contract to build the South Devon Railway, of which the first leg would run from Exeter to Newton Abbot.

Dispensing with the locomotive altogether, Brunel laid a 15-inch cast-iron tube between the rails, fitted a piston inside the tube and connected it to the front carriage. At each station along the way (Starcross, Dawlish and Teignmouth) a huge steam engine would pump the air out of the tube in front of the piston. This would create a low pressure, or semi-vacuum, and the pressure of the atmosphere behind the piston would push it forwards, and so propel the train.

Brunel put this into action between Exeter and Newton Abbot in September 1847, and the passengers loved it. The trains were very fast – as fast as today's InterCities – and there was no noisy locomotive, no smoke, no burning smuts. But the vacuum was never very good; it had to be maintained with a leather flap, which tended to dry out. Painting it with whale oil attracted rats, and they chewed through the leather. There was also the problem that the trains had no reverse gear; if the driver overshot the platform the gentlemen had to get out and push the carriages back to allow the ladies to alight. After nine months the whole system was abandoned, and the shareholders lost half a million pounds.

“ The Great Western Railway celebrates its one hundredth birthday this year, but unlike other Centenarians such as trees and turtles, grows more youthful after a century of existence. ”

Railway Ribaldry, 1935

THE BUILDING OF SALTASH BRIDGE

Saltash Bridge was the last major structure built by Isambard Kingdom Brunel. It carries the Great Western Railway from Devon into Cornwall, over the Tamar river. The building of the bridge was a celebrated engineering feat, and 80 years later, when the G. W. R. celebrated its centenary, Heath Robinson drew a full-page illustration of it in Railway Ribaldry. Although his work was billed as railway humour, he clearly understood the engineering techniques Brunel used. His drawing demonstrates in remarkable detail, albeit with fanciful flourishes, just how the job was done.

The 1846 Cornwall Railway Act said that the ferry linking the city of Plymouth with the town of Saltash should be replaced by a bridge, and Brunel was appointed as chief designer and engineer. The Tamar forms a vital safe haven for the Royal Navy; to allow ships to pass, the Admiralty insisted that the bridge should be at least 100 feet above high tide. The only way he could do this was to support the bridge on a single pier in mid-river, so that each span would be

455 feet. The original plan was to have two tracks, but the Cornish money ran out, so there is only a single track to this day.

Brunel wanted to construct a suspension bridge, but there was nowhere to anchor the chains, so he had to design a self-supporting suspension bridge. He did this by hanging the deck of the bridge from two oval-shaped arches, which seems to have been an idea adapted from Robert Stephenson's high-level bridge in Newcastle.

In order to build the central pier, Brunel constructed a cylinder 37 feet in diameter and 85 feet deep, which was floated into the middle of the river and sunk. The water was pumped out and the top sealed. The cylinder was then filled with compressed air to prevent flooding from below.

Forty men went down inside the tube, seen through an underwater window in Heath Robinson's drawing, and had to work in compressed air at about three times atmospheric pressure. They reported cramps and fainting, but in spite of this, they dug

Worn down by three major injuries and years of overwork, Isambard Kingdom Brunel was already in poor health as his bridge at Saltash neared completion in 1858.

The eastern span of the bridge is positioned on its piers in July 1858, ready to be raised to its full height at the rate of six feet a week.

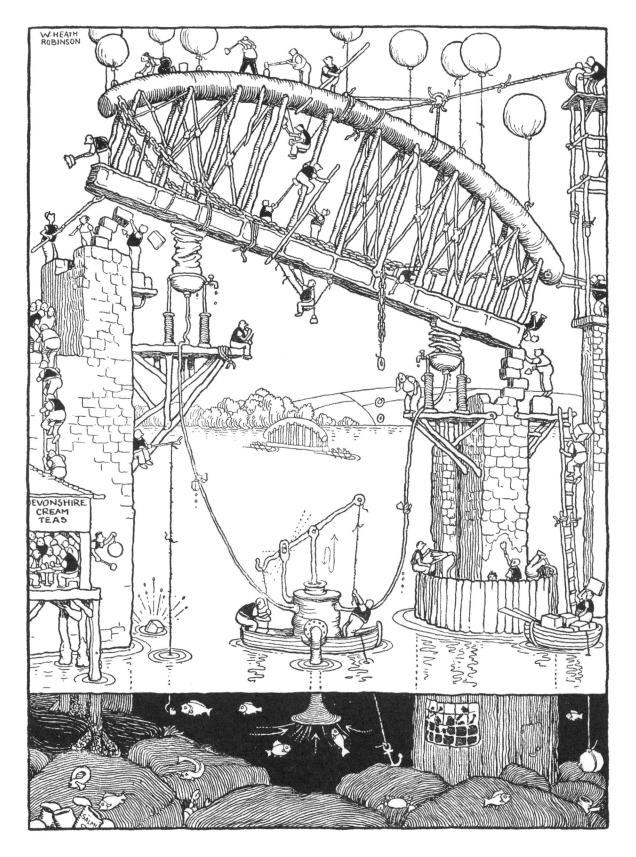

out 12 feet of sticky mud followed by three feet of rock before they reached a suitable foundation on which they could support the pier. Construction took three years, from 1853 until 1856.

When the Cornwall span was floated out on two barges and put in place, 20,000 spectators flocked to watch. Five navy ships and 500 men took two hours to manoeuvre it into position on the piers. It was gradually raised by six feet per week using hydraulic jacks, until on 1st July 1858 it reached its final height 100 feet above high tide.

When the bridge was officially opened on 2nd May 1859 by His Royal Highness Prince Albert, who had travelled from Windsor on the Royal Train, it was renamed the Royal Albert Bridge. Brunel was too ill to attend the opening. Having almost worked himself to death at the age of 53, he was towed across the bridge two weeks later on an open wagon to view his completed project. He died four months later on 15th September 1859.

In "The Building of Saltash Bridge" as imagined by Heath Robinson, pressure for the hydraulic jacks is generated by two men slaving at a beam-operated pump mounted in a dinghy, their efforts supported by hydrogen-filled balloons. Devonshire Cream Teas are on offer to spectators and an off-duty worker finds time for a little fishing, undeterred by falling masonry.

ANCILLARY SERVICES

Building a railway involved much more than creating the locomotives and the track, and the pioneers soon found themselves engaged in catering, property development and other forms of transport, including shipping. When the G. W. R. fell behind schedule, one of the directors asked Brunel whether he was being too ambitious in trying to go all the way from London to Bristol. Brunel jumped to his feet with passion, and said: no, no, on the contrary, he was not going far enough. The company should build a ship, the *Great Western*, which would steam across the Atlantic. Then passengers would be able to buy tickets all the way from London to New York. Astonishingly, the directors agreed, and he duly built his first ship.

The *Great Western* was the biggest ship in the world at the time. Built of oak, she had sails, but Brunel planned to use steam engines to drive paddle wheels. His great critic Dionysius Lardner said it was impossible to carry enough coal to cross the Atlantic. Brunel correctly reasoned that if a ship was twice as long, twice as wide and twice as high as any previous ship, then the resistance to ploughing through the water would increase by a factor of four, but the volume of the hold would increase by a factor of eight, so there would be plenty of coal – and he was right. On her maiden voyage in April 1838 she crossed the Atlantic in a record 15 days, with 200 tons of coal to spare, and went on to make 66 further crossings.

The railways also ferried people to the coast for recreational purposes. Heath Robinson loved his train journeys to the seaside – and in his lifetime such excursions were common. Many factories arranged for all their workers to be taken out for a day. All the Victorian seaside towns – including Blackpool, Scarborough and Ramsgate – had railway stations, and were poised to receive visitors, whether work outings or family holidays. The first G. W. R. excursion took place on 31st May 1838; Brunel invited 300 celebrities to climb aboard from a platform at Paddington, where there was no station yet, and they wobbled and rattled along the bumpy new track to Taplow, near Maidenhead. There they sat down to a vast celebratory lunch, and drank many toasts to the success of the railway.

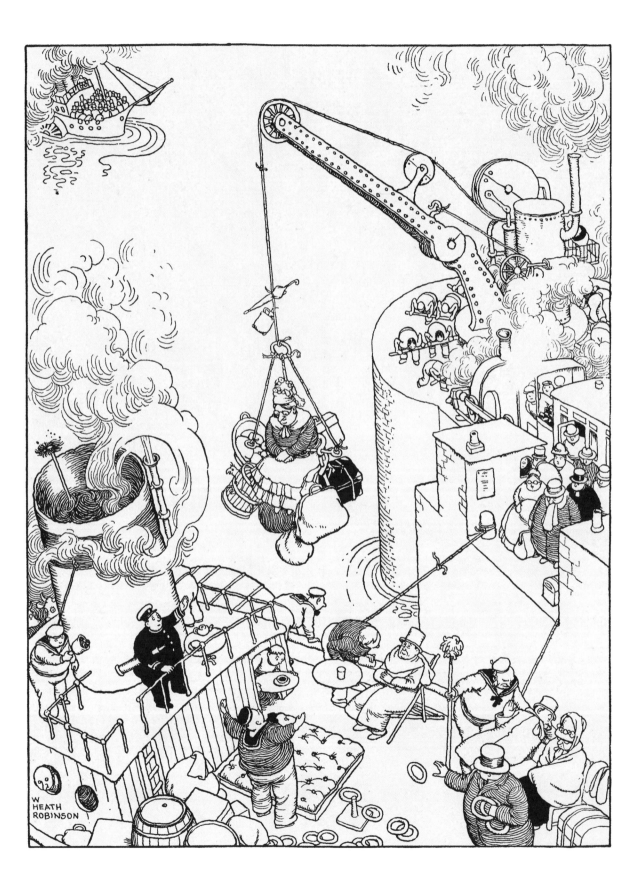

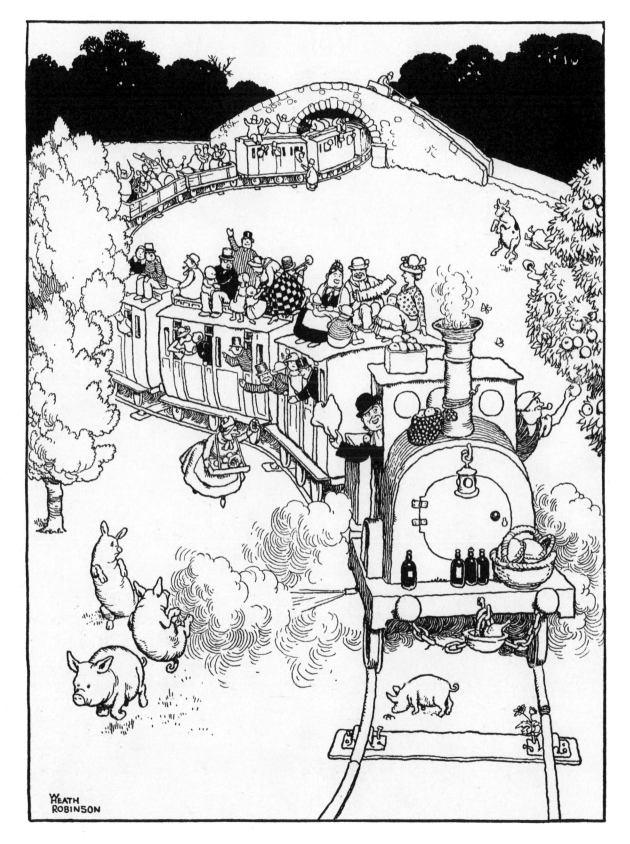

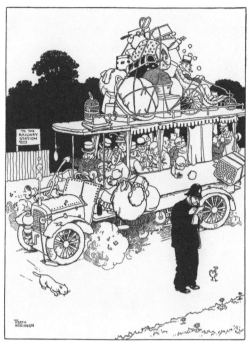

"The First Railway Bus" transports people and luggage to the station in comfort and safety.

Opposite page: Heath Robinson's steamer train deposits passengers and their luggage directly on board ship.

Left: During the G.W.R.'s first excursion in 1838, Tom Guppy, one of the Bristol merchants who founded the company, was merry enough to walk along the top of the train as it careered through the countryside at 33 m.p.h. In Heath Robinson's imagination, an entire company of revellers picnic on the roof.

COMPARTMENTS GALORE

The nature of trains meant that individual carriages could be first, second or third class, or reserved for different groups or activities, and Heath Robinson, with his delight in partitions and intricate divisions of space, made the most of the opportunities this presented.

The first sleeping car appeared as early as 1839 on the Cumberland Valley Railroad in Pennsylvania, but it was George Pullman, who founded his coach-building company in Chicago in 1867, whose name has become synonymous with them.

By adding carpets, cushions and curtains to the basic arrangement of folding berths, he increased the passengers' comfort and privacy and made the overnight sleeper train into an exciting luxury – though Heath Robinson had a few additions of his own.

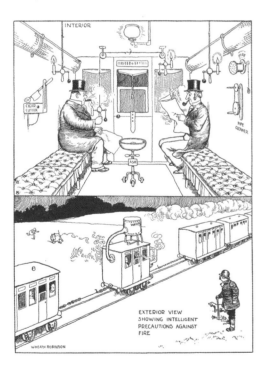

Heath Robinson clearly thought smoking carriages were unpleasant and dangerous, and should be kept well away from non-smokers.

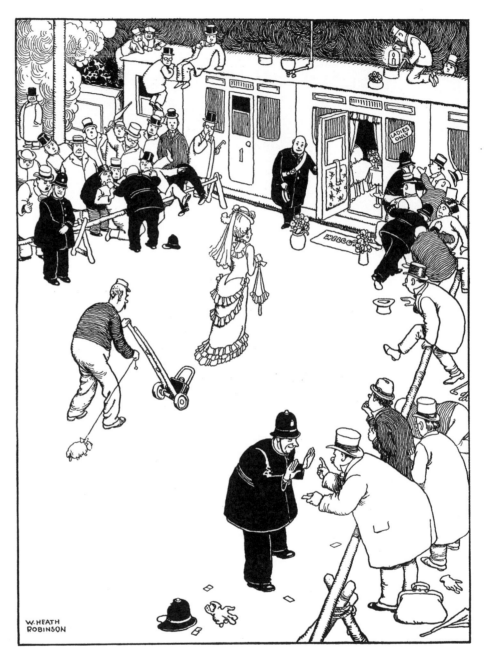

This Ladies Only compartment offers first-class home comforts, complete with flowers and welcome mat.

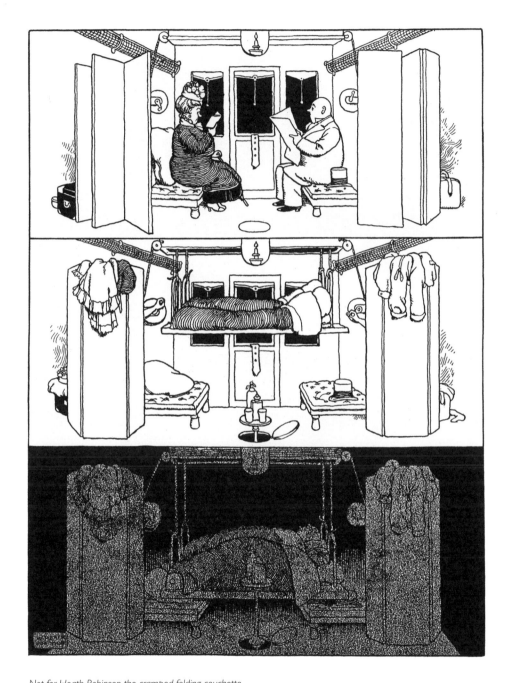

Not for Heath Robinson the cramped folding couchette
beneath the luggage rack; in his sleeping compartment,
a comfortable bed is lowered from the ceiling.

Victorian propriety encouraged the introduction of ladies-only carriages on London's Metropolitan Railway in 1874, but they did not prove popular. Only 248 of 1,060 ladies-only seats on the G. W. R. were used in 1888, with 5,141 women preferring to travel in the smoking carriages. The last women-only carriages in the U. S. A. were phased out in 1977, but they can still be found in India and Japan.

Smoking carriages became a feature of G. W. R. trains from 1868. Smoking continued to be tolerated for most of the 20th century but, as the anti-smoking movement grew, smoking carriages became rarer until, in 2005, smoking was banned from almost all trains and stations.

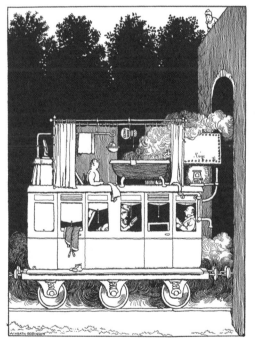

In reality, most overnight rail travellers had to make do with
a washbasin, but Heath Robinson had a much better idea.

RUNNING LATE

Delays on the line followed the establishment of regular passenger services as surely as night follows day. Among the myriad excuses offered by train operating companies, such as the wrong kind of leaves or snow on the rails, none could match Heath Robinson's ideas for how trains get delayed, which included tampering with the signals, both intentional and unintentional, and tall wildlife stories such as saving the life of an eel.

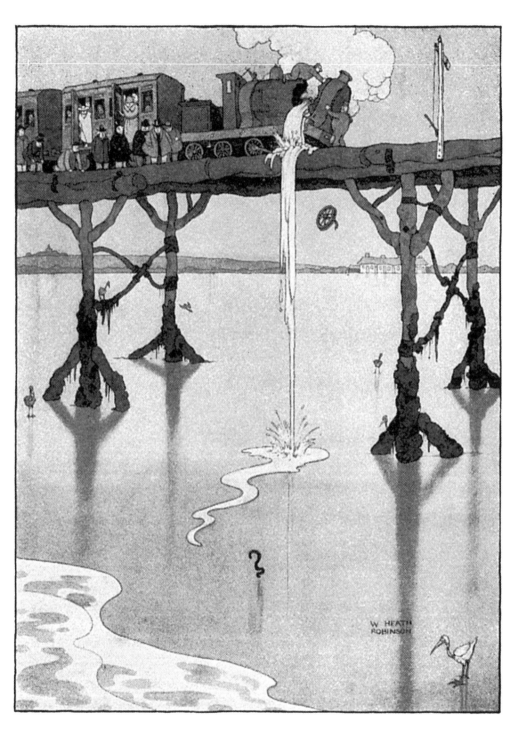

A lower-quadrant signal is held at Stop by the thoughtless action of a couple out walking, causing a near riot on the London, Brighton and South Coast Railway. To indicate the line is clear, the semaphore arm needs to drop.

An engine driver sacrifices his reputation for punctuality, not to mention his boiler and a wheel, to save the life of a stranded eel. Half a dozen predatory herons are left disgruntled by the driver's conduct, described as "heroic" in this 1925 drawing for Hutchinson Magazine.

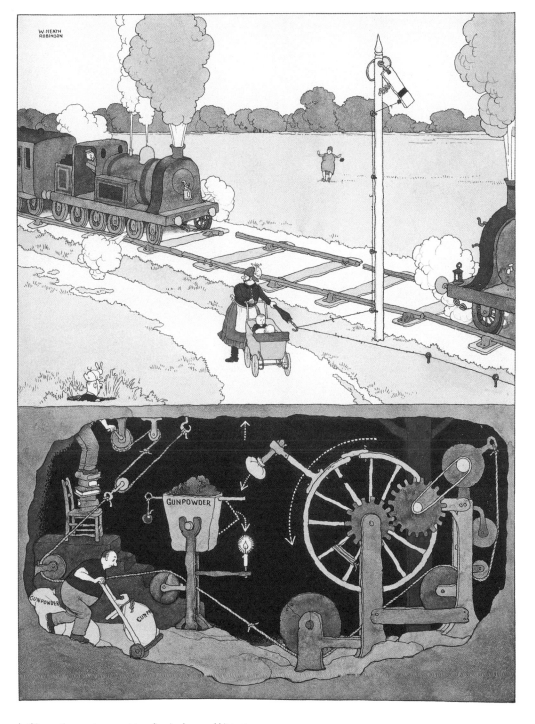

*In this war-time cartoon, a sapper disguised as a rabbit prepares
to set off several hundredweight of gunpowder. Beside the track,
an accomplice holds the signal at Clear in a "dastardly attempt"
to wreck two expresses and delay traffic for weeks.*

IMAGINING THE CHANNEL TUNNEL

Children, including the Robinsons, have always played with buckets and spades on the beach, making castles, building dams and digging tunnels. The idea of tunnelling right under the Channel between England and France has long exerted a powerful fascination, although there was the always danger that an army of belligerent Romans, French or Germans might use it as a convenient invasion route, much less hazardous than taking to the sea in boats.

In the early 1800s, Marc Isambard Brunel succeeded after many setbacks in digging a tunnel under the River Thames from Rotherhithe to Wapping. The first attempt on the English Channel was conceived by a French engineer in 1802. In 1881 mile-long tunnels were dug on both sides of the channel for the Anglo-French Submarine Railway Company, but the project was abandoned the following year, following scare stories in the press about British national defence. After various other false starts, serious tunnelling began from both sides in 1988, using 11 Tunnel Boring Machines, and the "Chunnel" was first used by passengers in 1994.

Heath Robinson anticipated this major engineering feat in a series of impressive if slightly fanciful drawings. As for security and safety, some immigrants have tried to get through the tunnel from France, but Great Britain has not yet been invaded. There have been a few fires in the tunnel, and some trains have broken down, but there have, thankfully, been no reported leaks.

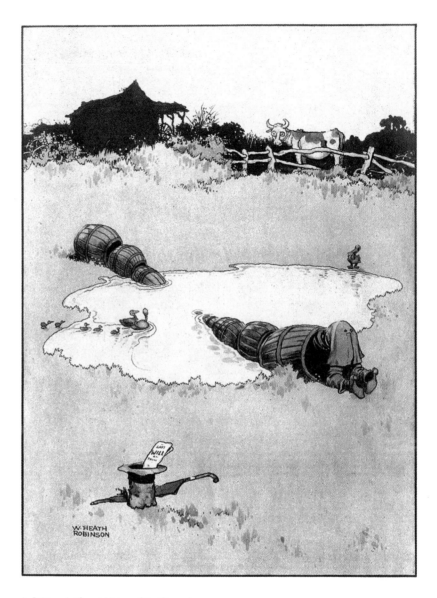

In Robinson's "Secret History of the Channel Tunnel", a pond provides the testing ground for an early experiment in prefabrication.

"A well-known magnate of the port of Dover laying the foundation stone of the tunnel in the Channel."

A leak in the Channel Tunnel would result in a catastrophic inrush of water, but in the gentle world of Heath Robinson, the consequences are somewhat less than disastrous.

MANNERS
FOR MOTORISTS

Heath Robinson was born before the the internal combustion engine was invented, and grew up in a world without cars. He recalled his horse-powered Sunday school treats with delight:"On the appointed day, eight or nine wagonettes assembled outside the school. Each of them was gaily decked with flags and streamers and had a brightly striped awning for protection against sun and rain… Two long benches, facing one another, ran along the length of each wagonette, and on these the children crowded… The horses tossed their heads, impatient to start."

The first experimental horseless carriages appeared in the 1880s, but cars did not become readily available until about 1908, when the Model T Ford hit the road. In that same year, Heath Robinson, now 36, had his first ride in a motor car. He had been asked to illustrate *A Song of the English* by Rudyard Kipling, and was summoned to visit the great man at his home in Burwash, Sussex.

"This was an excursion I shall always remember. I was met at Heathfield and journeyed thence in a motor-car. There were few cars on the road in those days, and this was a joyful experience as we drove through the pleasant Sussex lanes."

By 1934, there were two million cars on the roads of Great Britain. In that year no fewer than

"The Motorist's Companion."

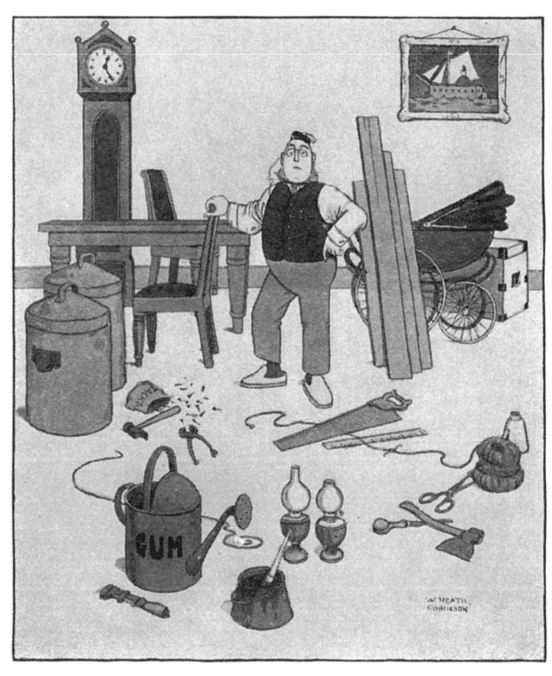

Heath Robinson could not resist the idea of drawing a set of instructions (above and opposite) for the do-it-yourself car-maker. The components include old dustbin lids, the movement and case of a grandfather clock and a picture frame for the windscreen.

"Wheel testing."

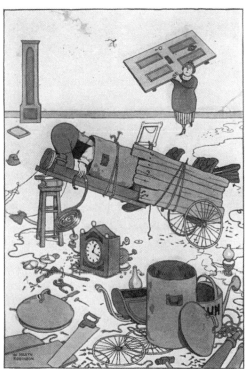

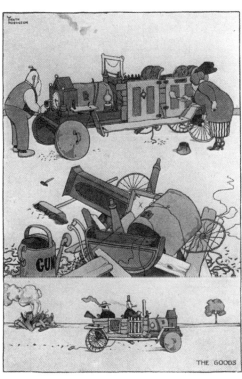

THE GOODS

7,343 people were killed on the roads; today there are 35 million cars, but fewer than 2,000 people are killed each year. Today's roads are crowded with cars that can travel at high speeds, and yet the roads are much safer, for several reasons: drivers were less well trained and less experienced in the early 1930s; there were no speed limits; and both road surfaces and brakes were poor.

In the introduction to *How to be a Motorist*, which Heath Robinson produced with K. R. G. Browne in 1939, Browne explains they were writing mainly for beginners, but "the experienced road-hog who needs something to read in road-blocks will find it pretty instructive too. Apart from Heath Robinson and myself, nobody knows everything about motoring; indeed, many motorists now at large know practically nothing, if one may judge by their behaviour on the road. Everybody, in short, who is ever likely to drive, be driven in, or get run over by a mechanically propelled vehicle will find something of interest in the following pages."

"The New Zip-opening Bonnet."

" I will build a motor car
for the great multitude...
constructed of the best materials,
by the best men to be hired,
after the simplest designs
that modern engineering
can devise. **"**

Henry Ford, 1913

215

SAFETY FIRST

The Highway Code was introduced in 1931 but did not mention mirrors and contained only one paragraph on how pedestrians should cross the road safely. In 1934, Leslie Hore-Belisha, the Minister of Transport, was almost knocked down by a sports car careering along Camden High Street. He quickly introduced the 30 m.p.h. speed limit, the driving test and the flashing orange Belisha beacons at pedestrian crossings. As a result, the death rate was greatly reduced.

The "Safe Road-Crossing" will hoist pedestrians over the busiest traffic in comfort and security and deposit them on the opposite side of the road.

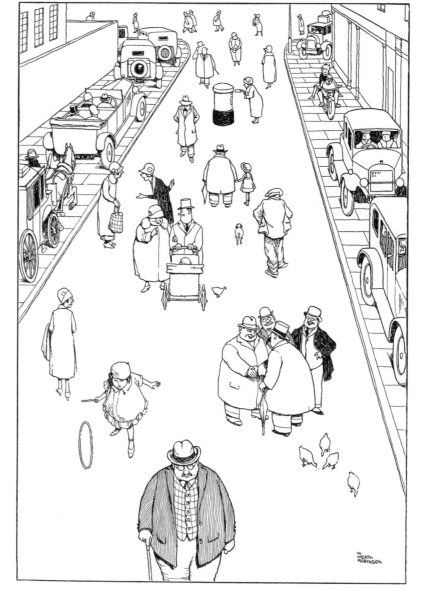

New traffic regulations envisaged by Heath Robinson "to ensure the comfort and safety of pedestrians" would give them the right of the road, while restricting motor vehicles to the pavements.

Left and opposite: Road signs made simple.

Heath Robinson had his own novel solutions to the dangers faced by pedestrians, although some of his whimsical remedies would perhaps be difficult to enact. Nevertheless, his concern for their safety was right and considerably ahead of its time. In many towns and cities we now have cycle lanes and traffic-free areas which are safe for pedestrians, though many motorists continue to drive too fast, and without sufficient care and attention.

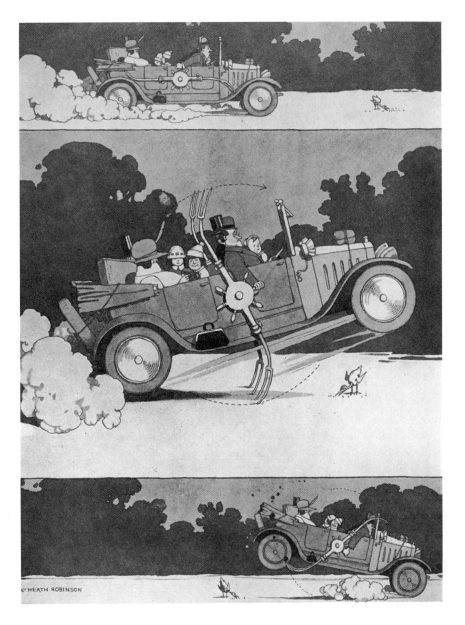

"The New Safety Fork Adjustment for Motor-Cars for the protection of Chickens on the Road."

A party of old beaux travelling aboard a bus act with gallantry and quick-thinking to save a pedestrian who has fallen in front of the vehicle.

DUCK TO WATER

When I was learning to swim around 1950, my usual flotation device was an inflated inner tube from a car tyre, which kept my head above water brilliantly, although I was occasionally prodded by the valve. Heath Robinson may have used an inner tube himself when learning to swim, but in any case was clearly taken by the buoyancy of inflated tubes, and used the idea in his amphibious Water Coupé.

There have been many amphibious vehicles, used for both domestic and military purposes. A memorable example is the D. U. K. W. or Duck, a six-ton beast made for American forces during the Second World War. The name comes from General Motors: D. means Designed in 1942; U. means Utility; K. means drive to all six wheels; and W. means dual rear axles. It has a top speed of 50 m.p.h. on land and 6 m.p.h. on water, and can carry two tons of cargo or troops. It was used extensively in various war-time operations including the D-Day landings. A number of Ducks survive, and you can often see one crossing the Thames and driving through the streets of London. I have also seen a pretty blue saloon driving into Loch Ness in search of the monster.

Heath Robinson enjoyed taking simple ideas to extremes, and stretching both his imagination and our credulity. In response to fuel shortages during the Second World War, he devised a pedal-driven car — but why not put her ladyship in a seat on the back of the bicycle? Clearly, he wanted her to travel in style and comfort.

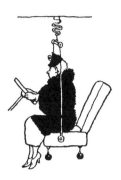

"The Anti-Vibration Seat."

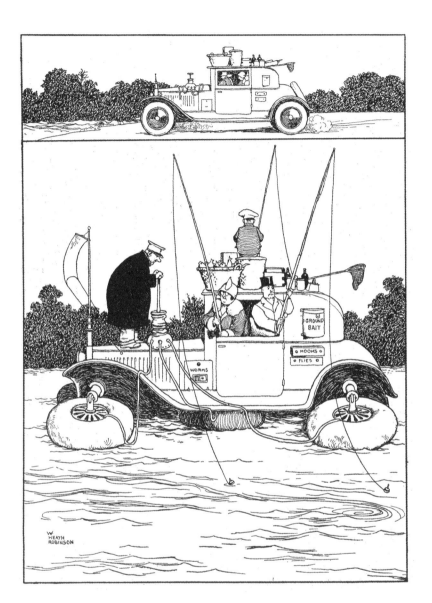

Heath Robinson's amphibious Water Coupé doubles as a fishing platform with compartments for worms and ground bait.

Robinson and Hunt's war-time book How to Make the Best of Things *proposes a novel solution to the problems of petrol rationing.*

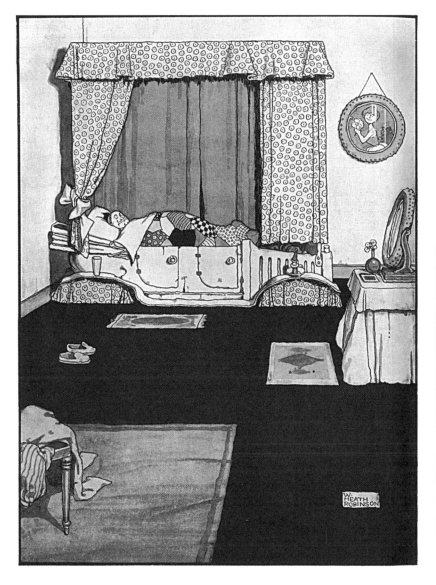 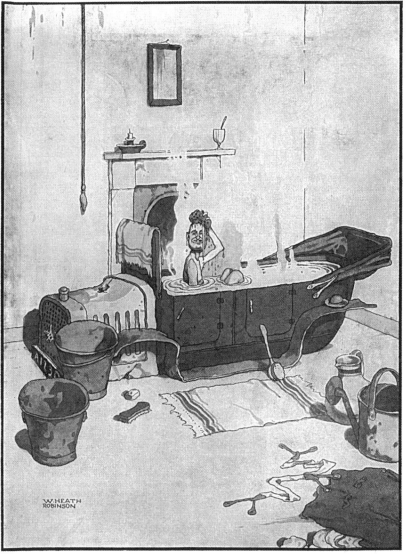

*Old cars, alas, usually get sold for scrap or left to rot
in garages or fields, but in Heath Robinson's world they
become luxurious beds or baths.*

"The early motor-car moved
in such mysterious ways
that it was often hard to say
if we were coming, going,
or just oscillating slightly."

W. Heath Robinson and K. R. G. Browne,
How to be a Motorist, 1939

CLEARING THE WAY

Litter was a problem that worried Heath Robinson. Always a nuisance – unscrupulous Romans were happy to discard their junk in the street, on the beach or in the sea – littering has become much worse in the past 50 years. Everyone has become more affluent and therefore able to buy junk food and fizzy drinks. Fish and chips used to be wrapped in old newspaper, which was biodegradable, but now comes in polystyrene boxes, which are not. Most city pavements are peppered with chewing gum. Fizzy drinks are sold in aluminium cans or plastic bottles, and much of our food comes in polythene bags, which litter the streets and hedgerows. Although polystyrene and plastic were unknown to Heath Robinson, he devised a fabulous machine for collecting scraps of paper, cigarette ends and other junk.

Snow is another problem that preoccupied Heath Robinson. Northern countries such as Canada and Sweden are well equipped to deal with it, but it falls too rarely in the U. K. for councils to invest heavily in equipment, resulting in chaos on the roads. They should be jumping at some of his ideas for clearing the way for motorists and pedestrians.

"The joys of motoring without consuming petrol."

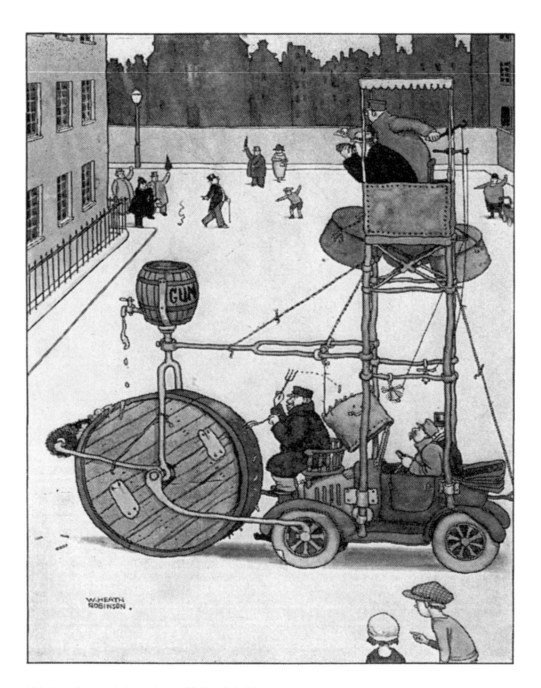

High above the street in the crow's nest of Robinson's Anti-Litter Machine, an eagle-eyed inspector sights a culprit

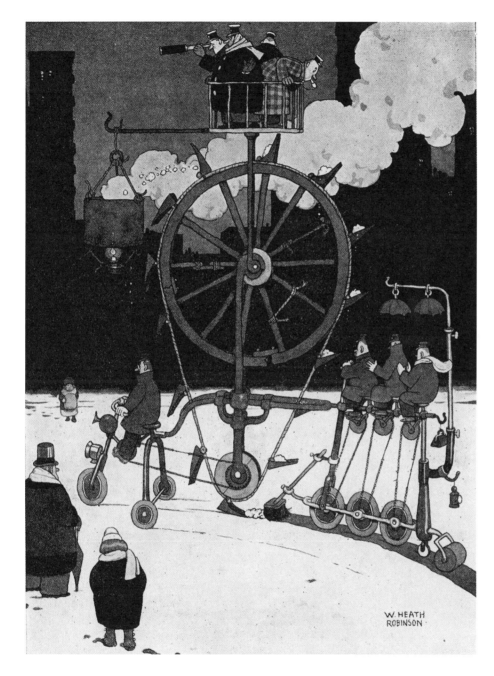

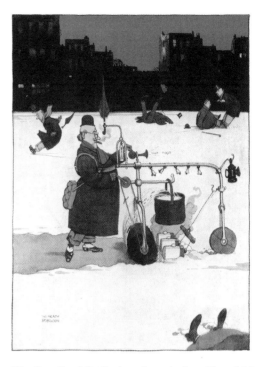

"New Snow Plough for Clearing a Footpath after a Heavy Fall."

"The wonderful Heath Robinson New Patent Thawing Machine.
This stupendous invention has been specially designed to enable
the pedestrian to walk with confidence on the most slippery roads."

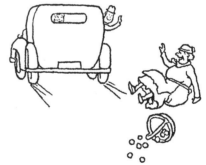

"Take your troubles cheerfully."

DREAMS OF AERIAL TRAVEL

During Heath Robinson's lifetime air travel was still young and was becoming ever more exciting. Over the 10 years after Wilbur and Orville Wright made their first flight in 1903, the technology developed gradually until the First World War, when the process was accelerated.

The first regular fixed-wing passenger service began on 1st January 1914 between St. Petersburg and Tampa, in Florida, and by 1931 passenger aircraft were flying from Great Britain to South Africa and Australia, as well as to Cairo, Basra and Karachi.

Airships, sometimes called "dirigibles" from the French *dirigible*, meaning steerable, were inspired by the balloons invented by the Montgolfier Brothers and Professor Jacques Charles in France in 1783. Charles used hydrogen to lift his balloon, and the same gas was used in early airships. One of the first, L. Z. 1., was launched by Count Zeppelin in July 1900. Zeppelin went on to build many more airships, several of which were used by the world's first airline, D. E. L. A. G., or Deutsche Luftschiffahrts-Aktiengesellschaft, which began in 1909 and carried 32,722 passengers over the next five years.

The problems with airships are that they are slow, badly affected by winds and carry small payloads because their lifting power is small: an airship carrying a cubic metre of hydrogen can lift only one kilogram. Furthermore the lightest gas for lifting is hydrogen, which is dangerously flammable. The terrible fire that engulfed the *Hindenburg* on 6th May 1937 killed 36 people – although 62 of those on board amazingly survived – and heralded the end of airship passenger travel.

Whatever the facts of aerodynamics and lift, Heath Robinson's imagination knew no bounds when he began to dream up flying machines.

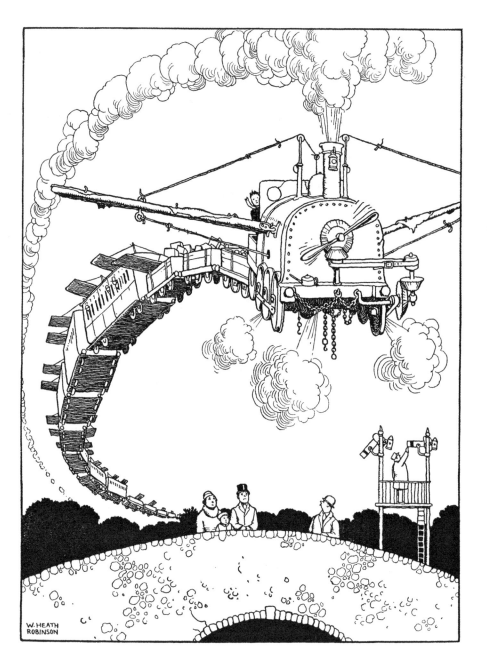

The steam locomotive takes to the air, doing away with the need for tunnels – or rails for that matter.

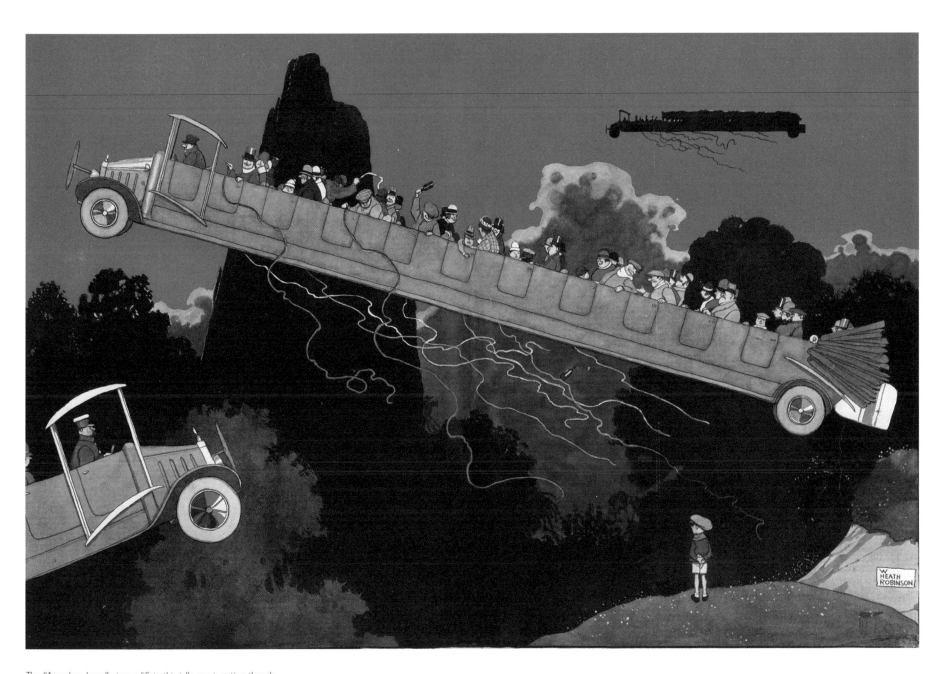

The "Aerocharabanc" gives a lift to this jolly group outing, though
spectators on terra firma should beware of bottles thrown overboard.

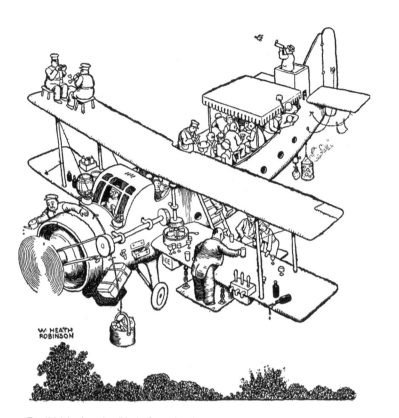

This "Holiday Aeroplane" looks forward to the age of mass charter flights, but comes complete with a small brass band, observation platform and bar.

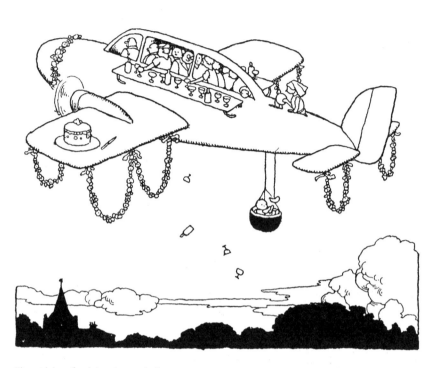

"A new 'plane for christening parties."

"Practical Aeronautics in comfort for married people."

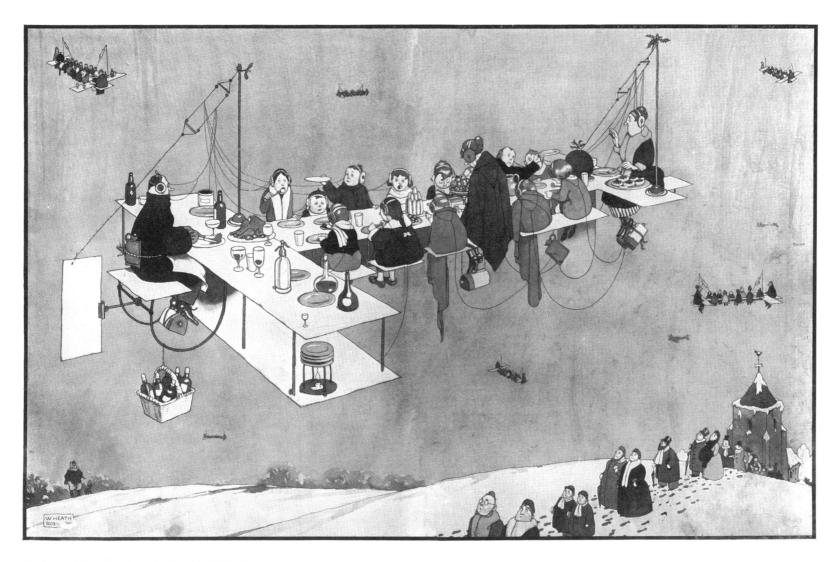

The first music broadcasts began in Holland in 1919, and could be picked up in England. Heath Robinson's Christmas gliders are therefore equipped with wireless sets and headphones so that the family could listen to these popular "Dutch Concerts" during their festive meal.

The "21st-Century Cycloplane" uses pedal power
to propel a balloon above the countryside.

The "Eton Plane" provides V. I. P. transport for
pupils at England's most exclusive private school.

Heath Robinson's "Personal Aerial Travel System for Ladies"
places great faith in the lifting power of the balloon.

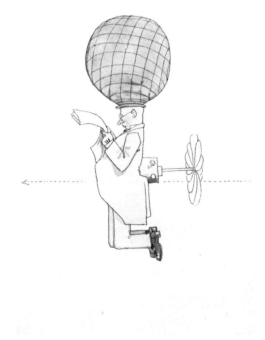

The "Personal Aerial Travel System for Gentlemen"
offers a foretaste of the James Bond jetpack.

> " Flying may not be
> all plain sailing,
> but the fun of it
> is worth the price. "
>
> Amelia Earhart

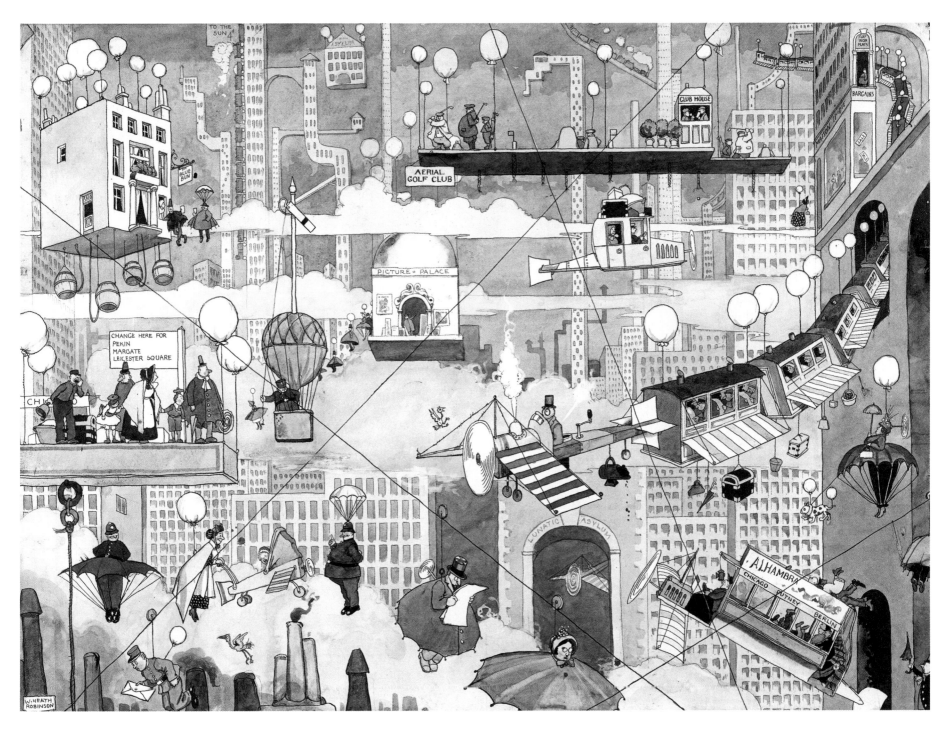

In Heath Robinson's imagined future, both public and
personal transport will take to the air, creating new problems
for traffic management.

SELECT BIBLIOGRAPHY

BOOKS WRITTEN AND ILLUSTRATED BY WILLIAM HEATH ROBINSON

Robinson, W. Heath,
The Adventures of Uncle Lubin, Grant Richards, London, 1902.
Bill the Minder, Constable and Co., London, 1912.
Hunlikely! Gerald Duckworth and Co., London, 1916.
The Saintly Hun, Gerald Duckworth and Co., London, 1917.
The Home-Made Car, Gerald Duckworth and Co., London, 1921.
Humours of Golf, Methuen and Co., London, 1923.
Absurdities, Hutchinson and Co., London, [1934].
Railway Ribaldry, Great Western Railway, London, 1935.
My Line of Life, Blackie & Son, London, 1938.

COLLABORATIONS

Hunter, N., and Robinson, W. Heath,
The Incredible Adventures of Professor Branestawm, Bodley Head, London, 1933.
Browne, K. R. G., and Robinson, W. Heath,
How to Live in a Flat, Hutchinson and Co., London, [1936].
How to be a Perfect Husband, Hutchinson and Co., London, [1937].
How to Make a Garden Grow, Hutchinson and Co., London, [1938].
How to be a Motorist, Hutchinson and Co., London, [1939].
Let's Laugh, Hutchinson and Co., London, [1939].
Hunt, Cecil, and Robinson, W. Heath,
How to Make the Best of Things, Hutchinson and Co., London, [1940].
How to Build a New World, Hutchinson and Co., London, [1940].
How to Run a Communal Home, Hutchinson and Co., London, [1943].

ADVERTISING BROCHURES

Robinson, W. Heath,
The Light Side of Photography, Wellington & Ward Ltd., Elstree, [1925].
The Wonders of Wilmington, G. & T. Earle, 1925.
Behind the Scenes at Moss Bros, Moss Bros. & Co. Ltd., London, [1936].
The Story of Connolly Leather's First Hundred Years 1878-1978, Connolly Leather, London, 1978.
Peacock, S. C., and Robinson, W. Heath,
An Unconventional History of Hovis, Hovis Ltd., Macclesfield, [1926].

BOOKS ABOUT WILLIAM HEATH ROBINSON

Andrews, C., Nickerson, F. and Wooton, D.
William Heath Robinson 1872-1944, (Eds.) Chris Beetles Ltd., London, 2011.
Beare, G.,
The Illustrations of W. Heath Robinson, Ltd., Werner Shaw London, 1983.
Heath Robinson Advertising, Bellew Publishing, London, 1992.
Heath Robinson, Dulwich Picture Gallery, London, 2003.
Beare, G., and Cornelissen, J. *The Brothers Robinson,* Chris Beetles Ltd., London, 2011.
Day, L., *The Life and Art of W. Heath Robinson,* Herbert Joseph Ltd., London, 1947.
Hamilton, J., *William Heath Robinson,* Pavilion Books Ltd., London, 1992.
Heneage, S., *Heath Robinson's Helpful Solutions,* The Cartoon Museum, London, 1979.
Lewis, J., *Heath Robinson: Artist and Comic Genius,* Constable and Co., London, 1973.

ACKNOWLEDGEMENTS

The author and editors have relied heavily on the help, goodwill and enthusiasm of a large number of people. We are enormously grateful to them for all their support.

In particular we would like to thank Geoffrey Beare, Luci Gosling, Jeremy Procter, Geraldine Beare and the Chris Beetles Gallery.

Sheldrake Press are grateful to the many people who worked tirelessly in our office to bring this project to fruition, including Sara Bellini, Amrita Dasgupta, Marco Di Gioia, Shriya Ghate, Guilia Grisot, Sarah Hamlin, Dawn Lisette Kanter, Tristan Kendrick, Katie Loughnane, Maria Naidenova, Tom Stottor, Danica Utermöhlen and Thomas Young.

The author would like to express particular thanks to Kezia Bayard-White, who was always quick to respond to e-mails and 'phone calls, and showed remarkable cheerful fortitude in coping with catastrophe – even when the office was largely destroyed by a typhoon of a severity rarely seen south of Clapham Common.

We offer special thanks to the Heath Robinson Museum in Pinner, for providing a permanent home for this artist's wonderful work.

PICTURE CREDITS

Sources for the illustrations in this book are listed from the top of the left-hand column to the bottom of the right-hand column on each double page.

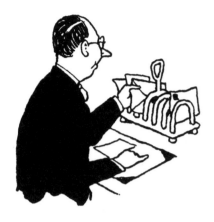

Front Cover - The Museum of English Rural Life.
Back Cover - Mary Evans Picture Library.
Front Endpapers - Sheldrake Press.
Back Endpapers - Sheldrake Press.
2/3 - Mary Evans Picture Library; The William Heath Robinson Trust.
4/5 - Don Kurtz.
6/7 - Sheldrake Press.
8/9 - Sheldrake Press.
10/11 - Jeremy Procter; Jeremy Procter.
12/13 - Mary Evans Picture Library; Sheldrake Press; Sheldrake Press; The William Heath Robinson Trust.
14/15 - Sheldrake Press; Mary Evans Picture Library; Mary Evans Picture Library.
16/17 - Geraldine Beare; Sheldrake Press.
18/19 - The William Heath Robinson Trust; Sheldrake Press.
20/21 - Mary Evans Picture Library; Sheldrake Press; Sheldrake Press; The William Heath Robinson Trust.
22/23 - Mary Evans Picture Library; Mary Evans Picture Library; The William Heath Robinson Trust; The William Heath Robinson Trust.
24/25 - The William Heath Robinson Trust; The William Heath Robinson Trust.
26/27 - Sheldrake Press; The William Heath Robinson Trust.
28/29 - Sheldrake Press; Sheldrake Press.
30/31 - Mary Evans Picture Library; Sheldrake Press; The William Heath Robinson Trust.
32/33 - Sheldrake Press; Sheldrake Press; Mary Evans Picture Library.
34/35 - The William Heath Robinson Trust; The William Heath Robinson Trust.
36/37 - Sheldrake Press; Sheldrake Press; The William Heath Robinson Trust; Sheldrake Press.
38/39 - Sheldrake Press; Sheldrake Press; Sheldrake Press; Sheldrake Press; The William Heath Robinson Trust.

40/43 - All Sheldrake Press.
44/45 - Sheldrake Press; Sheldrake Press; The William Heath Robinson Trust.
46/47 - Sheldrake Press; The Museum of English Rural Life.
48/49 - Mary Evans Picture Library.
50/51 - All Sheldrake Press.
52/53 - Chris Beetles Gallery; Sheldrake Press.
54/55 - The William Heath Robinson Trust; Mary Evans Picture Library.
56/57 - Sheldrake Press; Mary Evans Picture Library.
58/59 - Sheldrake Press; Sheldrake Press.
60/61 - All Sheldrake Press.
62/63 - Sheldrake Press; The William Heath Robinson Trust.
64/65 - Sheldrake Press; The William Heath Robinson Trust; The William Heath Robinson Trust.
66/67 - The William Heath Robinson Trust; The William Heath Robinson Trust.
68/69 - Sheldrake Press; Sheldrake Press.
70/71 - The William Heath Robinson Trust; Mary Evans Picture Library; Sheldrake Press; Sheldrake Press.
72/73 - Sheldrake Press; Sheldrake Press.
74/75 - The William Heath Robinson Trust; Sheldrake Press.
76/77 - Sheldrake Press; Mary Evans Picture Library.
78/85 - All Sheldrake Press.
86/87 - The William Heath Robinson Trust; Mary Evans Picture Library; Sheldrake Press.
88/89 - Sheldrake Press; Mary Evans Picture Library; Sheldrake Press; Sheldrake Press; Sheldrake Press.
90/91 - Mary Evans Picture Library; Mary Evans Picture Library; Sheldrake Press.
92/93 - Mary Evans Picture Library; Sheldrake Press.
94/95 - The William Heath Robinson Trust; Sheldrake Press.
96/97 - The William Heath Robinson Trust; Sheldrake Press; Mary Evans Picture Library; Sheldrake Press; Sheldrake Press.
98/99 - Sheldrake Press; Sheldrake Press; Sheldrake Press; The William Heath Robinson Trust.
100/101 - The William Heath Robinson Trust; Mary Evans Picture Library.
102/103 - All Modern Records Centre, University of Warwick, found in Hercules Cycle Magazine, MSS.328/C/5/HER, Cyclists' Touring Club Archive.
104/105 - Mary Evans Picture Library; Sheldrake Press.
106/107 - Sheldrake Press; The William Heath Robinson Trust; The William Heath Robinson Trust; The William Heath Robinson Trust.
108/109 - Sheldrake Press; The William Heath Robinson Trust; Sheldrake Press; Sheldrake Press.
110/111 - Sheldrake Press; Sheldrake Press; Mary Evans Picture Library.
112/113 - Sheldrake Press; Mary Evans Picture Library.
114/115 - The William Heath Robinson Trust; Sheldrake Press; Mary Evans Picture Library.

116/117 - The William Heath Robinson Trust; Sheldrake Press.
118/119 - All Sheldrake Press.
120/121 - Sheldrake Press; Sheldrake Press; Sheldrake Press; Mary Evans Picture Library.
122/123 - Sheldrake Press; The William Heath Robinson Trust; The William Heath Robinson Trust; Sheldrake Press.
124/125 - Sheldrake Press; Sheldrake Press.
126/127 - Mary Evans Picture Library; Mary Evans Picture Library.
128/129 - The William Heath Robinson Trust; Sheldrake Press.
130/131 - Sheldrake Press; Sheldrake Press; Sheldrake Press; The William Heath Robinson Trust; Mary Evans Picture Library.
132/133 - The William Heath Robinson Trust; Sheldrake Press; The William Heath Robinson Trust.
134/135 - Sheldrake Press; Mary Evans Picture Library; Mary Evans Picture Library; Mary Evans Picture Library; Mary Evans Picture Library.
136/137 - The William Heath Robinson Trust; The William Heath Robinson Trust; The William Heath Robinson Trust; Mary Evans Picture Library; The William Heath Robinson Trust.
138/139 - Mary Evans Picture Library; The William Heath Robinson Trust; The William Heath Robinson Trust; Sheldrake Press.
140/141 - Sheldrake Press; Sheldrake Press; The William Heath Robinson Trust; Sheldrake Press.
142/143 - Mary Evans Picture Library; Mary Evans Picture Library.
144/145 - The William Heath Robinson Trust; Sheldrake Press; The William Heath Robinson Trust; Sheldrake Press.
146/147 - Mary Evans Picture Library; The William Heath Robinson Trust; The William Heath Robinson Trust.
148/149 - The William Heath Robinson Trust; Sheldrake Press; Sheldrake Press.
150/151 - Mary Evans Picture Library; Sheldrake Press.
152/153 - Sheldrake Press; Bridgeman Images; Sheldrake Press; The William Heath Robinson Trust.
154/155 - Bridgeman Images; Mary Evans Picture Library; Sheldrake Press; The William Heath Robinson Trust.
156/157 - All Sheldrake Press.
158/159 - The William Heath Robinson Trust; Mary Evans Picture Library; Mary Evans Picture Library.
160/163 - All Sheldrake Press.
164/165 - Bridgeman Images; Mary Evans Picture Library.
166/167 - All Mary Evans Picture Library.
168/169 - All Mary Evans Picture Library.
170/171 - Sheldrake Press.
172/175 - All Sheldrake Press.
176/177 - Fotolibra.com; Fotolibra.com; Chris Beetles Gallery.
178/179 - All Sheldrake Press.

180/181 - Sheldrake Press; Mary Evans Picture Library.
182/183 - Sheldrake Press; Sheldrake Press.
184/185 - Photographed from an original copy in Calderdale Museums' Collection; Sheldrake Press.
186/187 - The William Heath Robinson Trust; Mary Evans Picture Library.
188/189 - Sheldrake Press; The William Heath Robinson Trust.
190/191 - Advertising Archives; Mary Evans Picture Library; Sheldrake Press.
192/193 - All Sheldrake Press.
194/195 - The William Heath Robinson Trust; The William Heath Robinson Trust; Mary Evans Picture Library; Sheldrake Press.
196/197 - Sheldrake Press; The William Heath Robinson Trust; Philip Porter; Sheldrake Press.
198/199 - The William Heath Robinson Trust; Sheldrake Press.
200/203 - All Sheldrake Press.
204/205 - Mary Evans Picture Library; Fotolibra.com; Sheldrake Press.
206/207 - All Sheldrake Press.
208/209 - All Sheldrake Press.
210/211 - The William Heath Robinson Trust; Sheldrake Press; The William Heath Robinson Trust.
212/213 - All Mary Evans Picture Library.
214/215 - All Sheldrake Press.
216/217 - All Sheldrake Press.
218/219 - Sheldrake Press; Sheldrake Press; Sheldrake Press; Mary Evans Picture Library; The William Heath Robinson Trust.
220/221 - Sheldrake Press; Sheldrake Press; Sheldrake Press; The William Heath Robinson Trust; Sheldrake Press.
222/223 - Sheldrake Press; The William Heath Robinson Trust.
224/225 - Sheldrake Press; Sheldrake Press; Sheldrake Press; Sheldrake Press; Mary Evans Picture Library.
226/227 - All Bridgeman Images.
228–240 - All Sheldrake Press.

INDEX

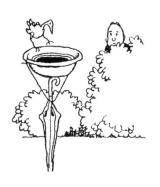

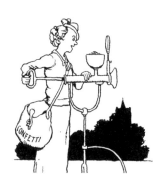

Angling

Brolly Bird Bath

Confetti-Gun

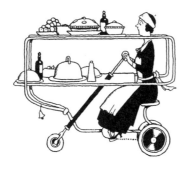 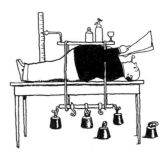

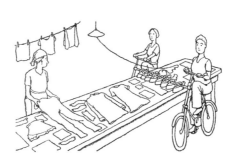

Gnome Seats

Holiday

Ironing

Japanese Fiddle

G

G. & T. Earle Ltd. 16, 161, 170–71
The Gadgets (or Glowmutton family) 17, 22–23, 26
game-hunting 150–51
gardens, gardening 20–21, 41, 44, 45, 46–51
George III 23, 87
George IV 87
George V 128
geyser 22, 105
Gilbert, Sir John 12
giraffes 150
Glendullan Distillery 190
Goldberg, Rube (Reuben Garrett Lucius
Goldberg) 11
golf 125, 134–37, 177
Gooch, Daniel 200
Goodall, Backhouse & Co. 183
Goodyear, Charles 126
Grand Tour 53, 95
Great Western Railway (G. W. R.)
17, 199, 200–03, 206–07, 209
Greenaway, Kate 12
greenhouse 44, 50
Gretna Green 72
Grimsey, Trent 141
Guts Muths, Johann C. F., *Kleines Lehrbuch
de Schwimmkunst zum Selbstunterrichte*
("Small Book of the Art of Swimming
for Self-Study") (1789) 138–39

H

hair (cutting, shampooing, drying) 84, 86, 87, 115
half-crowns 186
hammock 6, 84, 85
Hampton Court Palace 126
Harvard University 127
Harvey, Dr. William 87
hats 75
headphones 7, 225
Heath Robinson Museum and Gallery 17, 229
Heath, William 11
Heim, Jacques 108
Henry Frederick, Prince 53
Henry VIII 126, 128
Hercules Cycle and Motor Company 102
Hetherington, John 75
Highway Code 216
hiking 95, 125
Hitchcock, Alfred 123
Hlaváčová, Yvetta 141
Holding, Thomas Hiram 96
holidays 94, 95–97, 98, 99, 104–17, 224
Holkham Hall Estate, Norfolk 75
Hollywood 123
Honourable Company of Edinburgh Golfers 134
Hooley, Edgar Purnell 194
Hoover, William H. 19–20
Hore-Belisha, Leslie 216
Horman, William 60
horse-racing 157
Hosking, Patrick 11
hot water 22, 26, 27, 104, 105
hot-cross buns 189
Houghton Mifflin Co. 16
Hovis 178–81
Hunt, Cecil, 17
 How to Build a New World (with W. H. R.)
 (1940) 127, 156
 How to Make the Best of Things (with W. H. R.)
 (1940) 99, 218
 How to Run a Communal Home
 (with W. H. R.) (1943) 32, 39, 128, 137
Hunter, Norman 17
hunting 16, 144, 150–51, 191
Huskisson, William 199
Hutchinson's Magazine 210
hydraulics 19, 20, 26, 192, 196, 205

I

ice-skating 152–53
Ilford Ltd. 119
illness & ailments 90–93
Illustrated London News 150
Illustrated Sporting and Dramatic News 150
Industrial Revolution 13, 19, 95, 105, 165, 180
influenza 90, 91
iron 166
Isokon 32

J

The Jazz Singer (film, 1927) 123
Jerome, Jerome K. 95
 Three Men in a Boat (1889) 95
John Booth and Sons 16
Jones, Inigo 53
Jonson, Ben

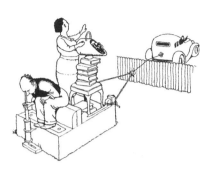

Kitchen Comfort

Levelling the Lawn

Magnetic Braces

Narrokar

Old Mines in Peace Times

Portable Petrol Pump

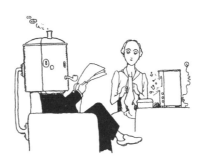

Quiet Read

Restoration

Skiing

Tea and Toast

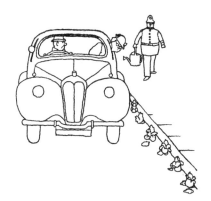